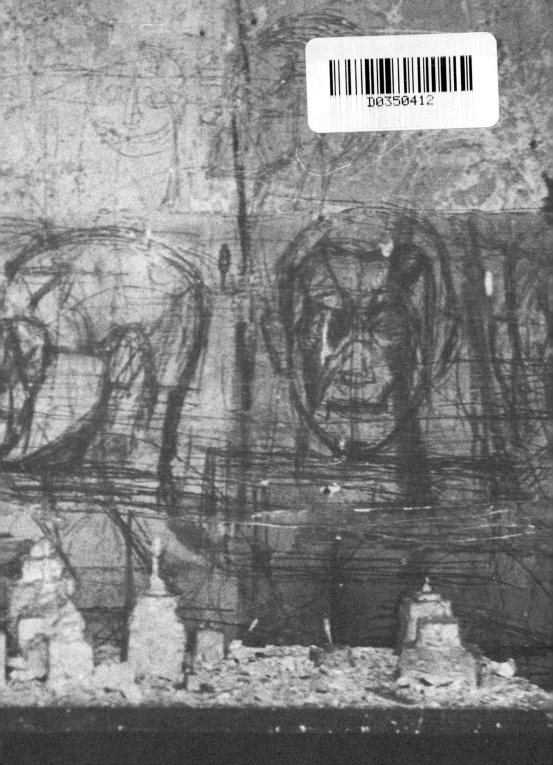

Figures and busts of 1943–46, plaster. Photograph by Patricia Matisse.

Looking at Giacometti

Looking at Giacometti

David Sylvester

Photographs by Patricia Matisse

A John Macrae Book

Henry Holt and Company
New York

Henry Holt and Company, Inc.
Publishers since 1866
115 West 18th Street
New York, New York 10011

Henry Holt® is a registered trademark
of Henry Holt and Company, Inc.

Originally published in a different format in the
United Kingdom in 1994 by Chatto & Windus, Limited.

Library of Congress Cataloging-in-Publication Data
Sylvester, David.
Looking at Giacometti / David Sylvester;
photographs by Patricia Matisse. —1st ed.
p. cm.
"A Jack Macrae book."
Originally published: London: Chatto & Windus, 1994.
Includes bibliographical references.
1. Giacometti, Alberto, 1901–1966—Criticism and
interpretation. I. Title.
N6853.G5S95 1996 95-44742
709'.2—dc20 CIP

ISBN 0-8050-4210-5
ISBN 0-8050-4163-X (An Owl Book: pbk.)

Henry Holt books are available for special promotions
and premiums. For details contact: Director, Special Markets.

First American Edition—1996

Designed by Peter Campbell

Printed in the United States of America
All first editions are printed on acid-free paper.∞

1 3 5 7 9 10 8 6 4 2
1 3 5 7 9 10 8 6 4 2
(pbk.)

*Frontispieces: Mountains south of Giacometti's village, photographed by Janet de Botton;
David Sylvester, 1960, in progress, photographed after the 19th and penultimate sitting by Herbert Matter.*

To John Hewett

Contents

Preface xi

PART ONE

1. Perpetuating the Transient 3
2. A Blind Man in the Dark 6
3. A Time-Space Disc 13
4. The Relevance of Opposites 19
5. The Residue of a Vision 22

PART TWO

6. Traps 39
7. With Slight Variations 66
8. Losing and Finding 79
9. Something Altogether Unknown 88
10. A Separate Presence 110
11. A Sort of Silence 113

Interview 123

Biographical note 149

References 153

Acknowledgements 159

Preface

When I first went to Paris, in the summer of 1947, three years after the Liberation, there seemed to be a sad shortage of new art that was seriously exciting. One thing that did seem to matter was the current work of Alberto Giacometti, who before the War had become famous for *The palace at 4 a.m.* and other surrealist sculptures and then, when in his mid-thirties, had suddenly isolated himself and was rumoured to have been endlessly making and re-making sculptures and paintings and drawings of a single head or a single figure, working much of the time from life. In 1946 *Cahiers d'Art* had published sixteen pages of illustrations of recent sculptures and drawings and these seemed marvellous in the hallucinatory way they showed a figure or head in the space surrounding it. And then, in the spring of 1948, Giacometti had his first one-man show for fourteen years, at the Pierre Matisse Gallery in New York. Imported copies of the catalogue, with its essay by Jean-Paul Sartre, its photographs of plasters in the studio taken by Patricia Matisse, its facsimile reproduction of an autobiographical letter from the artist with sketches of his past sculptures, were passed with a sort of reverence from hand to hand.

But in Paris there was no way of seeing the sculpture unless one had access to the studio. In the autumn of 1948 I was invited by Daniel-Henry Kahnweiler to the apartment he shared with Michel and Louise Leiris, and Giacometti was among the other guests. From then on I was able to make quite frequent visits to the studio.

I started trying to write about the work and in 1955 produced an introduction to the catalogue of a small retrospective exhibition which I curated in London at the Arts Council Gallery. That text is the opening chapter of the present book. Like almost everything else in the book, it has recently been to some extent revised.

At the end of 1959 I completed a version of a monograph; it was accepted by a publisher, but I took it back in order to go on working on it. Two sections of that raw version survive here as Chapters 2 and 3. In the summer of 1960 Giacometti asked me to sit for a painting and the twenty sittings each lasting several hours provided new material to absorb. Progress was slow. A short section which crystallised in 1962 forms Chapter 4 here. In the meantime Patricia Matisse agreed to let me reproduce a selection of her existing photographs of the sculptures and to take others especially for the book. These culminated in a series of views of the studio taken a few days after the artist's death.

In 1964, when Giacometti came to London to discuss the large retrospective I curated at the Tate in 1965, the BBC recorded two interviews, which now appear here in translation. These provided still more material to draw upon within my own text, as I did, for instance, in a chapter which appeared in the catalogue of the retrospective and is reprinted here as Chapter 5.

But most of the book was still in progress when Giacometti died in January 1966. I went on with it, delivered it to a publisher, and after working for some time on the galley proofs never returned them. It had become clear that a text written as a study of work in progress could not suddenly be converted into a text on the subject of a completed body of work.

I went on intermittently with the book but found no shape for it until I perceived two necessities. One was that it had to respect the passing of time by letting key themes appear differently developed at different points. The other was that it had to be divided into two parts, the first consisting of chapters written in the present tense while the artist was alive and the second including the chapters begun in his lifetime but completed in the past tense. The final chapter is a case apart – not begun until the 1980s and manifestly written from a different perspective.

<div align="right">

David Sylvester

London, 25 March 1994

</div>

PART ONE

1

Perpetuating the Transient

Giacometti's standing figures suggest objects long buried underground and now unearthed to stand out in the light. Fossils perhaps, but also columns or caryatids – caryatids indeed, with their compact, frontal stance, except that they seem too tenuous to be that. But they are not ethereal: they have a density which calls to mind the shrunken heads that cannibals preserve. They are figures without 'physical superfluousness', like Starbuck in *Moby Dick*, their thinness a 'condensation'.

That image of a standing figure is always a standing woman. She has a counterpart, an image of a man which again is an upright figure, but here an active figure, walking or pointing. There are also busts of a man and these too are somehow active, the head attentive, watchful. The female is passive, a figure standing motionless, whether with others in a row, parading (as a point of fact) in a brothel, waiting to be chosen, or alone, as if waiting in the street.

But as they stand there, they are not quite still. Their surface, broken and agitated, flickers and the figures, rigid in their posture, perpetually tremble on the edge of movement.

> A blind man is feeling his way in the night.
> The days pass, and I delude myself that I am trapping,
> holding back, what's fleeting.

Transience is everywhere, nothing can ever be recaptured. Yet merely to think of a happening is to try and recapture it, as our very awareness of it pushes it into the past. The days pass and all awareness is nostalgia. The sense of the transitory in these sculptures is a sense of loss.

It is also a statement of fact. The slender proportions and agitated surfaces may be loaded with a mass of romantic evocations whose weight might be a compensation for lack of corporeal mass, but the conjunction of these properties also serves to suggest quite simply that our sensations, for subjective reasons or objective ones, are always shifting, would cease to be sensations if fixed like a butterfly by a pin. If they are to be trapped or fixed, it must be less rudely. Now, Giacometti's aim, as he has put it, is 'to give the nearest possible sensation to that felt at the sight of the subject'. It is evident that for him this entails making it clear that the sensation is fugitive. And to make this clear, he uses forms whose appearance contradicts our notions about the appearance of things. Naturally, there are further attributes of our sensations which these forms are meant to convey. In order to find out what they may be, it is useful to look for a clue in the paintings and drawings, which, being less extravagant in their proportions (they are generally done from life), are easier to read.

The most striking thing about the paintings, and to a lesser extent the drawings, is the density of their space. The atmosphere is not transparent: it is as visible as the solid forms it surrounds, almost as tangible. Furthermore, it is uncertain where solid form ends and space begins. Between mass and space there is a kind of interpenetration.

At the same time, the paintings and drawings lay great emphasis on the distance of the things in them from the beholder's eye. The perspective is often elongated, giving an effect like that of looking through the wrong end of a telescope, so keying-up the nearness or remoteness of a figure or an object. The near extremities of bodies tend to be enlarged, as they are in snapshots, that is, in images whose perspective is optical and not idealised. The scale of the forms in relation to the dimensions of the rectangle (which is generally defined somewhere inside the dimensions of the actual canvas or paper) is peculiarly expressive of their location in space.

Giacometti, then, is preoccupied with problems that concerned Cézanne – the elusiveness of the contour which separates volume and space, and the distance of things from the eye. The stylistic resemblance between his draw-

ings (perhaps the most perfect aspect of his art) and those of Cézanne is not superficial. The attributes of sensation which obsess Giacometti therefore present no major problems which painting has not confronted hitherto. When it comes to sculpture, however, they might be thought to lie quite outside the scope of that medium. Giacometti's insistence that they should not is what has determined the form his sculptures take.

This long slender figure with its broken surface – sometimes as tall as ourselves and no thicker than our arm – clearly bears no relation to the real volume of a human body. There is a kind of core, and outside the core a suggestion of mass dissolving into space. The volume is confessedly an unknown quantity, by implication an unknowable quantity: the fact that in reality contours are elusive is conveyed by the fact that in the sculpture there simply is no contour.

Consider the elongation again. Is it not akin to the kind of elongation produced in painting by the device of anamorphosis? A sort of anamorphosis has distorted the sculptured figure or head, distorted it so that it embodies a perspective, implying that it was seen from a particular angle or distance, so that it belongs at a certain imaginary distance from us which is independent of its distance from us as an object. It is, in other words, like a figure in a painting, fixed once and for all in space, indifferent to our distance from the canvas. Again, the forms are sometimes placed in a kind of cage which defines a space around them like the space contained within a picture, or they are realised in relation to the base they stand on in such a way that the proportion of figures to base works like that between the figures and the foreground in a picture. At the same time, the surfaces have the vitality and autonomy of texture of the surface of a painting.

What matters most is not that the language of sculpture has been extended. What matters most is that, in arriving at proportions which give effects beyond the normal range of sculpture, Giacometti creates a mysterious and poignant image of the human head or figure, fragile, lost in space, yet dominating it.

2

A Blind Man in the Dark

Giacometti's current work in sculpture has three constant themes: a bust of a man, a walking nude male figure, and a standing nude female figure which, like the bust, is severely frontal. They may appear singly or they may appear in compositions of two, three, four, five, eight or nine units. These may bring together units which are all of the same sort – groups of standing women or of walking men – or they may combine units of two sorts – a standing woman with walking men, a male bust with standing women – but they never combine all three. Sometimes the compositions present themselves as possible scenes in real life, as in the combination of a standing woman and several walking men which obviously represents figures in a street; sometimes they are palpably artificial arrangements, as in the bringing together of standing women and a bust; sometimes they are artificial but less unequivocally so, as when groups of women on offer to the clientele of a brothel are translated into a schema which presents them lined up in a row as if on parade.

Since 1935 Giacometti has produced perhaps a dozen pieces of sculpture outside the scope of those three themes. It would be difficult to think of another modern Western sculptor whose subject-matter had been so rigorously restricted.

In his paintings the chief subjects have been a seated figure, often with legs crossed, and a bust. There have also been some single standing female figures, nude – whereas the seated women are usually clothed and the seated men always so – and a few figure compositions; also a number of landscapes, still lifes and studio interiors. The drawings, naturally enough, range more widely in subject.

The sculpture is made in plaster or clay; some of the plasters are painted here and there in black or rust; some of the bronze casts have been solidly painted the colours of flesh and hair. Between 1935 and 1939 virtually all of them were made from life; then, till 1953, mostly from memory; since then, from both. Most of the paintings and drawings have been done from life. The models, for the sculptures too, have been comparably restricted: they are usually the artist's mother, Annetta, his wife, Annette, his brother, Diego.

Giacometti normally has several sculptures and paintings simultaneously in progress. The thickness of the paint on most of the canvases suggests that they have been worked at over a long period. The sculptures also have usually been worked on for a long time. Those from memory are worked on in a way that is highly characteristic of Giacometti in that it reflects a curious combination of nagging self-criticism and a desire for spontaneity. While it is in progress, and this can be over a period of a couple of years, a sculpture from memory will be completely destroyed and remade over and over again, and each remaking will generally be achieved in one continuous day's or night's work. At the end of it all, the visible difference between the first and final states may well be negligible, certainly could have been achieved by a few adjustments here and there. Yet the sculpture has been whittled down to its armature every time some barely perceptible alteration has been wanted, begun again, and completed again at speed. It is as if the process of creation consisted of a series of rehearsals and the final rehearsal was the performance, though the performer didn't know till afterwards that this rehearsal was to be the performance.

This practice of beginning over and over again from scratch, always working at speed, yet through a lengthy period of time, cannot be explained away by any technical exigencies of using plaster or clay; it is entirely a matter of inner need. Giacometti has to go on and on with the thing, endlessly trying to get what he wants, but not by tinkering: he evidently cannot bear to change the thing from outside, he needs to do it each time from the inside out, reliving the full process of its growth. He has to go on and on for months or years, yet bring the work to realisation as near instantaneously as

is humanly possible. The figure as it stands has to come into being as if it had risen suddenly out of nothing, as an unalterable whole.

As an unalterable whole because it is conceived as an indivisible whole. And unalterable only in the sense that he considers it indivisible, not in the sense that it has pretensions to finality. When he stops working on a sculpture and lets it go to the foundry, this is not because he believes that at long last he has brought the work to completion, but because he feels that at this stage it would be pointless to go on: he knows that if he were to go on in search of finality, he would never finish anything. The interplay between spontaneity and sustained effort in his method of working signifies a totally different attitude to art from their interplay in the creation of Picasso's *Man with a sheep*. Picasso achieved the actual execution from start to finish of this life-size figure in a single day, but it was after making numerous preparatory drawings. He proceeded in traditional fashion from studies to the finished work, at the same time aiming to give the finished work the vitality and directness of a spontaneous production. Giacometti's sustained spontaneity leaves no room for a distinction between preparation and execution.

The question of the unfinished and the unfinishable is, of course, one of the things that modern art is about. The traditional distinction between an unfinished and a finished work ceased to be clear a hundred years ago, having already been blurred in the late styles of such masters as Michelangelo, Titian and Rembrandt: it is, indeed, this very factor that governs our concept of 'late style'. With the coming of Impressionism, loosely executed works began to claim the same rights as carefully executed works: whereas a study by Delacroix is a preparation for a definitive picture, a study by Boudin is intended to be seen as complete in itself; the case of Whistler vs. Ruskin was a debate on the validity of this claim. Once it was no longer possible to be certain whether a work was finished or not by looking at its degree of 'finish', it followed that, not only could artists declare unfinished-looking works to be finished, they could declare finished-looking works to be unfinished. There is no radical difference between a 'finished' and an 'unfinished' Cézanne, because a Cézanne is unfinishable. In Giacometti's

work this state of affairs is made especially explicit – above all through his habit of including in his exhibitions plaster casts or original plasters of works in progress along with those cast in bronze, but also in the roughness of the surfaces of the bronzes themselves. Since the work is unfinishable, a sculpture – or, for that matter, a painting – with the spontaneous facture of a sketch – because realised in its final state, as in its previous states, as rapidly as a sketch – has to stand as a final version; but although it was made like a sketch, it is no sketch, it is a long-considered statement. But although it is a long-considered statement there would be no point in giving it a finished look because it has no pretensions to being a finished statement.

Another thing modern art is about is art itself, perhaps beginning with paintings from Courbet to Matisse in which paintings clearly by the artist himself can be detected. Such use of art as part of the iconography has gone on in, say, Braque's series of *Studios* or, indeed, Giacometti's paintings of his studio. With the Cubists, painting moves on from this forthright contemplation of itself towards the exposition of its problems, by laying bare those conflicts and paradoxes which painting has always previously aimed to conceal, to disguise – the conflict between the opposing claims of representation and pictorial architecture and the paradoxes that the painter is trying to remake in two dimensions what exists in three, that he gives the impression that he is painting what he sees, though he cannot help painting what he knows, that his apparent viewpoint is single, but his real viewpoint is multiple. In Cubism the logic of painting, the demands of the language itself, are discussed in terms of painting. With Dada, the very status of art, its moral validity, its cultural role, become part of the subject-matter of art, and Duchamp goes to the root of the question of what is valid as material with which to make a work of art. In one branch of Surrealism, Magritte sets a series of semantic puzzles examining the difference between reality and a painted image of reality and the relation between them; in the other branch, the spectator's recognition of what automatic or quasi-automatic techniques have been used can become an integral part of experience of the work. Abstract expressionism has, of course, inherited the surrealist

exploitation of automatism, but, in placing a much greater emphasis on the pictorial reality of the work, makes a new act of faith in art, affirms the moral value of painting as an activity that arrives at the realisation of an unforeseen pictorial order (often on a scale that is a direct reflection of natural human gestures, so announcing that the work mirrors the actions of a man being unconstrainedly himself). And, because no small part of the content of the work is the struggle through which its order has been evolved out of chaos, this art also is self-regarding.

Giacometti, after a period of adherence to Surrealism, has set out to attempt to represent external reality as he sees it, disregarding his awareness that he cannot hope to succeed. Others of his generation (Balthus, for example) have renewed the attempt to deal with reality in a direct way, but have seemed to find it necessary to assume that what they are trying to do actually can be done. Giacometti's peculiarity is to combine rather traditional aims with an untraditional self-consciousness about the limitations of his art. His art is self-regarding, a criticism of art, a laying naked of certain of art's paradoxes, an analysis of the process by which a work of art is achieved, a questioning of the validity of the kind of art identified in the iconography of his paintings. This presents a world more or less bounded by the four walls of his studio, and the objects in this world, apart from the furniture and equipment of a studio, are two or three models, appearing again and again, and always in the conventional poses of the art school, that is, as models, not as personalities, let alone protagonists in dramatic action. The implications are that a total involvement in art is taken for granted (regardless of all doubts as to whether art can in effect justify its pretensions) with the proviso that the value of this involvement depends upon art's being, not an activity for art's sake, but one that is completely at the service of a vision of reality. As he wrote in 1945: '. . . in every work of art the subject is primordial, whether the artist knows it or not. The measure of the formal qualities is only a sign of the measure of the artist's obsession with his subject; the form is always in proportion to the obsession.' But with Giacometti the obsession involves the investigation through his work of a

somewhat philosophic question: what do we really mean by our intention to represent our sensations of reality in art?

The self-regarding element in twentieth-century art is equally present in every other aspect of the century's culture and is probably what does most to make it radically different from everything that has gone before. Obvious examples of creations which take the nature of creation and its relation to reality as their theme are – and it's significant that they have little else in common – *Ariadne on Naxos*, *Six Characters in Search of an Author*, *The Counterfeiters*, *Lolita*, *Doctor Faustus*, the *Sonnets to Orpheus*, *East Coker*. And art itself is the theme, not the figure of the artist, one of the great themes of the nineteenth century. The difference epitomises the differences between the two centuries.

In the popular arts the cinema has in recent years produced a crop of Westerns in which the conventions and values of the genre are more or less explicitly discussed, the modern stand-up comic constantly exploits the joke about the joke he has just told and how the audience reacted to it. He is forever reminding his audience that the biggest joke of all is the absurdity of his situation in trying to be absurd.

The most obvious expression of the tendency to self-regard has naturally enough occurred in philosophy. The great revolution in modern philosophy has been the rejection of the idea that philosophers ought to pronounce upon the nature and structure of the world in favour of directing their inquiries towards discussion of what philosophical discussion can achieve, what precisely is its valid scope, and hence towards the analysis of language. And there is much that reminds me of the greatest of such philosophers, Wittgenstein, in Giacometti's approach to his work. There is a similar consuming dedication to an activity, and a similar refusal to take for granted accepted assumptions about the purpose and possibilities of that activity. There is a similar feeling that this activity is not a means of producing works of philosophy or works of art, but a search that can never lead to a final solution. There is a similar passion for economy, a passion which in Giacometti shows in the narrowness of his themes and which also exercises itself in his instinct to attenuate, to eliminate. There is a similar reluctance to

make their work public: Wittgenstein published his first book in 1921; his next appeared in 1953, two years after his death. Giacometti had his first exhibition in 1932, his next in 1934, his next in 1948.

The whole pattern of their careers, indeed, is remarkably alike. Both were quick to acquire a high and influential reputation through early work which was rather schematic and formal and which they felt was conclusive but limited. As Wittgenstein wrote in the preface to the *Tractatus Logico-Philosophicus*: 'If this work has a value it consists in two things: . . . I am . . of the opinion that the problems have in essentials been finally solved. And if I am not mistaken in this, then the value of this work secondly consists in the fact that it shows how little has been done when these problems have been solved.' Giacometti's view of a group of his early works is that 'it seemed to me that they were in some way like things and like myself' but that 'it was always disappointing to see that the form I could really master amounted to so little'. After the long silence that followed, the work that emerged was much more provisional in finish, so that, in a preface written in 1945 to the still uncompleted *Philosophical Investigations*, Wittgenstein wrote of his ideas: 'I make them public with doubtful feelings . . . I should have liked to produce a good book. This has not come about, but the time is past in which I could improve it.' Giacometti has lately written of his current work: 'All I can do will only ever be a faint image of what I see and my success will always be less than my failure or perhaps equal to the failure. I don't know if I work in order to do something or in order to know why I can't do what I want to do.'

Their lives show a common readiness to sacrifice everything to their investigations, living with extreme austerity, refusing all compromise, and a common contempt for the idea of art or philosophy as a career. Linked to this is a common determination to find value in unexpected places rather than in the fabrications of fellow-professionals: Wittgenstein maintained that, if philosophy had anything to do with wisdom, there was less in the pages of *Mind* that was relevant to it than in detective stories; Giacometti says that for him there is less reality in the work of contemporary sculptors than in tin soldiers in toyshop windows.

3

A Time-Space Disc

In a text written in 1946, *The Dream, the Sphinx and the death of T.*, Giacometti set down a number of experiences, recent and remote, waking and dreaming, which he felt were mysteriously interconnected. He began by closely describing a dream and a dream within it which he had had the night after realising he had caught something at the Paris brothel called Le Sphinx, and went on to tell of certain events which came after and then of others, recalled by these or by the dream, which had happened, waking or dreaming, many years before (some had always haunted his memory, others been forgotten). As he recalls the events he tells how and when it occurred to him that each of the connections existed, and discusses the difficulties of expressing all the relationships and bringing all the diverse experiences into a coherent and effective narrative. He tells how he tried to deal with the problem by composing a schema which made all the elements visible simultaneously on a page, but this was no help in writing a narrative giving the facts, as he would have liked to do, in some sort of chronological order.

At this point, he introduces a further set of facts. When he was telling the dream to a friend the day after, it was transformed into another dream involving an event that had happened in his childhood and others that had happened when he was a student in Italy, and this led him to talk about the Temple at Paestum and St Peter's, Rome, and of the difference between the apparent and the measurable dimensions of the buildings. This had led in turn to talk about the dimensions of heads and the dimensions of objects and the affinities and differences between objects and living heads, so bringing him back to his principal preoccupation at the time.

Sitting in a café thinking of all this and trying to put it on to paper, he suddenly had a feeling that all these events existed simultaneously around

him, that time was becoming a circular space. He made a drawing in which events were disposed on a horizontal disc with himself, at the time of making it, at the centre. But as he walked along the street, he visualised the idea in other ways, ending up with a construction in space:

'A disc about two metres in radius divided by lines into sections. On each section was written the name, date and place of the event it corresponded to, and at the edge of the circle facing each section stood a panel. The panels were of different widths and separated by empty spaces.

'The story corresponding to the section was printed on each panel. I took a curious pleasure in seeing myself walking on this time-space disc and reading the story written on the panel in front of me, with the freedom to begin wherever I liked. . .I was anxious to get the orientation of each fact on the disc.

'But the panels are still empty; I don't know enough about the value of words or their relationships to be able to fill them in.'

He does, however, know the value of sculptural forms and their relationships, and in his sculptures he has done rather what he wanted to do with words. With the words, he wanted to use an object in space as a rigid construction upon which to register fugitive experiences, a formal structure on which to leave provisional imprints; his sculptures register fugitive experiences within compact, upright, frontal configurations with an ideal beauty parallel to that of the geometry of the panels. What is more, they often bring together several experiences, distant memories as well as recent memories and memories of the kind of things he is constantly seeing. In 1933 he wrote of his surrealist objects: 'Once the object has been constructed, I have a tendency to rediscover in it, transformed and displaced, images, impressions, facts which have deeply moved me (often without my knowing it) . . .' And displaced and transformed images are also discovered in his recent work. In 1950 he came across two groupings of figurines of various sizes and a bust on the studio floor, mounted them on boards as they stood, and later realised that they corresponded to memories of landscapes. Thus, looking at the composition with seven figures and a bust, he found that it

14

'reminded me of the corner of a forest, seen over many years (during my childhood), where trees with bare slender trunks, limbless almost to the top (and behind which granite boulders could be seen), always looked to me like people stopped dead in their tracks and talking among themselves'.

But it was not the simple crystallisation and transformation of memories that Giacometti was concerned with in *The Dream, the Sphinx and the death of T.*. His great concern was to find a way of establishing an intelligible relationship between those memories. The object he envisaged was intended not merely to describe and bring together certain experiences, but to show in its structure the way in which such experiences are related in time, in the stream of consciousness. In the same way, Giacometti's sculptures are objects that do not merely crystallise transient sensations but show the conditions in which transient sensations happen. Their content is not only the what but also the how of visual experience: their subject is not only what was seen, but also the act of seeing. In representing what he has seen, Giacometti objectifies the conditions under which he has seen it – the fact that it is seen in space, the fact that it is uncertain where the boundary is between solid forms and space, the fact that it is no sooner seen than it becomes a memory, the fact that it was seen from a certain distance.

But Giacometti has not only seen the figure, he has tried to re-create seeing it. His experience of seeing it is inseparable from his desire to trap that experience in a work of art, just as, in *The Dream, the Sphinx and the death of T.*, his obsession with the events and their connection is inseparable from his obsession with expressing their relationship in an intelligible form. So the conditions of seeing objectified in his sculptures are not merely those of seeing but of seeing with a view to representing: people are not much concerned with the distance from them and the elusiveness of the contours of the thing they are looking at unless they are trying to represent it, or have the habit of trying to represent things.

Giacometti's sculptures, then, don't merely convey the conditions of seeing but the conditions of trapping what he sees. They render visible the process of translating reality into art, and we go through that process in

15

reverse. In looking at the sculpture we experience the problem of trying to define the contour, of finding what cannot be defined, and what can, and to what point. For example, in a group of standing figures made, at least one of them from life, in 1953-54, the expected slenderness has given way to rather normal proportions. These figures are somewhat reminiscent of certain early sculptures by Matisse, not only because of superficial resemblances but because both combine a certain formality of posture with a rough surface suggesting spontaneity, informality, and because they have an introvert's kind of sensuousness. But they are not at all the same in vision. The Matisse sculptures are perfectly compact, perfectly self-contained, objects in a void, objects whose world begins and ends where their surface is; the Giacometti sculptures seem to carry an aura of atmosphere around them and to expand and contract in that atmosphere like a lung. The Matisse sculptures present a figure seen whole and entire now, in an instant of time, in any instant of time, meaning outside time; the Giacometti sculptures seem to present figures as they are perceived while time passes: they have a sort of inverted magnetism by which they persuade our eye not to become fixed on them but to wander over them and round them, building them in our consciousness as we go. I think this happens when we look at the sculptures because no detail of the figure – for all that the details here are rich and rounded – is put there as if this statement of it claimed to be absolutely true. The delicious curve of a shoulder is not something known with assurance, something it is possible to be dogmatic about, but is a mystery which must always elude the grasp and which can only be crushed in the attempt to grasp it firmly, finally. What is there can only be stated tentatively. And the greatness of Giacometti's art is that it is tentative but is not vague. What this art does is to convey precisely why our sensations of reality cannot be conveyed precisely. (This will seem an admission of weakness only to those who even now believe that the representation of reality in art is, though difficult, a straightforward affair open to all artists of good will.)

Again, in looking at the sculpture we experience the artist's experience of his distance from the subject. The real point of the expression of distance in

the sculpture is not really to make distance as specific as it can be in a painting, because it cannot be done with the same precision: it can only be established that the figure is not here but there. The real point is to render visible the fact that the effigy of a human figure which the sculptor is making is within his reach though the figure he is representing is beyond his reach. Our experience of the work reconstitutes the relationship between sculptor, sculpture and model. As an object, the sculpture is within our reach as it was within the sculptor's reach – indeed, it is the reverse side of his gestures, the traces of his gestures, and the roughness of its surface emphasises this – but the sculpture as a human figure is separate from the sculpture as an object, it is not within reach. It is detachable from the object. It can seem to move away while we are getting closer to the object until finally the figure dissolves into bronze or plaster and we are left with the object only. Thus the work shows forth the dual nature of a work of art as object and as image – an object that is hard and firm, flat, cold, an image that is soft, round, warm.

The world of art is solipsistic in a special sense: a tree functions as a tree regardless of whether it is observed, but a work of art is merely a piece of stone or bronze, or a flat piece of canvas covered with paint, until it is seen by a human observer who interprets it as a work of art. This fact about the nature of all works of art is made explicit by Giacometti's sculpture through the special demands it makes upon the spectator. Several of the surrealist objects were designed – some as constructions with moveable parts, others as projects for environments – to engage the active participation of the spectator, in reality or in imagination. The only life-size or near life-size sculptures by Giacometti which make dramatic gestures are the male figure called Man pointing of 1947, whose outstretched hand makes sense as a gesture only when we see him as pointing to ourselves or to someone or something in our world, and the female figure of The invisible object, 1934, who seems to be offering us the invisible object held between her hands. And the later sculptures, being seen at a distance, imply the observer at the other end of that distance. In one way or another the work involves the spectator directly, and this involvement is a comment on the dual nature of a work of art as object and as image.

The sculpture is object, here, image of a figure, over there. The sculpture is an enduring object and its forms symbolise that endurance, but they are also traps for what does not endure, indeed has no extension at all in time. The time between the instant when the artist looks at the model he is copying and the instant later when he looks at the work to add what he has just seen might as well be an eternity, because he is not copying what he is seeing now, but only what he is remembering. And perhaps one implication is that if we never tried to copy what we see, we could go on seeing it, could be lost in it. Nevertheless the work is there, a trap for the untrappable, and this has an enduring form. Art in general has tended to disguise this paradox. Giacometti's is a meditation upon it.

In 1935 Giacometti started to work from life with the intention of doing so for a few weeks before making some figure compositions. He went on doing so for five years. Since he began to work from memory again, his work has been a meditation upon what it means to represent reality in art. His obsession is what happens when a human being is seen by another who is obsessed with representing what he sees.

4

The Relevance of Opposites

The world presented in Giacometti's paintings rarely extends beyond the walls of a room that is very evidently a studio. The figures in it are never engaged in activities of their own at which they are caught unawares, but are posed facing the beholder, posed so that they can be clearly seen. The sculptures present figures seen in settings other than the studio: a street where four men are walking and a girl is standing waiting, a long room where the girls are on view at the far end of the polished floor, a small room where they stand uncomfortably close, a room where a single naked girl is watched by the head of a man - a rudimentary version of the theme represented by Titian as *Venus and the organ-player*. And all those single female figures who might be models in a studio might equally well be girls waiting in a brothel or a street or a room. Wherever they are, their role is to be seen and to return the beholder's gaze. They stand there motionless, always as if trembling on the brink of movement, always doing no more than see and be seen.

The male figures are never motionless: one stands pointing, another is falling over, the others are walking. At least one or two of them have been described by Giacometti as representing himself; others no doubt could be. The head placed with a naked woman in a room must obviously be identified with himself, and this head looks no different from the numerous heads of his brother: all of them can perhaps to some degree be identified with himself. And the heads are, in a way, as active as the walking figures. For their gaze does not seem to be one which, like that of the women, mirrors the gaze of someone looking at them: it seems to have taken the initiative. These heads appear to see rather than be seen. They have a watchfulness, an attentiveness which has something of the strangely attentive look of the

19

blind of the impression they give, because of the indifference of their eyes, that they can see us while it is we who cannot see them. There is the poem of Giacometti's in which images of blindness and movement are fused.

> A blind man is feeling his way in the night
> The days pass, and I delude myself that I am trapping,
> > holding back, what's fleeting.

The blind man in the dark, clearly an image of the artist himself, is an image of faltering motion, of heightened attentiveness, of a searching to connect.

But the women only stand there, offering themselves and continuing to offer themselves, out there in space beyond reach. 'The nearer one gets, the more distant they are.' They stand erect, alone in their own space, and whatever connection the beholder has with them can only endure so long as he keeps his distance. 'When I'm walking in the street,' Giacometti has said, 'and see a whore from a distance with her clothes on, I see a whore. When she's in the room and naked in front of me, I see a goddess.' These figures are untouchable because they are there to be adored. They hold their hands on their hips in a gesture that is enticing, but also protective, enshrining. When we get up to them, they dissolve into the play of light over the broken surface of a piece of bronze. Their faces, pert and pretty from the far side of the room, are ravaged as if by the pox when near. They bring to mind the women in the poems about dreams composed by the young Cézanne: the woman transformed into a corpse as he embraces her, the women who elude him as he draws near and, as he reaches out to touch them, dissolve away.

Whatever they suggest at once provokes the question whether its opposite is not more relevant. They are insubstantial, fragile, their surface looks as if it might have been corroded merely by exposure to the light. And they stand there like petrified trees or the tapered columns of Persepolis. They rise from the ground as if rooted. And they are poised in flight like medieval saints zooming complacently up to heaven. They are deities, remote, imperious, untouchable. And they are vulnerable naked girls trying to attract

customers at a cabaret. They are like dancers when a dancer stands motion-
less and seems to be drawing her body and the ambient air inward to a still
centre. And they are like the dead, their heads indrawn and dry as skulls,
limbs bound as though bandaged for the grave.

5

The Residue of a Vision

There was a period of about five years when every figure Giacometti made (with one exception) ended up an inch high more or less. The scale 're-volted' him, he set out persistently to make the sculptures larger, invariably pared them down: 'only when small were they like'. When he finally produced some larger sculptures, he discovered, to his 'surprise', that 'only when long and slender were they like'. Likeness is Giacometti's measure, so much so that the most cherished dogma of twentieth-century aesthetics is shrugged off: 'If a picture is true, it will be good as a picture; even the quality of the paint will necessarily be beautiful'. What seems to him to be 'like' or 'true' is something that cannot be foreseen: it can come as a surprise, can give the work a shape he would prefer it not to have. He said to me once that of all the pictures he had seen the ones that seemed most true to his sensations of reality were certain Egyptian paintings of trees, and that he too had thought them, as anyone would, too stylized for such a claim to be feasible until he drew copies of them.

But what precisely are the elements in Giacometti's sensations that might be thought to determine his notion of likeness? They can perhaps best be sought by looking for preoccupations which show themselves both in the sculptures and in the paintings and drawings, and therefore cannot be explained away by any exigencies of the medium.

In the paintings, space is like a cloudy heavy liquid that is seen no less than the mass at the heart of it is seen, and is hardly less tangible. The mass has an energy that is turned inward upon itself, violently compressed around a central core, so that it seems to have a highly concentrated density; the space has an energy that is turned outwards, sometimes as if exploding

out of the picture, and at the same time often seems held back, drawn in, by the mass at its centre, as if this were the centre of a whirlwind. Where the one meets the other there is an interpenetration. The boundary between them is not fixed. 'I have often felt in front of living beings, above all in front of human heads, the sense of a space-atmosphere which immediately surrounds these beings, penetrates them, is already the being itself; the exact limits, the dimensions of this being become indefinable. An arm is as vast as the Milky Way, and this phrase has nothing mystical about it. ' There is either no outline or a multiplicity of outlines in the paintings to mark the transition of mass to space. In the drawings, besides the same use of multiple outlines, an indiarubber is often used across a form rather as if its traces were brushstrokes made against the form: the traces suggest that the mass has been as it were smeared by space. When such traces cross the edge of a form, the elusiveness of the contour is implied more emphatically than by a simple gap left in an outline, for here it is evident that the artist committed himself to a contour only to find that it was not to be fixed.

The sculptures – except most of those anterior to 1935 – have a rough, fluid surface which rather resembles the surface typical of an unfinished work in plaster or clay. It is as if the existing boundaries of the form were provisional. At the same time, the attenuated proportions seem to imply that these provisional limits are not an approximation to the contour but simply have no pretensions to fixing the contour. The central column is defined with the most exact precision; the volume remains an unknown quantity. It is as if Delacroix's advice not to take hold of the outline but of the centre had been taken literally. All that is there is a hard core clothed with a suggestion of mass dissolving into space. Space has corroded the mass, or compressed it. There is only enough mass left to show that space can only go so far, little enough left to show just how little mass is needed for space to be dominated. If in one sense space has reduced the mass, in another sense the mass is always encroaching on space, in that it gives the feeling that it occupies more space than one thought it did.

Nothing is allowed to appear certain as to the relation between mass and

space. Even in those heads and figures, done, some of them from life, since 1954, in which there is relatively little attenuation and the curve of a breast or a shoulder is lovingly, delicately, rendered in its fullness, the contour is made to seem flexible as the forms appear to contract and expand like a lung in their aura of space. In certain other heads, some of the features are there in their fullness, the rest have simply been left out; as in those 'unfinished' still lifes by Cézanne in which the part left out means the discovery that some of the contours are indefinable. The head in *Stele II* and in *Stele III* of 1958 isolates the nose, eyes, mouth, chin and frontal plane of the cheeks and brow; the sides and dome of the head are absent. The nose thrusts forward aggressively; everything else that is there seems to retreat. I become conscious of its evasiveness when I try to look the personage in the eyes. I change position, trying as it were to catch his eye, but whichever way I move the head always seems to be turning away from me, looking the other way. Then I see that the very substance of the face seems to be eluding me. It is as if the sculptor had tried to seize the volume of the head with his hands, and as if as he did so he found that the form somehow drew itself in, shrank, becoming concave in outline where it was convex, so that it eluded his grasp, as a cat seems to make itself concave when one corners it and tries to pick it up.

In the companion-piece, *Stele I*, the face is reduced to a single curved frontal plane with the nose projecting slightly from it. Here again it is as if the sculptor had tried literally to seize the form. As I look at the swimmy, featureless frontal plane, I sense the hands shaping it out of the clay and have the feeling that, as he shaped it, the nerves in his fingers were echoing what they would have felt in groping their way over his own face to discover by touch alone a face's form. Here the form is elusive in that it only partly emerges from an inchoate mass. In *Stele II* and *Stele III* some of the form has emerged with emphatic clarity, while the part of the mass that has not become definite is cut away. Only, it doesn't seem to be missing, but rather as if it had been absorbed into the central core. It is as if this core had drawn the whole volume back into itself: it seems denser than the substance of reality.

Matter does not need to occupy the space it occupies in nature because here it is more concentrated than in nature.

And this seems relevant to all Giacometti's sculpture, and to the paintings. He frequently says, about his compulsion to pare things down, 'the more I take away, the bigger it gets' — says it every time with as much astonishment as if he had just perceived it for the first time. What he must mean is that he finds, again and again, that in reducing matter he is working it in a way that makes it come to seem compressed, so that the sculpture correspondingly acquires more presence, dominates more space, and so seems to fill out more space. Measurable proportions are irrelevant to finding the right proportions. What is relevant is the way a sculpture seems to act on space. For Giacometti, sculpture is no less an art of illusion than is painting. A sculptured as much as a painted figure is conceived — the sculptures with space-frames spell this out — not as a self-contained entity but as inseparable from a spatial context.

The space in the paintings is not only given a visible, even a tangible, presence, but also very definite dimensions. The interval between two forms or two points in a form, or from the observer's eye up to a form, is often traversed by a line indicating the distance in space traversed by vision in bringing something into focus. The distance between the observer and what is observed is again sometimes indicated with great emphasis by the use of an optical perspective which enlarges the near extremities of the subject as in snapshots. Often the whole space has the steep, narrow, hallucinatory perspective characteristic of Tintoretto, Beccafumi and other Mannerists, and found again in certain Vuillard interiors of the first decade of the century. It is a perspective which elongates the space rather as if it were seen through the wrong end of a telescope, and in it distances are so intensified that a figure seated on the far side of a room is separated from one by a chasm, a figure in the foreground is almost on top of one. The effect of this steep perspective is heightened by the painted border, like a mount, which occurs in most of Giacometti's paintings, defining the limits of the image somewhere inside those of the canvas (it's characteristic that Giacometti is one of

those artists who tend to find themselves subtracting from the dimensions of their canvases). This flat border, in the first place, helps to affirm the reality of the picture-surface, and it is needed to do this because the image itself tends to dissolve the picture-plane away. But the border serves above all to intensify the sense of distances within the image. Again, the drawings are nearly always coherent pictorial statements of forms in space, not studies of bodies or objects floating in a void, and there is often a bounding rectangle drawn within the rectangle of the sheet, like the border in the paintings. It occurs in drawings of a single figure or head, defining an ambience within which the scale and the placing of the motif can situate it at a certain distance from the eye.

'Once, when I was about eighteen or nineteen, I was in [my father's] studio drawing some pears that were on a table, at the normal distance for a still life. And the pears kept getting tiny. I'd begin again, and they'd always go back to exactly the same size. My father got irritated and said: "But just do them as they are, as you see them!" And he corrected them. I tried to do them as he wanted but I couldn't stop myself rubbing out. I kept on rubbing out, and half an hour later they were exactly the same size to the millimetre as the first ones.

'Until the war, when I was drawing I always drew things smaller than I believed I saw them: in other words, when I was drawing I was amazed that everything became so small. But when I wasn't drawing, I felt I saw heads the size they really were. And then, very gradually, and especially since the war, it has become so much a part of my nature, so ingrained, that the way I see when I'm working persists even when I'm not working. I can no longer get a figure back to life-size. Sometimes, in a café, I watch the people going by on the opposite pavement and I see them very small, like tiny little statuettes, which I find marvellous. But it's impossible for me to imagine that they're life-size; at that distance they simply become appearances. If they come nearer, they become a different person. But if they come too close, say two metres away, then I simply don't see them any more. They're no longer life-size, they have usurped your whole visual field and you see them as a

26

blur. And if they get closer still, then you can't see anything at all. You've gone from one domain to another. If I look at a woman on the opposite pavement and I see her as very small, I marvel at that little figure walking in space, and then, seeing her still smaller, my field of vision becomes much larger. I see a vast space above and around, which is almost limitless. If I go into a café my field of vision is almost the whole of the café; it becomes immense. I marvel every time I see this space because I can no longer believe in – how can I put it? – a material, absolute reality. Everything is only appearance, isn't it? And if the person comes nearer, I stop looking at her, but she almost stops existing, too. Or else one's emotions become involved: I want to touch her, don't I? Looking has lost all interest.'

Experiments in perception show that in normal vision the mind corrects the retinal image so that distant things are not perceived small but life-size and distant. Giacometti's peculiar tendency is to see in a way that is free of the normal conceptual adjustments and reacts to what is strictly visible.

This is not, however, an impartial, unselective way of seeing. On the contrary, it singles things out with great emphasis, and even its very positive awareness of the presence of the space surrounding any solid body does not lessen the intensity of its focus upon the body around which that space circulates. This narrow focusing upon a compact form out there in space, this attentiveness to apparent size at a given distance, produce the hallucinatory sense of nearness and farness which is probably the most characteristic feature of Giacometti's work.

Getting this sense of distance into a painting is a matter of controlling the notional space which painting creates automatically; getting it into a sculpture is another matter. The sculptor has to win a notional space within and around his forms, win it in the face of the fact that they inhabit the same real space as himself. It is, of course, one of the criteria of sculpture that the apparent distances within a work should not be identical with the measurable distances – for example, that the hollow of a back should look deeper than in fact it is. But Giacometti is concerned with doing more than this – not merely with creating notional distances within the sculpture, but with

creating one between the whole sculpture and the eye of the beholder. He points out that, among sculptures produced by early civilisations and by prehistoric man, there is a fairly common size for a figure and for a head and that this size is relatively small, and he suggests: 'I think that this actually was the size that instinctively seemed right, the size one really sees things. And in the course of history, perception has been mentally transposed into concept. I can do your head life-size because I know it's life-size.' Supposing that he is right about the reason for the size of most early Egyptian or Sumerian sculptures and the like, we still do not consciously interpret them as portrayals of heads or figures at a distance but simply as under-life-size sculptures.

Giacometti's minuscule sculptures (which were made about the time he stopped having the illusion that he saw things larger than he drew them) are not merely exceptionally small but are mounted on bases which, relative to the heads and figures and to the conventional proportions of a base to a sculpture, are very large – up to three or four times the height of the figures. Consequently, the head or figure seems to be very far away, like one small form in the middle of a large canvas. It is a sculptural equivalent for the pictorial principle that the illusion of distance depends upon the size of a figure or object in relation to the size of a rectangle. The optical effect as such could, of course, be achieved by sticking a match upright in a large lump of cheese. But these tiny figures and heads are intensely alive and rich, with the life and richness that can only come when the mind is concentrated on reality, not on a formal device.

In 1950 Giacometti made two complementary compositions based on the sight of groups of women on view in brothels. Each is formalised as a row of four nudes standing on parade. In one of them, the figurines are placed on a plinth the height of which is about half their height. Of this group Giacometti wrote: 'I've often seen them, above all one evening in a small room in the rue de l'Echaudé, very near and menacing.' In the other composition, the figures are on a plinth whose height is rather greater than their own, and this in turn is mounted on a tall stand in the form of a stool about four feet high, so that the figurines are standing on a construction

eight or nine times their height. Giacometti's gloss on this group was: 'Several naked women seen at the Sphinx while I was seated at the end of the room. The distance which separated us (the polished floor) and which seemed impassable in spite of my desire to cross it, impressed me as much as the women. ' Each row of figurines combines with its base to make the equivalent of a picture of figures in a setting – in the one case, figures all in the foreground, in the other, figures at the end of a deep perspective. But here nearness and farness are also conveyed through the proportions of mass to space in the rows of figurines. The intervals are much wider in ratio to the volumes in the group of far figures: here each seems lost in space; the other women seem a crowd, with a physical presence that rears up in one's face.

The space frame is a further sculptural equivalent for an attribute of painting: the definition of a space apart from reality's infinite space. One of Giacometti's reasons for using space frames must be that, by giving a sculptural image its own spatial ambience, it suggests that the space around an object is seen no less than the object is seen. But Giacometti has succeeded in conveying as much without the aid of this quasi- pictorial device. By the same token, he has not had to depend on the proportion of a figure to a rectangle to give his sculptures a notional distance, but has done so through the internal proportions of a figure or a head.

The single figures of standing women almost invariably seem to remain beyond one's reach whatever one's physical distance from them. When I face one of them from the far side of a room and start moving towards her, for the first few paces she seems to come nearer, then she begins to recede from me as fast as I approach. She keeps, so it seems, her distance. It is as if she were detached from the physical space of the room and existed within a separate space of her own. As I get near, I do not, as one normally would, see only the part of the figure around the point I am focusing on; I can still see the figure entire. And when I get right up to her, to the point at which I expect to be seeing details in close-up, relishing the curve of a cheek, of a breast, I see hardly anything of a figure at all, but a piece of bronze and the

light flickering over the imprints of the artist's fingers or knife — a hard, tangible object which has replaced a body become intangible at the moment it was near enough to be touched. Once the figure is no longer seen as if from far enough to be seen as a whole, she dissolves away.

The roughness of the sculpture's surface contributes by having the same sort of effect as loose free brushstrokes which from a few inches away are seen as no more than marks on the canvas. The slenderness contributes, in that the sculpture as an object doesn't get in the way, is insubstantial enough not to fill the field of vision as one gets near, continues to have space around it. And the proportions of the parts along its height contribute. The elongation is not consistent, but increases in degree from head to feet. Consequently, when one stands at the distance from the sculpture at which the artist stood in working on it, and has it at the height it must have been at, it becomes foreshortened in such a way that the proportions actually seen are near enough those of a model seen standing some distance away. The figure usually has greatly enlarged feet and often a base whose top plane is sloping, rising from front to back. And as one looks down on the feet and the base from where the artist would have seen them while working, they reproduce the appearance of the feet of a model standing over there and of the floor she is standing on, the instep apparently extended, the floor apparently an inclined plane rising away. The proportions, then, are somewhat anamorphic, in that there is a viewpoint where they become foreshortened in such a way that they resemble the proportions of a thing seen in reality. Except that these sculptures do not only make sense from where the distortion is rectified. There is some complex of distortions in them — clearly arrived at empirically, not through the conscious exercise of optical devices — which modifies the normal functioning of ocular disparity and convergence. The illusory effects do not occur when the sculptures are looked at one-eyed. Giacometti's sculptural language takes account of the fact that vision is stereoscopic.

The standing figures which do not work in this way are the four which are nearly three metres tall, figures made 'in a sort of nostalgia for large

outdoor sculpture' – a nostalgia to which Giacometti knowingly subdued the expression of his way of seeing. If they do imply a notional distance, it would be a nearness not unlike, though less extreme than, that of the *Spoon-woman* of 1926, whose proportions, the huge spoon-shape out of scale with the rest, suggest a woman as seen by someone crouching just in front of her, his field of vision almost filled by her belly and thighs, so that the head and thorax above and the shins below are foreshortened. An extreme nearness is also implicit in some of the plaques which followed – and which like the spoon present a smooth wide subtly inflected form with a thin profile – especially the *Gazing head* of 1928. When I asked Giacometti whether this head was meant to recreate the sensation of a face seen from very near, he answered that this had been precisely his intention. That sensation of nearness occurs in the later work in some of the series of busts of Annette, with their form somewhat spread out, modelled in the 1960s, a time when Giacometti was making a point of doing paintings from a position unusually close to the sitter.

Most of the busts, however, are as if seen at the distance we would be from someone sitting at the same table. At that sort of distance the rounded forms which a human head presents from the other side of a room have been broken down. We see the head near us more as a structure of planes: the head and the shoulders, seen from a three-quarter view, become two slabs at right angles to each other. And this is the form of many of the busts of Diego done from memory. Giacometti constantly points out what a total discrepancy there is between the impression we get of a human head from the front and the one we get from the side – that it would not be possible to infer either from the other. 'If I look at you from the front, I forget the profile. If I look at you in profile, I forget the front view.' This is palpable in one of those heads which is so narrow that it seems to be slicing through the air. On the one hand, it is simply a profile in silhouette. Seen frontally it is a wedge thrusting at one. But it only remains so within a very narrow angle of vision: as soon as I move a few inches to the right or left of collision course, the wedge becomes a profile – there is no transition. As I move

31

around the sculpture I still seem to see the same profile. Though its shape, of course, changes somewhat, the contour does not change as that of a form fully in the round would, and, as I move through an angle of, say, 120 degrees, watching it, I have the illusion that it is keeping pace with me, turning away.

The apparent position of the image, then, is dissociated, liberated, from its physical position. At the same time, the apparent position is not limited to a single position. As I stand looking at one of the standing women, she will be as distant as a person on the other side of the street, then suddenly appear to be looming up over me: at one moment she is like a figurine, a little object I could pick up in my hand if I could reach her; at the next she is a giantess. Sometimes these changes are entirely subjective, at others they may be determined by a change in the light. These sculptures are peculiarly sensitive to their lighting and placing (seen in a wrong sort of light or at the wrong height, their impact is not diminished, it is nullified). To face one of the figurines placed squarely on a table, feet at right angles to the wall, is to have a quite different sensation from that received when one turns it through an angle of, say, 30 degrees and moves over to face it as before. Placed at an angle to the wall, the figure seems to recede farther: it is as if a human body had shrunk to the size of this figurine. Placed squarely, the figure seems tauter and more imposing: I am made intensely aware of being confronted by it, whereas when I confront it as it stands at an angle to the wall, it appears more self-contained.

Everything said here so far as to what 'likeness' might mean for Giacometti has been about the context in which the figure or head is seen. What of the attributes of the figure or head itself which most concern him? The thrust of a form through space, the figure's stance, the set of head on shoulders, the articulation of the limbs, the tautness of a standing figure firmly on the ground and stretching upwards through space, the movement of someone walking tentatively or buoyantly or warily: the way man *acts* – this seems to be what is seized on above all in the paintings, the drawings, the sculptures alike, but most evidently in the sculptures from memory, the works

which must show what has impressed him most. The act portrayed is usually very simple – not the complicated postures of a Rodin but the elemental ones of archaic and primitive art. But the portrayal is complicated by ambiguities. For example, it sometimes happens, when a standing figure is being looked at from a three-quarter view, that it will give an illusion of starting to walk, the concave of the shins and instep seem to spring forward – as when a taut bow is released – and give the sensation that the figure is taking a step forward. Seen frontally, a figure will appear weightless at one moment, seem to be all energy thrusting upwards; at another, it is as if the energy were turned inwards, producing a mass that is packed with it, dense with it. Again, at times a figure will no longer seem attenuated, will stand there easy and relaxed, a body generously curved; a moment later it will appear drawn out as a length of elastic at full stretch.

There is one constant. Figures and busts look straight out in front of them, straight back at the beholder. And not with unseeing eyes. When sitting to Giacometti, one has the feeling that he wants one to be looking back at him as hard as he is looking at one: 'he demands an attentive presence', Annette said to me wryly. For Giacometti, it seems, looking is the quintessential human act.

He was talking about the contrast between drawing a living head and drawing a skull. He described how, when at art school in the early 1920s, he had stopped going there one winter which he spent in an hotel room painting and drawing a skull. Then he went on: 'One day, when I wanted to draw a girl, something struck me, which was that I suddenly saw that the only thing that stayed alive was her gaze. Everything else – the head turning into a skull – came to more or less the same thing as a dead man's skull. What made the difference between a dead man and the person was her gaze . . . New Hebrides sculpture is true, and more than true, because it has a gaze. It's not the imitation of an eye, it's purely and simply a gaze. All the rest is a prop for the gaze.' Watching him work on a figure from memory, I have had the impression that all he was trying to create was a gaze and 'a prop for the gaze'. I am thinking especially of an occasion in 1962. Practically all of the

work was going into the head and the feet. His hands were moving frequently and rapidly from head to feet, and all that was in between was almost neglected. Except that he was constantly making gestures which seemed to be measuring the distance between head and feet. It was almost as if the length of the body and legs were there only because they were needed as something to which to attach the head to the feet, only to traverse the distance between them: getting that distance exactly right seemed to matter far more than the shape which the body and legs assumed. He was frequently turning the figure through an angle of 90 degrees and back again, working on it from just two viewpoints – frontally and in profile. The way of working seemed to imply that in making a standing figure there were two things that counted: the fact that the figure was standing, and the fact that it looked straight ahead.

It is clear in all his work that when Giacometti talks about the gaze as the very sign of life he is talking about a gaze directed straight back at the beholder, mirroring his own gaze. And the concern with distance may well be inspired by its relevance to the idea of confrontation. When two human beings come face to face, each is aware of the meaning of the precise distance between them. Their distance shows their relationship at that moment.

Face to face with a Giacometti image, the spectator finds himself as if involved in a reciprocal relationship. Giacometti has made a life-size sculpture of a girl with hands held out as if offering an invisible object to the beholder. He has also made a life-size sculpture of a man extending his arm and pointing – and the gesture only makes sense when we confront the figure and see him as indicating ourselves or something in our world. In these two works a dramatic gesture is used to establish a relationship between the figure and the spectator. In the standing women no gesture is used, or needed. I feel within my muscles the stance of the figure, feel I am adopting the same stance, feel this so strongly that sometimes I find myself doing so in reality – holding myself more taut and upright, squaring my shoulders, placing my hands straight down my sides. But, however strongly I feel the figure's action within myself, I never – as one normally does when

one feels this – feel myself identified with the figure, never have the sensation of losing myself in it, out there. I do not even feel a tingle in the muscles of my hands as if I were holding the figure; or rather I come to feel this when I get close to the sculpture, to the point where it ceases to be a figure for me and is only bronze, and then I have a sensation in my fingers as if they were grasping the bronze – the bronze, not a figure - but so long as it is a figure for me I feel no sensation of touching it. Neither of touching it nor of becoming it. Only, I feel I have its stance, here, where I am, not out there. And the more I feel with it, the more do I feel my apartness from it confirmed, the more do I recognise its otherness. I am what the figure is, out there, and in being like it I am separated from it.

The confrontation seems to say that the reality of a person is only established through his relation to another but that this relation reveals the solitude of each, the untraversable distance between them, recognises that this other is no projection or extension of oneself or creature subject to oneself but a being separate from oneself. In affirming this state of affairs, Giacometti's art defines a situation intolerable to the artist, for any artist wants to take possession and control of all he sees. Like Cézanne (who, as Merleau-Ponty says, 'thought himself impotent because he wasn't omnipotent'), Giacometti brings together in the work his suffering through reality's elusiveness and his affirmation of its inevitability. 'The days pass, and I delude myself that I am trapping, holding back, what's fleeting.' This is not necessarily the language of an artist obsessed with trapping fleeting atmospheric effects or the movement of bodies or the pose of a girl caught standing on one leg holding her other foot. It was Cézanne (according to Gasquet) who said: 'Everything we see disperses and vanishes, doesn't it? Nature is always the same, but nothing remains of it, of what we see. Our art has to inspire a feeling of its permanence while still showing the elements of all its changes. It has to make us sense it as eternal.' Something that is looked at for any length of time is as elusive as if seen for an instant. 'It might be supposed that realism consists in copying a glass as it is on the table. In fact, one never copies anything but the vision that remains of it at each moment, the image

that becomes conscious. You never copy the glass on the table; you copy the residue of a vision . . . Each time I look at the glass, it seems to be *remaking* itself, that is to say, its reality becomes uncertain, because its projection in my head is uncertain, or partial. You see it as if it were disappearing, coming into view again, disappearing, coming into view again – that's to say, it really always is between being and not being. And that is what one wants to copy.'

Working from life is working from memory: the artist can only put down what remains in his head after looking. And the time between the instant when he looks at the model and the instant later when he looks at the paper or canvas or clay to copy what he has just seen might as well be an eternity. The model can go on standing still for ever, but the work will nonetheless be the product of an accumulation of memories none of which is quite the same as any other, because each of them is affected by what has gone before, by the continually changing relation between all that has already been put down and the next glance at the model. And it is not merely because of the necessity to look away from the model to look at the paper, canvas, clay that, as soon as we try to copy what is seen, it was seen: it is also because our mind has to get outside the sensation before we can copy it, our very awareness of having a sensation pushes it into the past, for we cannot think about our present thought, it slips away as we try and grasp it, because we try and grasp it. The artist can never get there, whether he works from nature and builds up an accumulation of memories modifying and contradicting one another, or whether he works from memory and constructs a synthesis of what he remembers having seen. Giacometti's work lays naked the despair known to every artist who has tried to copy what he sees. At the same time it is an affirmation that there is a hard core which remains from all that has been seen and that this can be stabilised, this can be saved, this can be rendered as if indestructible.

PART TWO

6

Traps

Sculptures influenced by Cubism and tribal art materialised when Giacometti, after spending three years in Bourdelle's class steeped in the anxieties of working from life, left there in 1925 to find a studio of his own and try working out of his head. The first significant outcome was a *Torso* clearly indebted to Laurens. The forms are an armless trunk and a pair of thighs packed together to insist that the sculpture be compact. It is a work that announces the artist's ability to give eloquence to the slightest inflections in a surface, whereas in *The couple*, male and female frontal figures side by side, completed in 1926, the surfaces have stylised features in low relief superimposed upon them.

The female figure here was based upon a Bakota funerary statuette which Giacometti owned, while a Dan spoon in the Musée de l'Homme was the probable inspiration for the *Spoon-woman* of the same year. This frontal figure, Giacometti's first standing woman, is made up of distinct parts. A cubistic form uniting the head and thorax surmounts the huge bowl of a spoon which unites the pelvis and the thighs and is convex where it represents the belly, and this is supported by a tapered pedestal which also stands for the shins and feet.

A series of works followed in 1926-27 which look as if they were largely influenced by the Cubism of Lipchitz. They also seem to have to do with some thoughts which Giacometti set down in a notebook around 1925: 'Reciprocal harmony of bodies, or of *the body*, and harmony of bodies or the body in the atmosphere. Object independent of the forms that exist in nature, like organic beings. Search for *ensemble* of sensations, exclusively formal, for co-ordination – harmony or contrasts – equilibrium, balancing. To

model a new, living, existing, real object in its own especial material . . .' The piece which looks as if it was the first of these, *Cubist composition*, packs blocks together, like *Torso*, but here there are so many blocks that, although no space is admitted between them, they convey an overwhelming sense of assemblage and also a sense of struggle between the assembled parts. Three further works are very much constructions made from separate components, and components which are very varied in form. These are no mere essays in a cubist manner; they have a strong sense of reference to life, especially the *Composition* sometimes known as *Reclining couple*. In these abstracted, metaphorical, forms there are intimations of closeness to bodies and closeness between bodies. They seem to convey a feeling of discovery and gratification enjoyed by someone who, having lived in a highly rarefied atmosphere, has come down to earth. But with this there is a sense of tension as if between bodies in opposition. There is a good deal of the ambivalence of feeling which can be induced by an interlocking with another's body.

These early works show clear signs of a duality which was going to be an important feature of the work of the following years – a duality between a language of compact forms, forms as if carved from a block, and a language involving construction, whether actual or notional, and resulting in transparent or assembled forms. Common to Giacometti's use of both languages was the invariable tendency of his free-standing sculptures to be virtually two-sided reliefs.

The *Spoon-woman* was a classic instance of that tendency and it was also an instance of a number of the characteristics that were to appear in the frontal standing female figures of the Forties and Fifties, for all their thinness and its massiveness. It has their insistent symmetry, their peculiarly hunched shoulders, their slenderness in profile. More than that, it shares their creation of a notional distance from the spectator: as I have suggested elsewhere, its proportions give the impression of the presence of a figure that is very near. And there is reason to suppose that Giacometti intended this effect or at least was aware of it. The piece was inspired by African sculpture, and Giacometti often said to me that the proportions of African figures, with their large

40

heads and short legs, were generally misunderstood in being assumed to be conceptual, that on the contrary they were perceptual, representing what we actually see when we stand opposite another person as in conversation and their head is enlarged by its facing ours while their legs are diminished by foreshortening.

The *Spoon-woman* was also a step in the development of a line of research which Giacometti pursued consistently from 1927 on. 'I worked at home forcing myself to reconstitute from memory alone what I had felt at Bourdelle's in the presence of the model, and it got reduced to very little. What I really felt got reduced to a plaque, placed in a certain way in space, in which there were just two hollows, which were what could be seen as the vertical and horizontal aspects that are found in every figure. To arrive at the plaque I began by wanting to realise from memory as much as possible of what I'd seen. So I simply began by making an analysed figure, with legs, a head, and arms. And it all seemed false to me, I didn't believe in it. To make it more what I wanted I was obliged bit by bit to sacrifice, to reduce, to let go the head, the arms and everything. Of the figure, all I was left with was a plaque. And it was never either intentional or satisfactory – on the contrary. It was always disappointing to see that the form I could really master amounted to so little.'

Nevertheless, he was convinced that the plaques were 'in some way like things and like myself'. And indeed, these works, for all their totemic quality, are essentially imprints of impressions. At about the time he started making them he also made several portrait heads which were very relevant to them – heads in which the highly particularised features are incisions or inflexions in a flattish surface. The outstanding piece is a portrait of the artist's mother in a free-standing low relief which brings one side of the face round to broaden the frontal plane. This results in a shape not unlike that of those plaques that stand for heads, a shape that suggests the torsos of Cycladic figures, and not fortuitously, since the subtly inflected flatness of these sculptures has everything to do with Giacometti's love of the Cycladic.

There is a sense transmitted by these plaques of looking at human beings,

as well as at the uncanny beauty of the play of light on those inflections of their surface. The most telling piece is the *Gazing head* of 1928 in which the features are reduced to two oval dells, one vertical, one horizontal, but which seems to have a compelling gaze. In later years Giacometti used to say that in representing a head what mattered was not to imitate the eyes but to give the sensation of their gaze, and it is this quasi-abstract piece rather than the relatively naturalistic low-relief head of his mother, in which the eyes are represented, that generates a gaze. But this is a very particular gaze, the gaze of someone very close to one, at a point at which one is gazed at only by a lover, or in infancy was gazed at by one's mother, when just a part of the other's face – an eye and a cheek and part of the nose – fills the field of vision. The mystery of the piece is that this swimmy sensation of part of a form whose edges are invisible is re-created in a carving that is so precise and formal a free-standing entity in space.

The series of small plaques – which seem to me among the very finest things Giacometti ever did – had a remarkable extension in a stone carving eight feet tall which was executed between 1930 and 1932. It was the result of a commission from Charles and Marie-Laure de Noailles for a sculpture for the gardens of their château at Hyères. A number of plaster models were made in the early months of 1930 but the definitive model was not achieved until December; the carving was completed in the summer of 1932. It is a consistently rough-hewn standing figure, a compact mass but with a some-what angled stance, and a horizontally rectangular head. Physically it is a massive work and much more a work in the round than the plaques, but it is very like them in the quality of its effect and in the mystery of its effect. For, while it looms up above us like a solid rock, it looks ethereal, spectral, disembodied. The place it occupies in Giacometti's work is not at all marginal.

The plaques were emphatically compact forms, and in 1928 the oppos-ing tendency towards transparent construction started to assert itself again. Some of the products, such as *Apollo* and *Three people out of doors*, are as it were low reliefs with the ground removed to let air through. Others – *Reclining*

woman dreaming and *Reclining woman, gazing man* and *Man and woman* — are like assemblages of independent units, following some of the cubist pieces, but with the units now more clearly defined and more separated by spaces.

Reclining woman dreaming is perhaps the first of Giacometti's works to have something of the atmosphere of Surrealism. Dreaming is suggested by a motion like that of the sea, and it is remarkable how three undulations suffice here to suggest a movement that goes on and on. *Man and woman* is perhaps the first of his sculptures to convey action, and the only one of his sculptures to show one person acting on another (as against looking at another). At the same time, what is happening, apart from the certainty that some sort of assault is involved, is curiously obscure. The fact that the spike aimed at the vulva is both a dagger and a phallus creates a serious ambiguity in that a phallus might ultimately be enlivening. The woman's posture is equally ambiguous: it is not really clear whether she is recoiling or coyly receptive. It is also unclear whether penetration is on the point of happening or whether the action is in momentary suspense or whether the scene depicts a threat that is not going to be fulfilled. A further ambiguity as to the nature of the action, whether fulfilled or threatened, is created by the fact that the vulva is more like a mouth (a caricature of a Josephine Baker mouth) and a mouth that is going halfway to receiving the spike. If, then, the action is indeed suspended, the reason might be less the man's fear of his aggression than his fear of castration.

While these pieces have key features which Giacometti had already made his own — the spoon-shape, the slender profile — they look as if they must have been crucially influenced — *Reclining woman, gazing man* above all — by Picasso's contemporaneous drawings and paintings of projects for sculpture in which bits of bodies and bones and stones are combined in various ways, including being balanced on one another. Giacometti was on the threshold of a new phase, in which 'it was no longer a question of presenting a figure's external likeness, but of living my life and only realising what had moved me or what I desired'. And the impact of those notional constructions of Picasso's was especially relevant to the first work beyond that threshold, a

work sometimes called *The time of footsteps* (*L'heure des traces*) but finally *Suspended sphere* (*Boule suspendue*). What Giacometti now added to the language was to place the construction within a space-frame made of iron rods and to allow and encourage the spectator to move one of the components. In the centre of the space is a ball suspended by a thread and just resting upon a crescent which is poised, tilting upwards, on a platform fixed inside the frame two-thirds of the way down. Where it touches the crescent the ball has a cleft, resembling the gap left when a section has been sliced out of a fruit; the crescent, spherical below, wedge-shaped above, might be a sector from a larger fruit. The possibility that there is going to be a point at which the wedge firmly fits into the cleft provides a stimulus to slide the ball up along the crescent in search of this consummation. There is no such point.

The work was made in 1930 in plaster with metal rods and then, by a craftsman, in wood and metal, with the crescent tilted into a rather more erect position. The replica was shown later that year in the window of the Galerie Pierre when Giacometti shared an exhibition there with Miró and Arp. It was purchased by Breton, and Giacometti was invited to join the Surrealists.

He joined them at a late date and at a time of crisis for them. The previous year, many of Breton's most gifted adherents had turned against him, and Giacometti had become closely associated with several of these dissidents, including Masson, Leiris, Queneau and Desnos, and with their new mentor, Bataille, Breton's perennial rival. His acceptance of Breton's invitation was therefore somewhat surprising. It was certainly a feather in the Surrealists' cap. He had already been singled out by critics of the calibre of Zervos, Tériade, Cocteau and Carl Einstein, as well as Leiris; Einstein, supreme among interpreters of Cubism, had listed him alongside Laurens, Lipchitz and Brancusi. His entry into the depleted ranks of the surrealist faithful was a gain for them of someone to set beside Dalí, last year's new star.

In December 1931 Dalí published a pioneering article on 'Surrealist objects', headed by a list of six types of such objects but thereafter devoted to one, 'objects operating symbolically'. He described and illustrated five

examples by different hands; *Suspended sphere* took pride of place and was credited with having opened up the world to the creation of objects of this kind. Georges Sadoul was to say retrospectively that Giacometti 'started the fashion for surrealist objects with symbolic or erotic overtones, and it became the duty of every self-respecting Surrealist to make them', and Breton was to say that the factors which had engendered them had been, first of all, Duchamp's *Why not sneeze?*; then his own proposal that objects seen only in dreams should be manufactured and disseminated; next, 'still more decisive', Giacometti's contributions in general and *Suspended sphere* in particular; finally, Dalí's concept of 'objects operating symbolically'.

Suspended sphere, then, introduced a form of kinetic art highly charged with affective significance in that its operation became a symbolic enactment of unnerving sexual experiences and anxieties: it was very precisely an object operating symbolically, with a symbolism that was patently 'Freudian'. Nevertheless, as Dalí's article did not neglect to point out, that object was from his point of view – virtually the party line – backward-looking in its formal idiom and that though it had taken a leap into the future it was burdened with a redundant aestheticism. 'Objects operating symbolically were visualised in the wake of the silent, mobile object, Giacometti's suspended sphere, an object which already propounded and united all the essential principles of our definition but still adhered to means peculiar to sculpture. Objects operating symbolically leave no room for formal preoccupations. They depend only on everyone's amorous imagination and are extra-aesthetic.'

Dali's argument is reiterated and amplified by implication in the layout of the illustrations. As always in *Le Surréalisme au service de la Révolution*, all the plates, whether associated with articles in the issue or not, are at the back of the book. Among the illustrations of objects operating symbolically *Suspended sphere* comes first, reproduced full-page on a right-hand page; the next right-hand page reproduces the objects by Gala Eluard and Breton, and the following left-hand page those by Valentine Hugo and Dalí himself. Turning back, the page facing *Suspended sphere* shows a recent large construction by Miró in which an open umbrella and a sprig of leaves are attached to a highly styl-

ised, emphatically male *personnage* carpentered in wood: as if to forestall any misapprehension that this plate relates to Dalí's article, the illustrations to which are captioned only by the artists' names, its caption reads 'Joan Miró – Sculpture'. As to the left-hand page between the Giacometti and the other objects, this is given over to Dalí's presentation of the photograph of an African village interpreted as a 'paranoiac face'. All this makes for visually valid layouts, but their very validity is a message that *Suspended sphere* is more at home in the company of sculpture than in that of fully-fledged objects operating symbolically, that Miró and Giacometti are important precursors (deserving of full pages), but that the influence now directly impinging on the creation of surrealist objects is Dalí's paranoiac-critical method. Even Miró was to give way somewhat to that pressure in later pieces. Giacometti's objects, however – perhaps with the exception of *Captive hand (Main prise)* – persisted in employing 'means peculiar to sculpture'. Dalí was, of course, right about him. It is the formal rather than the surrealist qualities in these works that matter most.

'Silent mobile object', a phrase used in Dalí's opening reference to the *Suspended sphere*, reappears in the plural across the top of the double-page spread overleaf, as the title ('Objets mobiles et muets') of Giacometti's initial contribution to a surrealist periodical. It consists of a set of drawings reproduced in line, together with a text which was his first published piece of writing. The seven drawings, framed and laid out as in a strip cartoon, depict sculptural objects; the text has no direct relation to the drawings, either in iconography or in mood. The drawings are full of irony, the text is an elegiac prose poem which evokes a sequence of fugitive sights and sounds with a constantly dying fall. Its beginning and end seem altogether controlled but just over halfway through it moves into what seems to be automatic writing (just as the poem beginning with the image of the blind man was to do, though composed long after Giacometti's break with the Surrealists).

'All things. . . near, far, all those that are past and the others still to come, they're all moving and my girlfriends – they're always changing (the nearer

one gets, the more distant they are), others arrive, rise and fall, ducks on the water, there and there, in space, rise and fall – I sleep here, the flowers on the wallpaper, the water from the dripping tap, the pattern of the curtains, my trousers on a chair, there are voices in another room; two or three people, from what station? The engines are whistling, there's no station near here, someone was throwing orange peel down from the top of the terrace, down into the deep and narrow street – at night the mules brayed despairingly, towards morning they were slaughtered – I'm going out tomorrow – she moves her head close to my ear – her leg, the big. . . – they're talking, they're moving, there and there, but it's all in the past.'

Five of the drawings of 'silent mobile objects' show pieces that are extant – *Suspended sphere, Cage, Project for a piazza, Object without a base, Disagreeable Object*. The other two are of objects that were never made, Diego informed me, and which, indeed, look as if there was never a chance of their being made, not so much because they are so radically different in style from any recorded Giacometti sculpture as because they have the air of caprices dreamed up with no thought of realisation. They are obviously there as light relief; they might even be parodies of other people's objects operating symbolically. The ones that were made were among the earlier examples of a series realised, between the beginning of 1930 and the end of 1933, of small sculptures which were either objects that could be played with or looked as if they could be played with, or were models for environmental sculptures which would have been like playground or fairground apparatus. Giacometti worked on them in plaster, using further materials only when they were needed for space-frames, armatures or other supporting elements: he even used plaster for the system of pulleys in *Captive hand*. Most of the sculptures were translated into more permanent materials by craftsmen. Diego did the stonecarving, as he had heretofore; there was a cabinet maker, he told me, who was a Basque probably by the name of Ipousteguy, and a metalworker who was an Italian called Bastianelli.

Giacometti's autobiographical letter to Pierre Matisse established retrospectively that he had made moveable objects at this time because

movement was one of the aspects of reality that he wanted to put into his work but that he kept finding that he couldn't bring himself to realise sculptures giving an illusion of movement, a leg advanced, an arm raised, a head looking sideways. This inhibition had led him to introduce movement by making objects in which there was a capacity for actual movement that could be fulfilled by provoking movement in the spectator, and that he had also sought to provoke movement in the spectator by creating environments, or models for them, with objects meant to be walked on, sat on, leant on.

In 1933 he published a statement about the objects he had lately been making in which he said that for some years he had been realising only sculptures that presented themselves to his mind in a finished state and that he had reproduced these images precisely as he had visualised them. This was a perhaps misleadingly rhetorical way of putting it, in that it might be taken to mean that the images came to him unbidden, as in visions, when in fact their 'finished state' often took time to evolve in his mind. Incidentally, he told me that in realising those visualised images without modifying them he had been responding to a challenge, since he had had an argument with another sculptor as to whether it was possible to do so and was out to prove that it was. (As usual, he was working to test himself.)

The 1933 statement went on to say that he had been realising the sculptures 'without asking myself what they might mean' but that 'once the object has been constructed, I have a tendency to rediscover in it, transformed and displaced, images, impressions, facts which have deeply moved me (often without my knowing it), forms which I feel are very close to me, although I am often unable to identify them, which always makes them more disturbing to me'. Among the things this does not tell us is the extent to which, once he had recognised an element in one completed piece as an unconscious symbol which he did feel he could interpret, he had that interpretation in mind when a similar element appeared in a subsequent piece. But then unconscious symbolism does not all reside in one layer, and meanings discovered have further hidden meaning: were this not so, Surrealism

would have been a non-event. But it would be interesting to know whether *Suspended sphere* was one of the sculptures which Giacometti had realised without asking himself what they might mean. If it was not, another question of interest is whether the cleft was designed to be what it so vividly is: oral as well as genital.

The objects divide into three groups. First, constructions which have moveable parts – or look as if they have – and here there are two sub-groups: those in space-frames and those in the form of board games. Second, objects which are entirely moveable – portable objects which can be placed this way or that. Third, models for environments in which spectators could move about. They will be surveyed here in reverse order. The titles given will be limited to those in use in the 1930s.

Among the models for environmental sculptures, *Project for a piazza* certainly came first. It is likely that both the original plaster and the wood replica were made in 1931. The forms on the base are a sort of menhir, a slanting cone, a stylised snake, a tilted bowl and a low horizontal unit; a shallow circular hollow is scooped out of the base near one of its corners. Had the garden sculpture which Giacometti had in mind been made, it would have been in stone. He did in fact carve the forms in plaster on their intended scale in 1932; they stayed in the studio for some years until they were destroyed to make room.

Project for a corridor was realised only as a plaster model, completed in 1931 or 1932, much more probably the latter year. It is best described as if it were on an environmental scale. You enter it via a long narrow passage with high walls and no roof. This suddenly widens into an elongated oval bowl along the axis of which floats a long pole, its near end a knob, its far end a spike, balanced on a spring, so that you can press or sit on the pole to push it downwards. You continue into a passage which is very narrow and roofed in, except for the narrowest aperture along its length. It leads to a circular bowl on the far side of which is a slope you have to climb before crawling through a short tunnel. You emerge into an ovoid space in the centre of which stands an artificial tree. At the far end you go up a flight of steps and

49

find yourself looking down at a rectangular compartment partly filled with water and on the floor of which are several large scallop shapes. You turn aside to slide down the inside of a narrow tube to the exit.

This tunnel of love, or, rather, this metaphor for the entire female reproductive system, is in every way the antithesis of the *Project for a piazza*: it is more like an endurance course than a place to relax in; it contains an element which does respond to the visitor's pressure (so overlaps in type with the objects with moveable parts); it is a sequence of confined spaces, therefore has a beginning and an end, and in between offers the visitor very little scope to choose which way to go, whereas the *Piazza* is not only a conglomeration of forms situated in the open air but one in which these forms are so related as to withhold any suggestion as to what route to take. These environments are also possibly complementary in that they may be reminiscences, conscious or unconscious, of two complementary sights which Giacometti loved in early childhood and described in a series of reminiscences of those years published in 1933 – a large black monolith, the memory of which may have inspired the form like a menhir, and a cave containing chambers of different sizes on different levels.

There is another object, executed in 1932 in plaster, which looks as if it could have been conceived as a further model for an environmental sculpture. Its origins seem palpable and nicely mixed: on the one hand, the *Project for a piazza* and the *Object without a base*, on the other, Dalí's *Paranoiac face*, the photograph of an African village interpreted as a recumbent head. The base is oval at one end, square at the other. At the oval end is a large projection, like a nose, sloping gradually on three sides and on the other steeply angled and stepped; immediately in front of it, almost traversing the base, is a deep rectangular hole, like an open grave. The elements at the spoon end are a shallow circular hollow and two cones. The object bore the inscription *Life goes on*, but when reproduced in 1932 it was captioned *Falling body on a graph* (*Chute d'un corps sur un graphique*) and when it was lent by the artist to an exhibition in America in 1936, he called it *Head-landscape*, a title he echoed a decade later when he described it to Pierre Matisse as 'a sort of reclining

head-landscape'. The exhibition in question was Barr's *Cubism and Abstract Art*, which does rather signify how totally Giacometti could transform an image that might have been indebted to Dalí into an object using 'means peculiar to sculpture'.

That project for an environment, if such it is, differs from the others in presenting itself as a compact form. Another compact sculpture carved in the same year, first in plaster then in marble, is closely related to it and is also related to the whole class of environmental pieces. For, while it does not look magnifiable into something people could move about in, it is a piece designed, while static in itself, to provoke movement in the spectator: *In spite of hands (Malgré les mains)* or *Caress*. Seen in profile, one half is a generous smoothly curving convex form like a pregnant belly, by far the most Arp-like form Giacometti ever made, while the other half is a series of abrupt straight contours stepping down and along and up and along and down and so forth. It looks rather as if it were an enlargement of the nose in the *Head-landscape*, and the lengthways extension of the step effect certainly appears designed to make the piece resemble an entire recumbent head. Nonetheless, it is not this image which holds the attention but that of the generous belly of a woman. A device has even been added to call attention to this, a device which, according to a contemporary article written when only the original plaster existed, Giacometti was planning to eliminate from the marble version, but which was retained – a device which iconographically seems to be the key to the piece, inasmuch as neither the original title, *In spite of hands*, nor the alternative, *Caress*, would be intelligible without it: on each side of the pregnant belly is incised the outline of a man's hand, indeed, of the artist's hands. They are life-size versions of the outline of the hand shown rocking the *Disagreeable object* in the drawing in 'Silent mobile objects' and, of course, carry the same message. In this object the spectator's participation is solicited through diagrammatic instructions as to where to place his hands.

The *Disagreeable object* rocked by that hand is another compact sculpture combining curved and angular forms, but moveable. It was made in plaster in 1931, a replica was carved in wood and a version was carved in marble

which is more a variant than a replica. Its shape was almost certainly derived from an Easter Island bird figure, but what it really looks like is a piece of equipment bought at a sex shop. Indeed, it does of course hark back to the banana form in *Suspended sphere*. Even the idea of a rocking motion could easily have been inspired by experiment with the angle at which the crescent was to be tilted on the platform (that there was such experiment is suggested by the disparity in the slant between the plaster and the wood versions). And the little spikes near the tip of the *Disagreeable object* call attention to the phallic aggression implicit in *Suspended sphere* – the thought that if the wedge does not fit into the cleft, this may partly be because it is felt to be a disagreeable object, an offensive object. When a titillating apposition fails to be resolved in penetration, it may be because of anxiety about doing damage or about being damaged.

The *Object without a base*, sometimes also known as *Disagreeable object*, was made in both plaster and wood in 1931. It is basically another plaque, with a shape not unlike that of the *Gazing head* and a similar depression in its surface. The cones projecting from the surface are akin to those in *Project for a piazza* and *Disagreeable object* but on a larger scale. There are two on one side of the piece, one on the other, and they are so placed that there are several positions in which the object can be made to stand up, in most of them with perfect stability. There are in fact four such positions when the piece is resting on two points, one when it is resting on one. There is therefore a provocation, when the object is on a table, to keep picking it up, turning it this way and that, putting it down again now in one way, now in another.

In some of these positions it is clearly a head. Now, the treatment of the head in the *Gazing head* was a profoundly visual solution, visual in being an extrapolation from gazing at the human face, visual in its subtle control of light. Against this, the cones are strongly tactile, are forms which can cause harm but at the same time feel comfortable and agreeable to the grip. This sculpture is a head but also very much an object, something to be handled, passed from one hand to the other, put down again. The contradiction is totally resolved. Indeed, that resolution might be said to be the *raison d'être* of the piece.

Turning to the objects with moveable parts, I shall begin with those in the form of board games. The earliest may have been *Circuit*, which was probably executed in plaster in 1931 and then in wood, possibly the same year. The board has a serpentine groove hollowed out of its surface and in a corner a cup hollowed out. It is equipped with a ball which can either rest in the cup or be propelled around the circuit. If the ball is in the hole there is no ball in the groove, and vice versa. We are always likely to want the other.

Man, woman, child was probably made in 1931 in plaster and possibly the same year in wood and metal. Placed in an incised circle at the centre of the board is the man, who takes the form of a cut-out triangle of sheet metal on a pivot on which he can be swivelled in all directions. (The triangle is, indeed, a highly formalised head, anticipating the attenuated head of a man that appears together with a female figure or figures in sculptures realised in 1950.) Just outside the circle is a slot in which the woman is fixed so that she can be shuttled to and fro along it. Her linear form is so schematic as to be difficult to read but she seems to be a half-figure with arms outstretched. Behind her, moveable along a similar slot near the edge of the board, is the infant, represented by a tiny egg. All three figures, then, are capable of movement within strict limits that keep them well apart, while their relative positioning and the woman's span tends to ensure that, wherever she is in her pathway and wherever the infant is in its pathway and whichever way the man's nose is pointing, she can virtually conceal the child from him. It is reminiscent of those games in amusement arcades in which models of footballers or ice-hockey players in glass cases are made by remote control to shoot and save goals. Here the man is like an attacker, the woman like a goalkeeper, the child like the ball, but the goalkeeper is not protecting the goal from the attacker; she is protecting the ball.

No more play (*On ne joue plus*) was completed in plaster in late 1931 or possibly early 1932; its replica in marble, wood and bronze was made in 1932. The board is divided into three areas. The areas at either end are pitted with round and oval hollows of various sizes, one of which has a little wooden figure like a chessman standing in it, female at one end, male at the other.

The middle area has three rectangular cavities sunk into it like tombs. Each tomb has a lid, one lifting off to disclose a skeleton in bronze, another to disclose an empty space; the third lifts off in the marble version but it is not in fact meant to do so and in the original plaster is immoveable. The beholder is free to tamper with the tombs, but not with the living: the man and the woman, divided by the dead, standing on ground pockmarked as a battlefield, the woman perhaps signalling with her upraised arms, are unalterably rooted. Described, this object seems to be the most literary, allegorical almost, of the entire series; perceived, with the light playing mysteriously over the concaves and flatness of its surface, it seems one of the most elusive in meaning.

Point aimed at the eye (Pointe à l'oeil) or *Disintegrating relations (Relations désagrégeantes)* was realised in 1932 in plaster and in wood and metal. Along most of the length of a rectangular board marked out rather like a tennis court runs a slender tapering blade, transfixed and supported in space by a large pin. Its point just touches one eye of a head, as naked and impassive as a skull, mounted on part of a rib-cage. The blade seems designed to thrust at the head which it is menacing. In reality its only movement is circular, swivelling on its pivot, pointing pointlessly. That blade suggests a long steep perspective in which the head becomes like one of Giacometti's female figures seen at a distance. But the blade is also like the spike in *Man and woman*. And there the woman's body was also a face. *Point aimed at the eye* thus becomes a transformation of *Man and woman* in which the threat of death or violation is formalised, ritualised, turned into a game.

Flower in danger or *Taut thread* was realised in plaster, probably in early 1933, though conceivably at the tail end of 1932, and then in wood, metal and plaster. At one end of the wooden base stands a spindly flower or figure, its stalk or body of bent wire, its head of plaster. Facing it is a catapult, tense and threatening. Here again there is an echo of the curved spike in *Man and woman*, but here it is not because of the pointed tip but because of its bow shape, and this reminds me of a suggestion that Meyer Schapiro made to me that *Man and woman* could well have been a parody of Bourdelle's *Archer*. There is no real

threat, however, not only because the catapult is not moveable but also because the flower is not in fact in its line of fire. However, there is something moveable. It is the head of the flower or the girl, which is attached so that it hangs free like a pendant earring. And it is made of plaster, so that if we flicked or touched it we might break it. It is in danger after all.

While the original object operating symbolically was a composition in a cage – and was also the first piece in which Giacometti used a space-frame, a device he used again not only in surrealist objects but in sculptures made after the war – there were several fewer of these than there were of objects in the form of board games. *Suspended sphere* was followed by another of those illustrated in 'Silent mobile objects': *Cage*. This was made in plaster in 1931; the replica in wood may not have been executed till 1934. If one feels a desire to find some moveable part here, that desire is perhaps fired by an intimation of how dramatic that movement might be, because the element that appears most likely to be moveable is the large foreground form whose five parallel curved blades are like predatory teeth or a clutching, tearing hand. The whole complex of forms within the frame, with all its petals and tubes, suggests itself to be in an oblique and irrational way – and almost certainly not as a conscious metaphor – the female counterpart to the *Disagreeable object*. It evokes Duchamp's *The bride* of 1912, but a bride with a *vagina dentata*. However, *Cage* is not made so as to be capable of action. As *Suspended sphere* creates an expectation that its movement will achieve a certain end and the expectation is thwarted, so *Cage* creates an expectation that it is capable of movement and the expectation is thwarted. Each of them is a tease. And the way in which *Cage* is a tease is also found in some of the objects with moveable parts. Indeed, the frustrations created by these objects include almost as many derived from a part's being static when it promises to be moveable as from movement which does not achieve what it seems to promise. A gambit that appears more than once is for one part to be moveable when it does not much matter whether it is or not, whereas another part that looks capable of more momentous movement cannot be moved.

The work which inherited the original title of *Suspended sphere*, *The time of*

footsteps, was executed in painted plaster in late 1931 or more probably in 1932, with a replica probably made in 1932. It took off from *Suspended sphere* in precisely the opposite direction to *Cage*. In *Cage* the idea was retained of putting heterogeneous simple forms together in a frame, but their number was greatly increased and their positions all fixed. In *The time of footsteps* the idea was retained of opposing just two contrasting elements, a moveable pendant one and a static one, but here they were separated, with the pendant left hanging free and alone inside the frame while the static element was placed on top of the frame and was elaborated into a figure with a complex articulation. *Cage* and *The time of footsteps* also took opposite directions in the choice of materials for their replicas: as against the wood and metal of *Suspended sphere*, *Cage* was made all in wood, *The time of footsteps* in wood, metal and plaster.

The choice of plaster for one form, the heart-shaped pendant, was significant, given that the prime reason for having replicas made was that they would be less fragile than the original plasters. Clearly, plaster would have been used so that this form should have a weightlessness, a lunar luminosity, should seem a compact parcel of light poised in space. The insistence on such qualities tends to confirm a suspicion that this pendant was inspired by the egg hypnotically suspended from a scallop inside a barrel vault in Piero's *Madonna and Child with Saints and Federico da Montefeltro* at the Brera, an image Giacometti must have encountered early and perhaps often, for he was frequently in Milan, Stampa's nearest city. He wrote once of the 'sensation of a luminous sphere . . . like an eggshell' given him by the sight of Bramante's east end of the interior of Santa Maria delle Grazie in Milan; that sensation as if of the inside of an eggshell is certainly to be had from the luminous scallop from which Piero's egg is suspended by a thread.

That egg, indeed, could conceivably have been the inspiration for the *Suspended sphere* itself. Something which may be relevant to that possibility happened when in 1965 Giacometti modelled a plaster replica of the work for inclusion in his retrospective at the Tate, as neither of the original versions was available. For this he used rods of a narrower gauge than before,

telling me that he thought the rods in the original plaster version were too thick. He intended, on the other hand, that the hand-made forms within should duplicate those in the original. It was therefore involuntary when the sphere turned out smaller and the crescent thinner. The forms thus became less sensuous, more ethereal, the sphere more like Piero's egg.

The figure in wood and metal surmounting the wooden frame in *The time of footsteps*, spiky, nervously energetic, insect-like in its linearity and angularity, is assembled in such a way as to emphasise how it has been put together from discrete components, but also in such a way as to make its referential anatomy and posture as ambiguous as its formal structure is explicit. It is nonetheless certainly a male human figure, and that certainty is conveyed by its whole bearing and independently of the recognition of its only other certain attribute, the erect phallus. What is uncertain is whether the legs are striding or are simply apart, whether the cross-piece represents outstretched arms or merely defines the contour of the shoulders, whether the head tilted back with the mouth open is taking breath or declaiming and whether it is agonised or ecstatic. It is a figure that can be seen as an urgent messenger, as a tragic puppet, as the spectre of a soul in torment. It summons to mind the ghost of Petruchka suddenly appearing on the top of his tent.

A frame is used in a more purely utilitarian way in *Courrounou U-animal* or *Captive hand*, both the original plaster and the wood and metal replica of which were made in 1932. A frame of horizontal format attached to a base is almost filled by a near-life-size forearm and hand. Extending from the frame is a system of pulleys with a crank, a system which appears designed to punish the hand that played with the dangerous phallus and left its imprint where it caressed a pregnant belly. Assuming that the machinery works, the very least that ought to happen to the hand is that it be made to move like a sort of piston, made to perform a shaming act in public. When the crank is turned, the wheels all do indeed revolve, but the hand is not affected, since the mechanism is not linked to it.

Here the familiar scenario, the setting-up of a menacing situation that is not carried through, is given its most palpable, least ambiguous, exposition.

What with this direct story-telling, what with the concomitant use of straightforward figuration, what with the illusion the hand gives that it might be an *objet trouvé* from the flea market, what with the incorporation of machinery, this is the one object in the series that tends – or at any rate pretends – to conform with Dalí's rules for objects operating symbolically.

Easily the most elaborate of the cage-constructions is *The palace at 4 a.m.*, made in plaster in 1932 and then in wood and glass. In the article about his objects written the following year, Giacometti said that this work related at one level to the immediate past, to 'a period of six months spent hour after hour with a woman who, concentrating all life in herself, made every moment something marvellous for me. We used to construct a fantastic palace in the night (days and nights were the same colour as if everything had happened just before dawn; throughout this time I never saw the sun), a very fragile palace of matchsticks: at the slightest false move a whole part of the minuscule construction would collapse: we would always begin it again'.

He goes on to say that he doesn't know why it contains a bird's skeleton and a spinal column in a cage, but that each was the souvenir of a crucial moment in his relationship with his friend. He describes the main part of the construction as 'the scaffolding of a tower which is perhaps unfinished, or perhaps the whole of its top has fallen in, been broken'. In the figure of a standing woman, 'I discover my mother, as she appears in my earliest memories. I was troubled by her long black dress, which touched the ground: it seemed to be part of her body, and this frightened and confused me; all the rest was lost on me.' He says he is unable to interpret the form attached to the panel – a form like one half of a pod containing a single spherical seed – but that he identifies himself with it.

The palace at 4 a.m. is the paradigm of the way in which the sculptures of the period deal with the nostalgia that permeates its poems, such as the one used in 'Silent mobile objects'. It is a toy. Its imagery relates both to present affective life and to infantile fears and wonders. Its forms are light, lifted off the ground, and brittle as skeletons – thus, insubstantial. At the same time,

they are perfectly smoothly finished, as if denying change, whether growth or decay. The scene is set for action but action is suspended. Time is arrested, only the spell is fragile, itself transitory. The atmosphere of The palace is that sense of being cut off from the world when staying up all night, that tangible silence towards dawn when awareness is pitched high: objects appear weightless, separate, held in suspense; the world is light; the passage of time seems held in suspense; as if the present extended behind and before one. The least intimation of day will fracture everything.

Whereas the poems try to keep pace with the flight into nothingness of marvellous moments and of banal moments which have come to seem marvellous through having flown into nothingness, the sculptures postulate a tenuous, precarious world where things are not built to last, but oppose it with a will to hold time at bay. Gravity, density, are denied. Thus the invention of space-frame sculptures seems to have been motivated initially by a desire to lift things off the ground (or any other solid surface): after making a cactus-like sculpture called Woman, head, tree – which in its entirety can be read as each of these – Giacometti proceeded, in Cage, to mount a similar structure in a space-frame, so that it was no longer rooted but suspended in air; and Suspended sphere gives an effect of lightness such that one has the illusion that the string is not so much holding up the ball as rising from it by an act of levitation. On the other hand the fragile constructions are made to look fixed, immutable. In the replicas which are their definitive form, the surface reflects no nervous groping of the artist's fingers to catch up with the irresistible consuming flow into the past. 'I couldn't bear the surface's not being absolutely smooth and precise': these, for once, were 'absolutely finished objects'.

The palace at 4 a.m., the most famous of Giacometti's surrealist objects, is, alas, perhaps never as charismatic in reality as it is in Man Ray's photograph of it. The real masterpiece of the series is the Slaughtered woman (Femme egorgée), made in plaster in 1932 and later cast in bronze. In structure it is in a category of its own among the objects, though related to the board-game pieces in being a work to be seen from above. Its moveable part is the torpedo-

shaped appendage to an arm, an appendage we are free to place in any number of ways: Giacometti said it referred to the common nightmare experience of feeling one's hand to be too heavy to lift.

Formally the piece goes on from where *Man and woman* leaves off, and is at a point a long way along the line, dominating space with its electric energy. Iconographically, it completes an act unfinished in *Man and woman*, attaining fulfilment through outright carnage. It represents 'a woman strangled, her jugular vein cut'. But there is hardly a form there that doesn't have several meanings. Thus the form on the same side of the body as the moveable element is a leaf and a hand and a flower, and also a part of the crustacean's shell into which the woman has been transformed in death as well as being transformed into a reptile and an insect, with her neck suggesting a scorpion's tail. Her menace, furthermore, lies not only in her sting but in how threatening the spikes of her shell are. The man's victim incorporates parts of a man, bad and good parts. The helpless appendage is a symbol of passivity. But the neck combines with the small twin globes of the breasts to form an effective-looking organ. Splayed out in death, the figure is explosively alive, as if activated by its immolation.

The idea common to Giacometti's surrealist objects is to give a sculpture the form of a game or toy which in some way can involve the beholder in active participation or a desire for it. It is a challenge, and even if he chooses not to play, prefers to stand back and fantasise about what it might be like to play, he is only making another kind of move in the game. In practice, of course, he rarely gets the chance to make a choice, since, now that the pieces are museum pieces, they are mostly seen behind glass or with a prohibition as to touching, but then it always has been characteristic of games that prudent authorities have tended to proscribe them.

If the object succeeds in provoking the beholder to act upon it, he enters into its world, its spatial continuum. This is not by virtue of touching it, for the mere fact that we are handling some statue or holding some statuette does not make us feel that its life is less independent of our own than it is when we are standing there looking at it: on the contrary, once we have

recognised that it exists in a spatial continuum of its own, physical contact tends if anything to heighten awareness of its separateness. What takes us into the world of these objects is the recognition of their need for our participation and the arousal of a desire to be involved. The physical contact is incidental: it would be accurate to say that we enter the world of these objects not when acting upon them, but already in wanting to do so – in imagining ourselves playing with them or, in the case of the models for environmental sculptures, being in them.

Throughout most of his working life Giacometti was concerned with the problem of creating sculpture that would involve the beholder in its spatial continuum, sculpture that, rather than seeming to pursue a self-sufficient life in a notional space apart, would seem to imply a beholder's presence, as if this were necessary to its being. It is a problem to which Baroque sculpture found solutions and to which Giacometti found solutions of his own. The answer he found in objects in the guise of games was a playful answer, a simplistic one. But art is not made of answers, it is made of forms, and the forms of these objects anticipated or actually influenced three crucial subsequent trends in art: sculpture that includes space frames; sculpture that demands to be seen from above; and installation art.

Provoking the spectator into action, or into a will to action, also seems to correspond with a preoccupation of Giacometti's which in this instance was not at all perennial but, by his own testimony, crucial at that particular time: a concern that his work should be of interest to others. Disguising art as a game is analogous to educational methods which try to involve the child in a subject by getting him to find out about it through his own activity. If, in operating an object, the spectator comes to feel he is symbolically re-enacting the artist's fantasies and obsessions, he is identifying where he might otherwise not have done with something of what the work is about. When Nadeau tells of the impact on the Surrealists of the *Suspended sphere*, he describes the violently disturbing effect it had on 'everyone who saw this object in operation'. Nevertheless, experience of the object's operation is surely no more than a way in. If one has moved the ball up along the

61

crescent, tried to make it fit, seen and felt how it does not, no doubt the piece will mean that much more, but what renews and retains interest is not repeated manipulation but repeated contemplation. It is when gazing at these forms and their relationship, these rather schematic forms which have been made so disturbingly sensuous and sensual, that their continuous interplay between delightful intimacy and final incompatibility comes to have a resonance. The element of play is a sort of bait.

But the places where bait goes are in traps. So Giacometti sets up a situation in which nothing is happening but there is an evident potential for action, leaving it to us to intervene before something can happen. If we become involved, we get into a situation in which we want certain things to happen which look as if they ought to happen and which he has ensured will not happen. The boards change, the pieces change, the pattern of play is always a cause of frustration. Sometimes there are parts which look as if they should be brought together in an amorous conjunction: invariably they remain beyond each other's reach. Sometimes there are parts which are positioned menacingly in regard to others and look capable, if activated, of inflicting damage on them: invariably the victim remains beyond reach. These are self-defeating machines, ineffectual as Duchamp's bicycle wheel mounted on a stool and revolving in the air, only not frankly impotent but disappointing – therefore, defeats for us too. They are black jokes about the infernal machinery contrived by gods who claim it is not in their power to control our will and all the while ordain the patterns in which we shall choose fatally to move. Our knowledge that the perverseness of the gods reflects their own weaknesses is no compensation. Of course it is clear that Giacometti's games unconsciously symbolise his personal anxieties and frustrations, that the pattern he ordains is a compulsive pattern of which he is the victim. At the same time, by provoking us to join in the game, he finds a sub-victim to dilute his pain. It is like the game he played one evening in 1960 when he took me to a nightclub with his friend Caroline. He invited me to dance with her, which he couldn't do because of his limp, was intrigued by our getting on rather well, and insisted that we go on dancing

while he sat alone at the table watching. When we finally rejoined him he told us that, as we patently liked each other, if we didn't sleep together that night we were stupid bastards (the actual word was 'salauds'). He watched my ill-concealed mixed feelings with evident relish, paid the bill and left, having instructed Caroline that she and I were to go off in her car. After a while we did that, and I sat beside her wondering how I could rise to the occasion when preoccupied with his ambiguous behaviour. When we reached my hotel, she dropped me and – as he gleefully informed me the following day – drove to the street corner where he was expecting her.

During the years when the objects were being made, work was continuing on the big carving of a figure at Hyères, though the greater part of that work was done by Diego. In 1932-3, however, Alberto himself did all the work on a life-size figure in plaster, a headless and armless walking female nude, of which he made two slightly different versions. The style seems influenced by Egyptian Fifth Dynasty carvings. The earlier version was originally designed to have optional appendages in a conflicting style and with the plaster painted dark – a head resembling the scroll and pegs of a cello, and outstretched arms with a bunch of feathers in place of one hand. It was exhibited in this form in 1933, entitled Mannequin. When the appendages are excluded, a dreamlike quality persists through the tendency of images of the female torso to evoke a face with a cool provocative gaze, and the figures have something of the air of one walking in her sleep. The missing head and arms suggest that an antique statue is coming tentatively to life.

Giacometti saw these graceful creations as lightweight works, saying that a lay figure was just about what he had set out to make. Similarly, he said retrospectively that in the Table of 1933 he was only aiming at 'the realisation of a whimsical object in the taste of the time'. The Table relates back to the sculptures with several separate forms freely disposed on a board, only here the representational idiom and the iconography produce a paraphrase of the convention of a still life with a classical bust and other attributes of art: the things on the table top are a life-size bust of a woman with a shawl draped over her head and half-concealing her face, a pestle and mortar, a

polyhedron, and a hand. The table has disproportionately long legs which are located asymmetrically and are not of matching design.

The following year Giacometti made another life-size female nude in the style of the two walking figures, but incorporating the head and arms. This is, indeed, his earliest extant image in a representational idiom of a whole human figure. With knees half-bent she is seated on a sort of throne to one side of which is attached, as if for her to take hold of, the beaky head of a bird or a reptile: this, according to Giacometti, represents the male principle. Her shins are covered by a board which seems to be there to constrain her like a pillory from performing any action other than the gesture she is making with her hands. These are held out in front of her as if holding some object. They are holding nothing: the alternative titles of the work are *The invisible object* and *Hands holding the void*; it's the perennial Giacometti situation – nothing there to touch. And it seems as though this void, this positive lack of contact, were being offered to the spectator as he moves into the field of the girl's dead gaze. That gaze belonged to a head which Giacometti had been unable to invent and which was finally shaped by his discovery of a metal mask when walking around the flea market with Breton, who went on to write in great detail about this discovery and his almost simultaneous discovery of a very unusual spoon – the 'two finds that Giacometti and I made *together*' – as a manifestation of an extraordinary bond between two beings, a bond to which he attributed an almost religious significance. By the end of the year Giacometti was to appal Breton by suddenly starting to devote himself to modelling a head from life, and Breton to appal Giacometti by protesting that everybody knew what a head was.

Before this happened, Giacometti made some heads in which he again took Cubism as a point of departure – a *Cubist head* in plaster and marble versions and a plaster four feet high standing on the floor called *Cube*, which seems an enlarged version of the polyhedron in *Table* and looks like a pure abstraction but which Giacometti thought of as an equivalent for a head. Both of them are faceted blocks which are the solidest, most three-dimensioned pieces he ever made. The *Cubist head* resembles a skull, compact,

indrawn, withdrawn into being an inert object, something to be stumbled over like a stone; it resembles a living, perhaps a talking, head, animated by the sharpness of the facets, because of its jagged edges, menacing, because of the dells which are its eyes, pitiful, like a clown's tragic mask – 'something simultaneously alive and dead'.

'I saw anew the bodies that attracted me in reality and the abstract forms that seemed right sculpturally, but I wanted to do the one without losing the other, to put it very briefly.' He was doing something of both in the *Cubist head*, but went on to show that he wanted one distinctly more than the other. At Maloja in 1934 – the year after his father's death – he painted a portrait from life of a girl, Maria, in which there is a cubistic faceting of certain planes of the face, a faceting apparently motivated largely by the desire to bring out the structure clearly. He also worked on a plaster head with faceted forms (destroyed, but not without being photographed) which was a step from the *Cubist head* in the direction of a more inclusive and naturalistic treatment, less concerned to get things 'right sculpturally', and in this attempt to get nearer to what 'attracted (him) in reality' he made something which was no longer a telling piece of sculpture but, rather, a study, a palpably tentative study. The time had come to begin again, to resume working from life, to return to the torment.

Whatever he said later in denigration of his surrealist work – that it was masturbation and so forth – he also, when walking through his retrospective at the Tate in 1965 and looking around the room with the surrealist pieces, grinned and said 'Nobody likes my work as much as I do'.

7

With Slight Variations

'As a child (between the ages of four and seven), the only things I noticed in the outside world were those that might give me pleasure. They were mostly stones and trees, and seldom more than one object at a time. I remember that for at least two summers I saw nothing of my surroundings but a large stone about half a mile from the village – this stone and the objects directly related to it. It was a golden-coloured monolith whose base opened onto a cave: the whole of the bottom part had been hollowed out by water. The entrance was long and low, just about the height we were at the time. In places the interior was further hollowed out so that there seemed to be a second small cave at the back. It was my father who showed us this monolith one day. A real find: from the outset I thought of the stone as a friend, a being filled with the best intentions towards us, calling us, smiling at us, like someone previously known and loved, and rediscovered with infinite surprise and joy.'

From then on he and his friends spent all their time there. They were careful to narrow the entrance so that it was just wide enough to let them in. When he found he could crouch down in the smaller cave at the back: 'all my dreams had come true'.

Once, wandering off alone, he found himself on a piece of high ground. 'In front of me, a little lower down, in the middle of the undergrowth, stood an enormous black stone like a narrow pointed pyramid with almost vertical sides. I can't find words for the resentment and distress I felt at that moment. The stone immediately struck me as a living being, hostile, menacing. It menaced everything: us, our games and our cave. Its existence was intolerable and I felt straightaway – not being able to make it disappear – that I had to ignore it, forget it, and not mention it to anyone. I did approach it,

even so, but with the feeling of giving myself up to something reprehensible, secret, suspect. With repulsion and terror I just touched it with one hand. I walked round it, trembling at the thought of finding an entrance in it. No trace of a cave, which made the stone still more intolerable to me, yet I felt a certain satisfaction: an opening in this stone would have complicated everything and I could already sense the desolation of our cave if we had had to be involved with another at the same time. I fled this black stone, I didn't talk about it to the other children, I ignored it, and never went and looked at it again.'

In winter, as soon as the snow was heavy on the ground, he would go off on his own with a sack and a pointed stick to a meadow near the village. There he would try to hollow out a hole just big enough to get into. Its opening was to be nearly invisible; the sack was to provide a lining; it would be very warm and dark. While waiting for the snow to fall, he would pass the time in working out, down to the smallest detail, how he proposed to make the hole; he longed to spend the whole winter there alone, regretted having to go home to eat and sleep. 'I have to say that, in spite of all my efforts and also probably because external conditions were unfavourable, my dream never came true.'

When he first went to school, he heard about Siberia and thought continually of being there, in an immense plain covered with grey snow and bounded on one side by a monotonous dark forest of pines.

There were periods of several months when he could only get to sleep after imagining that he had crossed a thick forest at twilight and found his way to a remote grey castle. 'There I would kill two men who put up no defence: one of them, about seventeen years old, always appeared pale and frightened, the other wore armour with something on its left side that shone like gold. I would rape two women – after ripping off their clothes – one aged thirty-two, all in black, with a face like alabaster, then her daughter, who was veiled in white. The whole forest would resound with their cries and moans. I'd kill them too, but very slowly (by now it was night), often beside a pool of stagnant green water in front of the castle. With slight

variations each time. After that I'd burn down the castle and go to sleep contented.'

This was the first of two stories Giacometti published which dealt with fantasies that had obsessed him for a while. *Yesterday, quicksands*, was written in 1933 for *Le Surréalisme au Service de la Révolution*. *The Dream, the Sphinx and the death of T.*, which is about recent events but goes on to relate these to the past, was composed for *Labyrinthe* in 1946, more than ten years after his break with the movement, but is unrepentantly surrealist in its concern with dreams, hallucinations and coincidences.

An enormous furry brown spider is suspended over his bed and he cries out in terror for someone to kill it. He wakes up, but in his sleep, and even as he tells himself that it was only a dream sees 'a yellow, ivory-yellow, spider far more monstrous than the first but smooth, as if covered with smooth yellow scales, and with long thin legs that look as smooth and hard as bones'. His girlfriend reaches out and touches the spider's scales, without fear or surprise, but he begs for the creature to be killed, and someone unknown crushes and beats it to death with a long stick. Examining the spider's remains, he realises that he has brought about the death of a rare specimen belonging to the friends whose house he is staying in. This is confirmed a moment later by the lamentations of an old housekeeper who comes in looking for the lost spider. He first thinks of telling her the truth, but anticipating the displeasure of his hosts decides to say nothing, feign ignorance and hide the remains. He goes out into the garden and buries them secretly, telling himself that the scales will rot before they are discovered. As he does so, the master and daughter of the house ride by on horseback; without stopping, they say something to him that surprises him, and he awakes.

Shortly before going to sleep that night, the text goes on, he and his friend, lying in bed, had discovered, to her amusement, traces of ivory-yellow pus which confirmed his suspicion that a few days earlier he had caught the clap at the brothel called Le Sphinx. He had gone there that day on hearing the news (this was the moment when France's brothels were out-

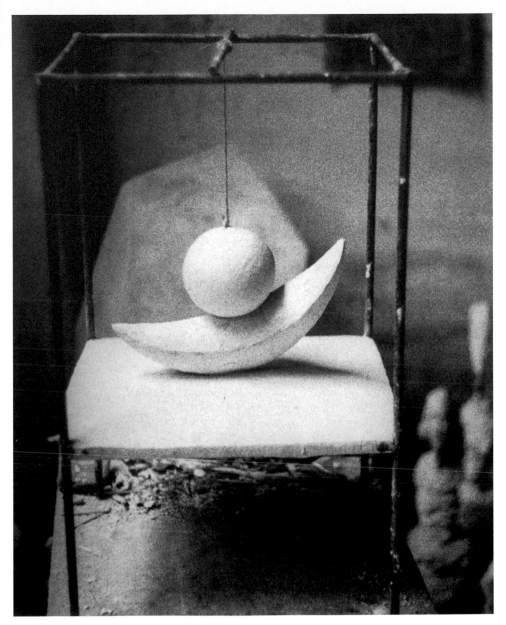

Suspended sphere, 1930

Overleaf:

Figures in progress, 1947

A figure in progress, 1947

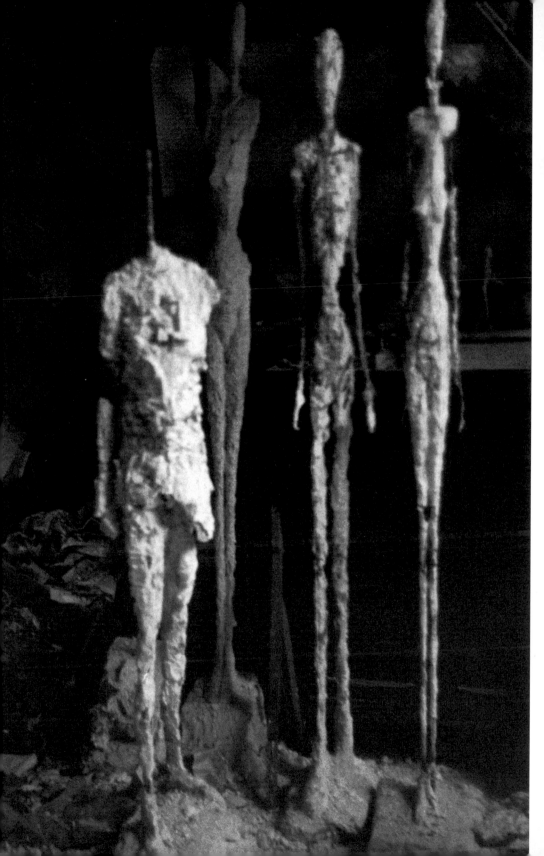

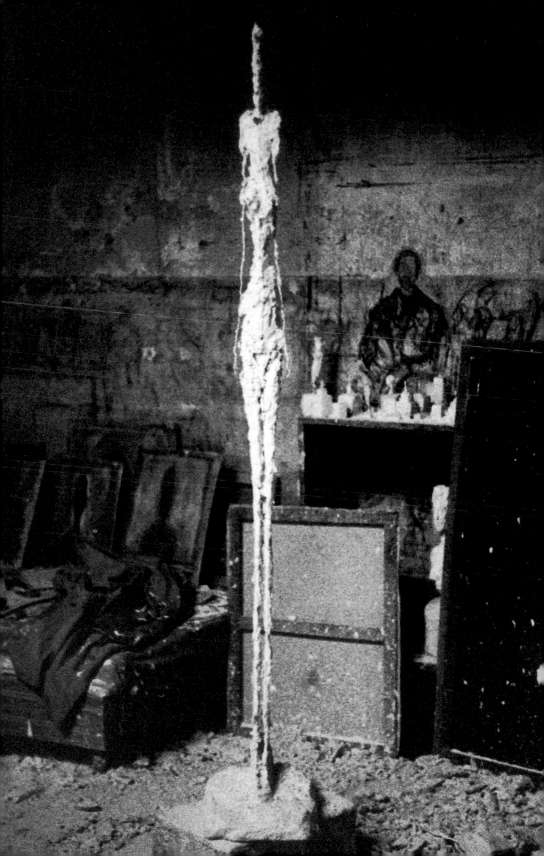

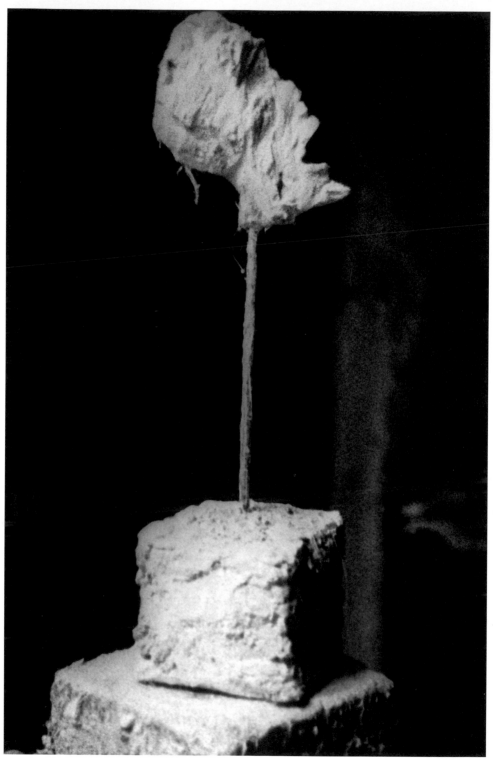

Head on a rod, 1947, *in progress*
Opposite: Large head, Man walking I *and* Man walking II, 1960, *in progress*

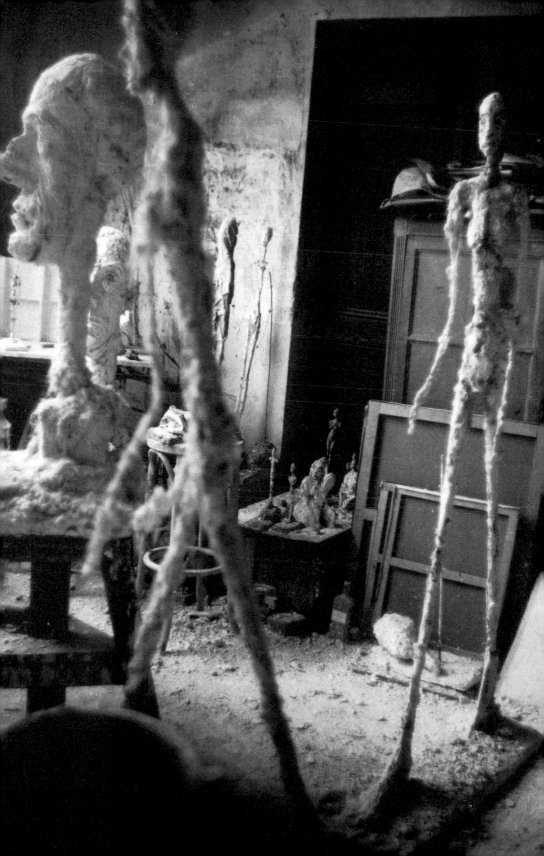

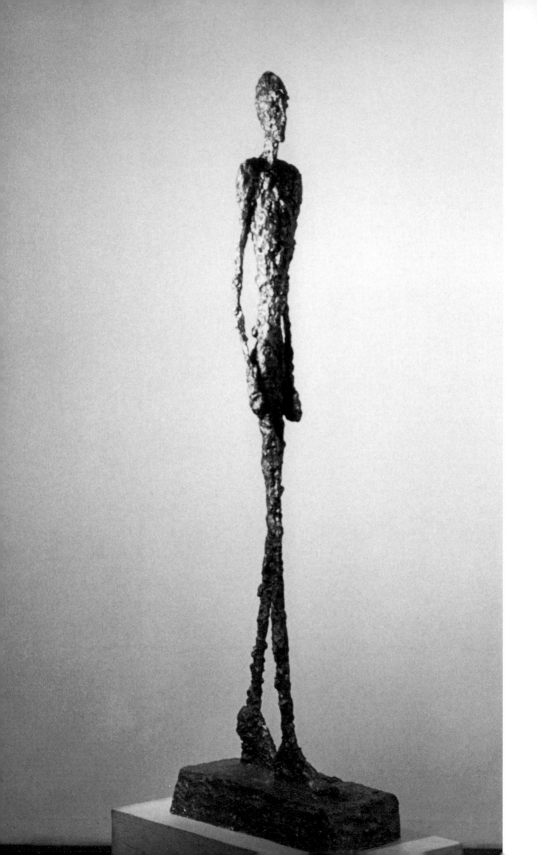

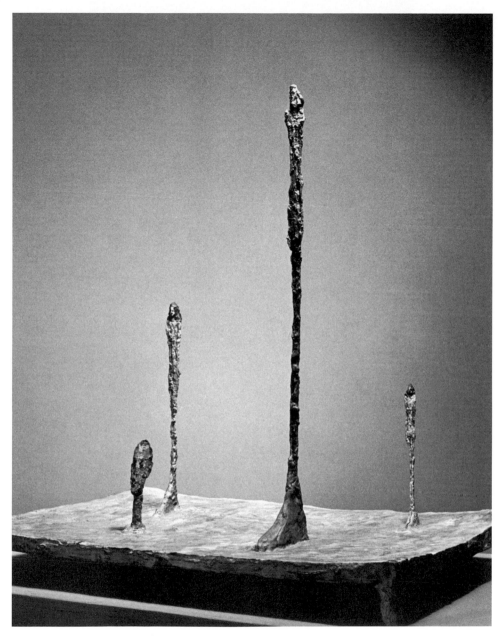

Composition with three figures and a head, 1950

Opposite:

Man walking, 1947

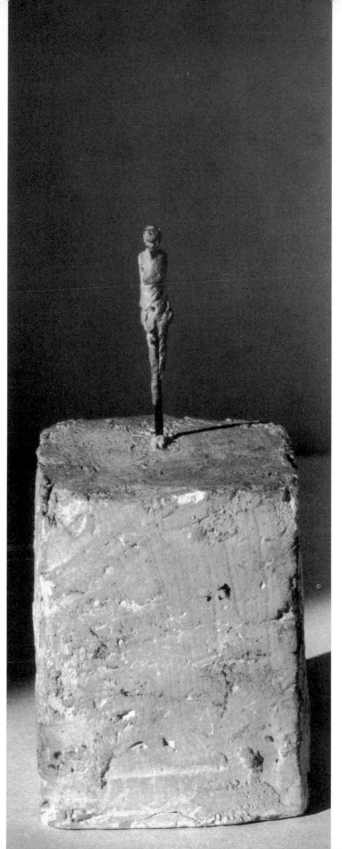

Figurine
on a base,
1944

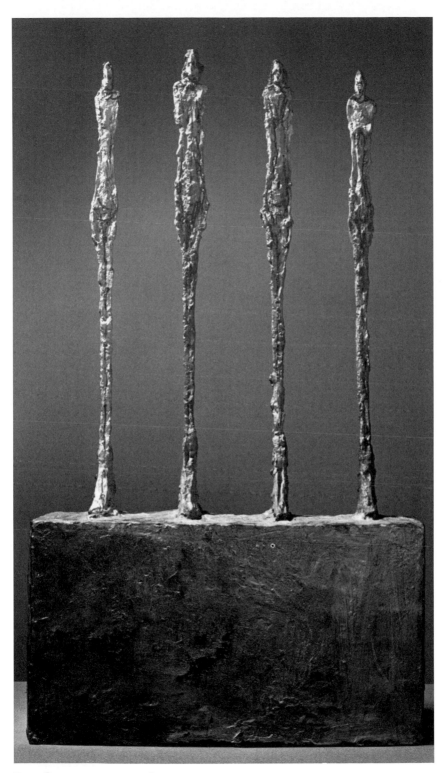

Four figurines on a stand, 1950

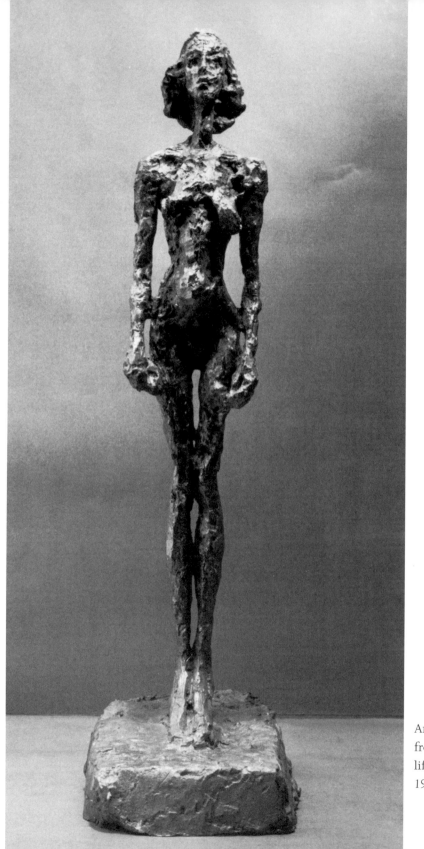

Annette
from
life,
1953

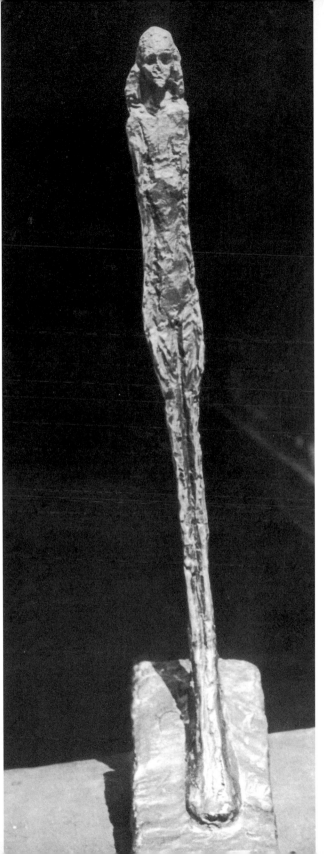

Standing
woman,
c. 1952

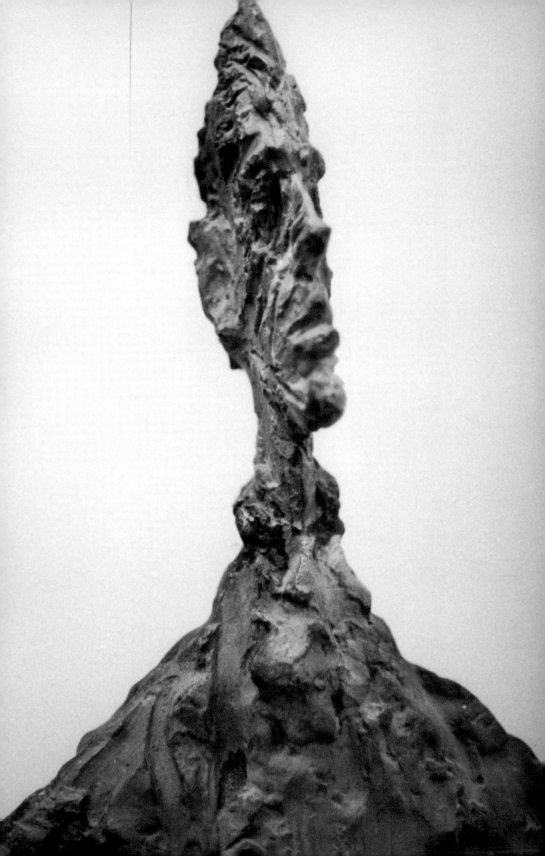

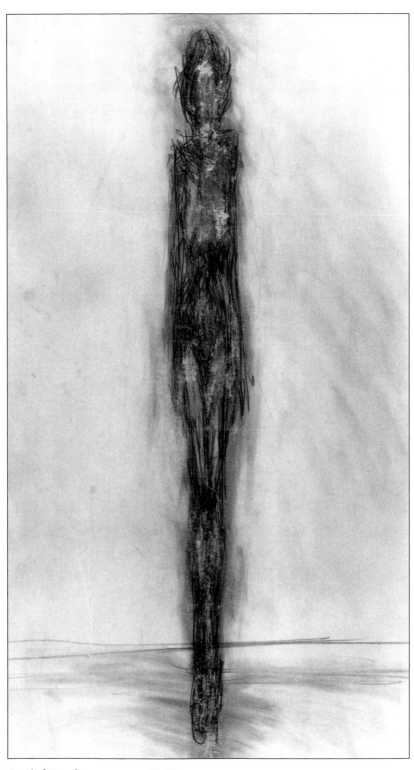

Detail of Standing woman, 1946
Opposite: Detail of Bust of Diego, 1955

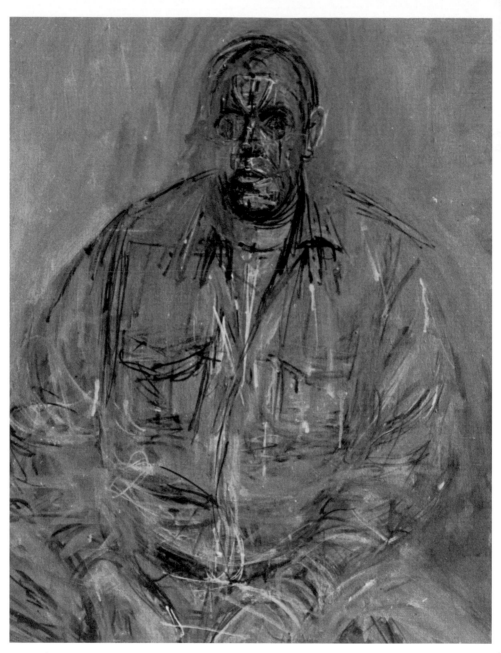

Detail of David Sylvester, 1960, in progress

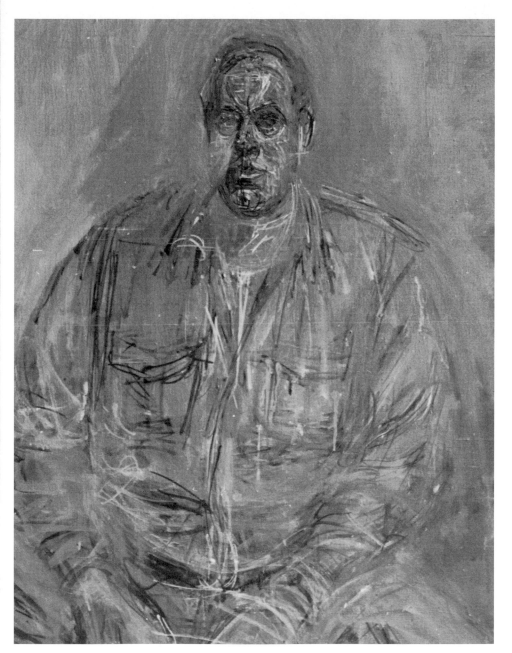

Detail of David Sylvester, 1960

Hotel room III, 1963

lawed) that it was going to be closed down: 'I hurried there, unable to bear the thought of never seeing that room again.' He had been rather drunk, after a long lunch with the publisher of the review in which the text is printed, who had reminded him of a story he had told some time before about the death of a friend, T., and had asked him to write it down for the review. He had promised to do this, but without really seeing how to go about it. But now, in the wake of the dream and of the illness which connected with the lunch, T.'s death was becoming real to him again.

'As I walked, I saw T. again in the days preceding his death in the room next door to mine in the small house at the back of a rather dilapidated garden where we were living. I saw him sunk in his bed, motionless, his skin ivory-yellow, withdrawn into himself and already strangely far away, and then shortly after, at three in the morning, dead, his limbs as thin as a skeleton's, flung out, spreadeagled, abandoned, an enormous swollen belly, his head thrown back, his mouth open. Never had a corpse seemed to me so inexistent – just sordid refuse to be thrown into the gutter like a cat. Standing motionless by the bed, I looked at this head that had become an object, a small box, measurable, insignificant. At that moment, a fly approached the black hole of his mouth and slowly disappeared inside it.'

He helped to get T. dressed as if for some great occasion. The following night, in the darkness of the corridor outside the dead man's door, 'even though I didn't believe it, I somehow felt that T. was everywhere, everywhere but in the wretched corpse on the bed, the corpse that had seemed so inexistent; T. had no bounds and, terrified of feeling an icy hand touch my arm, I crossed the corridor with an immense effort, went back to bed and with my eyes open talked to A. till dawn. I had just experienced the other way round what I had felt some months earlier in the face of living beings. At that time I was beginning to see heads in the void, in the space surrounding them. The first time I became aware that as I looked at a head it became fixed, immobolised forever in that single instant, I trembled with fear as I never had before in my whole life, and a cold sweat ran down my back. It was no longer a living head but an object I was looking at, in the same way as I

might look at any other object . . . No, though, not quite; not as if it were any other object but as if it were something simultaneously alive and dead. All the living were dead, and this vision often recurred, in the metro, in the street, in restaurants with friends . . . But objects as well as people underwent a transformation . . .

'Waking up that morning I saw my towel for the first time – a weightless towel in a stillness I had never before perceived, as if it were in suspension in a dreadful silence. It no longer had any relation to the drifting seatless chair or to the table whose feet no longer rested on the floor, barely touched it; there was no relation at all between the objects now separated by immeasurable chasms of emptiness. I looked at my room in dread, and a cold sweat ran down my back.'

Some days after having written the text thus far in one go, he continues, he was sitting in a café trying to take the story up again and rework it. A feeling of boredom and hostility stopped him rereading it, and despite himself he started describing the dream differently. He tried to tell it all in a more precise and striking way, with more emotional impact, and without looking for connections between the elements. He stopped after a few lines, discouraged. 'There was a contradiction between conveying in an emotive way what had been hallucinatory and the sequence of facts I wanted to recount. I was faced with a confused mass of times, events, places and sensations.'

Increasingly, the story is about the writing of the story. In the piece about his childhood, he set down separate recollections, allowing the echoes and links to remain implicit. This time the method is more Proustian. He is trying to define connections between the events, connections which he perceives more or less clearly, always uneasily, but also with the satisfaction of solving something; recall of an object seen at one time frequently dissolves into that of another at another time; the text is in part narration of past experiences, in part reflection on the present experience of narrating them. The problem is to show every incident vividly while bringing out the connections between them, getting everything in, and in its proper place. It was a problem that seemed particularly acute, of course, because most of his

output as a writer had consisted of short pieces, leaving him inexperienced in the torment every writer undergoes in trying to put overlapping material in the best possible order.

'I tried to find a possible solution. First I attempted to designate each fact by a couple of words placed in a vertical column on the page: this came to nothing. I endeavoured to draw small compartments – again vertically – which I could fill in bit by bit, trying in this way to place all the facts on the page simultaneously.'

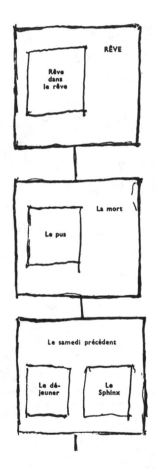

But the question of chronology kept on troubling him. He could find no way of conveying the real sequence of the events, with their complicated

movement backwards and forwards in time. In particular, he had been unable to find a place in the original draft to describe his lunch with a friend, R.M., on the day he wrote it.

He was telling his dream to R.M. when, coming to the burying of the remains, he saw himself elsewhere, in a meadow at the edge of a forest, removing the snow from his boots, digging in the hardened ground, burying a piece of bread: 'theft of bread in my childhood', he adds in parenthesis. He saw himself running through Venice holding a piece of bread he wanted to be rid of and finally throwing it into an obscure canal. He described a journey to the Tyrol when he sat for hours in a hotel room alone with a dying man, van M., watching and finally trying to draw his head as the life drained away from it. He went on to talk about journeys to Rome and Paestum the summer before that, comparing the scale of the temples at Paestum with that of St Peter's, and then about 'the scale of heads and of objects and about the affinities and differences between objects and living beings, and thereby ended up at what preoccupied me most at the very moment when I was telling this story on Saturday at midday.

'Sitting in the café on the Boulevard Barbès- Rochechouart, I thought of all this and tried to find a way of putting it. Suddenly I had the feeling that all these events existed simultaneously around me. Time was becoming horizontal and circular, was space at the same time, and I tried to draw it. Soon afterwards I left the café.

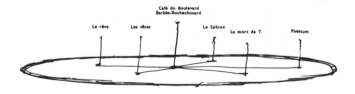

'This horizontal disc delighted me and, walking along, I saw it almost simultaneously under two different aspects. I saw it drawn vertically on a page.

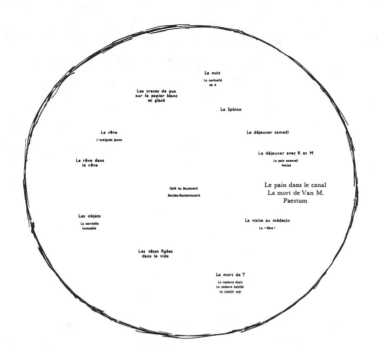

'But it had to be horizontal, I didn't want to lose that, and I saw the disc become an object.

'A disc about two metres in radius divided by lines into sections. On each section was written the name, date and place of the event it corresponded to, and at the edge of the circle facing each section stood a panel. The panels were of different widths and separated by empty spaces.

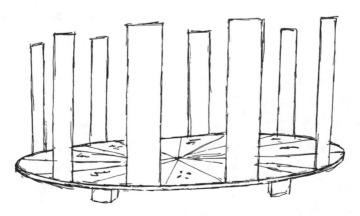

'The story corresponding to the section was printed on each panel. I took a curious pleasure in seeing myself walking on this time-space disc and reading the story written on the panel in front of me, with the freedom to begin wherever I liked, to start off, for example, from the dream in October 1946 and, after going all the way round, end up a few months earlier in front of the objects, in front of my towel. I was anxious to get the orientations of each fact on the disc.

'But the panels are still empty; I don't know enough about the value of words or their relationships to be able to fill them in.'

A note appended to the text adds that the journey to the Tyrol happened in 1921. (No indication is given as to when he was in Venice: his first visit was in 1920, when he went there with his father on his first trip abroad.) The note goes on to say that van M.'s death was a sort of watershed in his life, changing everything and obsessing him continually for a year − that he talked about it endlessly, often wanted to write about it, was never able to until now, because of the dream and the bread in the canal. A few months after writing the story, Giacometti modelled two versions of a Head on a rod intended to recapture his sensations of the head of a dying man.

One of the kinds of investigation woven into the story is virtually psychoanalytic. Telling a dream brings to mind various other experiences; connections emerge between recent and remote history; present events release the need to relive painful past events; recalling and describing behaviour in the past influences future behaviour. In particular, the conversation with R.M. quite precisely resembles an analytic session: the account of the dream is interrupted when one of the images sets off a chain of associations; at the critical point a theoretical digression provides an escape from facing the affective problem.

The other investigation within the story is semantic. It deals with the relations between a given event and thinking of that event and thinking about the event and thinking about thinking about the event, and also deals with levels of self-consciousness in dreams and in regard to dreams. It is

concerned with difficulties arising out of the fact that the mind, when attempting to fix past experiences and their possible connections, is doing so neither from a fixed position – since present experience continually modifies awareness of the past – nor in regard to a stable field – since at every instant the past becomes an instant longer. It deals above all with the problem that the shape of a continuous narrative unfolding in time does not correspond to the shape in time of the complex of events to be represented. It points to flaws in the conventions current in representing reality in a given medium, and takes it for granted that a sense of responsibility towards representing reality entails a state of doubt as to the validity of the means of communication.

Two years earlier Giacometti had been faced with the problem of giving verbal shape to his feelings about a sculptural œuvre he deeply admired, that of Laurens. He had found that looking for the words and a structure for them had precipitated in his mind a series of images which seemed to him to have an oblique relevance to his responses to the sculpture. There was one in particular which took over from all the others – the one, he noted, which had no direct connection with reality:

'I saw myself in a strange clearing, a vaguely circular space, mainly the colour of autumn leaves, whose sides were fairly close together but had become blurred in an atmosphere that was both thick and light, and very pleasant. Around me, rising at irregular intervals to a height of about thirty centimetres above the ground, curious little hills alternated with indeterminate whitish constructions which looked like little castles seen through a smoke screen. But these hills and constructions were complex, surrounded by vibrations, and I felt they were gestures, sounds of voices, movements, marks, sensations that had once existed, very far from one another, in time, over many years. And now these sensations had become objects, existed simultaneously around me and *absolutely enchanted me*.'

When Giacometti later came near, he felt, to finding a form for the 'confused mass of times, events, places and sensations' relating to the death of T., it was in the form of a circular construction surrounding him which had a

very clear and regular geometric form. 'I took a curious pleasure in seeing myself walking on this time-space disc. . . with the freedom to begin wherever I liked.' A feeling of freedom was discovered in a rigid structure.

For the last thirty years of his life, Giacometti's work in sculpture was virtually restricted to the three themes of the bust of a man, a walking man and a standing woman, invariably looking straight ahead. Endowed with all the freedom of the modern artist to do whatever he pleases, Giacometti chose to work as if under the kind of restrictions imposed upon artists by civilisations such as Egypt and Byzantium – not only the demand for adherence to stereotypes, but the insistence that the pose be formal, compact, impassive, frontal. It was not that he was aiming to create an impersonal kind of art: the nervous, agitated surfaces of the sculptures and the paintings are the imprints of the gestures that made them. It was not that he was trying to create ideal forms; the ideal was supposed to look after itself: 'If a picture is true, it will be good as a picture; even the quality of the paint will necessarily be beautiful.' The point of the rigid stereotypes could only have been that here again he felt most free to act when operating, ritualistically, within a firm, constant, repetitious framework. His figures stand there like the upright panels of different widths, separated by empty spaces, on which he thought of printing his story.

'But the panels are still empty: I don't know enough about the value of words or their relationships to be able to fill them in.' Where the medium was one in which he did fill in, it was still with the reservation, endlessly repeated, that the results were provisional, unfinished, not what he wanted. 'I know it is utterly impossible for me to model, paint or draw a head, for instance, as I see it, yet this is the one thing I am trying to do.' Perhaps not in spite of but because of the impossibility. An ostensible confession of inadequacy can be a symptom of inordinate ambition, as he knew. 'Simply trying to draw a glass as you see it seems rather a modest enterprise. But then, as you know that's practically impossible, you no longer even know whether it's modesty or pride.'

'I don't know if I work in order to do something or in order to know why

I can't do what I want to do.' The difficulties of telling his story were the recognition of how words must fail to re-create experience. The problems of using a language likewise become part of the subject-matter of his sculpture and painting. The problems that concerned him in telling a story arose from the fact that the relations between events in a narrative and those in reality correspond hardly at all; the problems that concerned him as an artist arose from the fact that the appearance of a sculptured or painted image might be taken to be capable of corresponding quite closely to that of reality.

When a sculpture in bronze of a woman is made as tall and as broad in every dimension as a real woman measures, 'if it takes four men with machines to move it, isn't that enough to make it false to start with?' If a sculpture externally resembling a head is in bronze, it is empty inside, if in stone, is solid stone; either way it is nothing like a real head, 'since there isn't a millimetre inside your skull that isn't organic'. If in the search for likeness a sculpture is painted in naturalistic colours, it can easily become a monstrosity, because it offers so complete an illusion that 'all one would feel was that it couldn't move'. 'If I didn't know that your skull had a certain depth, I wouldn't be able to guess it. So, if I made a sculpture of you according to my absolute perception of you, I would make a rather flat, scarcely modulated sculpture that would be much closer to a Cycladic sculpture, which has a stylised look, than to a sculpture by Rodin or Houdon, which has a realistic look.' Modelling or painting or drawing something from nature, 'one never copies anything but the vision that remains of it at each moment, the image that becomes conscious. You never copy the glass on the table; you copy the residue of a vision . . . You see it as if it were disappearing, coming into view again, disappearing, coming into view again – that's to say, it really always is between being and not being. And that is what one wants to copy.'

And the uncertainty had to be copied with certainty. Copying the uncertainty was something that accrued, through adding together contradictory precise observations, from copying with certainty. Copying wasn't a matter of working from doubt towards clarity; it was a matter of being led by clarity towards doubt.

The semantic problems and paradoxes that present themselves in Giacometti's art do not seem to have been positively sought out, as the Cubists sought them out. It was rather that in the pursuit of likeness he ran into contradictions and absurdities, and that his awareness of them is manifest in the work because he refused to evade them. He did not so much set out to show them as let them show themselves by not disguising them.

8

Losing and Finding

The need for repetition was insatiable and comprehensive. It applied to the method as well as to the theme: his habitual way of realising a work was by incessantly building, effacing and building again. It applied to the sitter as well as to the pose: of the several tens of thousands of hours spent, during the last thirty years of his life, in working from a model, all but a minute percentage were shared between nine sitters – and that, he sometimes hinted, was eight more than he would have used if he had had the choice.

Most of the painting and drawing during those thirty years was done from life, and in the final ten years very few paintings indeed were done from memory. There was a period – 1935 to 1939 – when little sculpture was done from memory and another – from 1939 to 1953 – when little was done from life, but after that there was a roughly equal amount from memory and from life. Since the one dealt with all that was there in all its complexity, the other with what stayed in the mind, the results were bound to be different: 'the truth lies between the two – the relative truth of perception, anyway … none of them is really right, which is why one has to go on trying.' He hoped to close the gap between them. 'Ultimately, my idea would be to work in exactly the same way whether from memory or from life – that the two should overlap completely.' As it was, they did help each other: he said one day in the summer of 1960 that the progress made the day before with a portrait he was painting from the model had helped him make decisive progress that night with a figurine he was working on from memory.

The portrait was the one that I was sitting for. The sittings would begin between three and four o'clock and go on till about seven-thirty, when the light went, and then he would work by electric light (a single tungsten

bulb) with Isaku Yanaihara, of whom he was doing both a painting and a bust in clay of near life-size. (The several previous portraits of Yanaihara had been done while he was working in Paris; this time he had come from Japan expressly to sit. Giacometti was having to work overtime because he had absent-mindedly brought these two models to Paris simultaneously and did not want to disappoint them. He was, of course, paying our expenses, and more than once he told me with great relish that Yanaihara's air fare was making him the most expensive model in the history of art.) He would usually stop working towards midnight and would then go out and eat at a brasserie and drink in a bar or a cabaret. He generally invited me to join him and sometimes Caroline; when I said that he must be bored with seeing me day and night, he answered that those who work together dine together. (Yanaihaira was not with us because he was seeing Annette.) Coming home at about four or five o'clock in the morning, he would work from memory for an hour or two or longer on the figurine.

There were twenty of those three to four hour sittings for my portrait; there would probably have been several more if I had not had to leave Paris. At the first sitting he started two paintings – a large canvas for a three-quar-ter-length in medium close-up, and a small canvas for a head-and-shoulders in close-up which was abandoned after the second day. He painted sitting down, putting thin paint on rapidly, mostly with sable brushes. His glance moved very quickly, almost continuously, between canvas and model; he rarely hesitated before making a mark. He never got up to stand back and take a look at the picture. He waited till the next break for a more distant view – and then, as this particular picture was large by his standards and there was little room to move in the studio, he would sometimes take it outside. There would generally be three breaks in a session, two of them to allow me to stretch my legs, the other long enough for coffee at a nearby bar.

For about two-thirds of the time he would be working in a relaxed way, talking freely and listening fairly attentively. His talk itself was more relaxed and less argumentative than usual. Normally his conversation tended to become vehemently analytical, often rather like a game of chess in which,

after taking a piece, he would reset the board in an earlier position and try out an alternative series of moves. Here he mostly gossiped, and when he told stories about himself they were less consistently self-mocking than usual. There would be about three spells in a sitting when he made it clear that he wanted silence. Then he would soon start muttering to himself, often exploding into a curse or a lamentation: he didn't know how to paint; he lacked daring; why was I wasting my time sitting to him; it was hard even to put the brush to canvas. I never heard him go on in this way when he was working from memory, and he was often doing this on a sculpture when I was in the studio, simply because a visit was no reason to interrupt work. Furthermore, that sort of wailing and cursing has been reported by observers of both Cézanne and Matisse when they were painting from the motif or the model: it is working in the presence of the subject that tends to generate despair. When the portrait was going more or less well for a while the incantatory recurrent phrases would stop and from then he would hold on to his tension. He generally seemed to make most progress during the final half hour, perhaps because the failing light was helpful, perhaps because time was running out.

At the end of the twenty sittings there were still patches of canvas left bare as in an *alla prima* painting, and the shirt and trousers had hardly been touched since the first day. The work had gone into the head. This was painted out and painted in again at every sitting. It was Giacometti's habit to efface by careful overpainting. He seldom scraped paint off. He never – while I sat for him, and no doubt this too was habitual – freely obliterated an area. The demolition was gradual and deliberate; it appeared, indeed, to take more time than the ostensible reconstruction, was, of course, already the beginning of the reconstruction (hence, perhaps, the eschewal of scraping-off). Losing and finding were a continuous process.

Sometimes, at the end of the day, the head was softly modelled, atmospheric, sometimes hard and stark. One small area, the middle of the forehead, remained relatively unchanged, as if this central vertical plane were serving as a *point d'appui*. At one stage, after a few days, the head was rather

bright in colour, predominantly terracotta; within a day or two it was grey and dark; later some colour came back, then went again. The underlying aims seemed to be, from what he said recurrently, to get the nose to appear to project from the face as it did in Byzantine art and to give the head the presence of a portrait of Gudea: he several times spoke, alluding to my ancestry, of the ancient relationship between the Jews and the Chaldeans.

The painting developed as Giacometti's talk habitually developed: one line of argument was pushed to an extreme, and then an opposing line was taken up and pushed to an extreme; any assertion had to be balanced against its antithesis; reality was not either/or but both/and. The more he pinned down something he had seen, the more aware he would be the next day of just those things in the model which contradicted what was on the canvas – as if by being on the canvas this was now subtracted from his sensation of the model. Each day's work seemed an attempt to reconcile the contradictions between what had been got so far and what emerged as he went on looking.

The daily loss of what was there at the start was plainly of no account to him regardless of how pleased he had been with it the night before: the value of the work done so far was in what had been learned in doing it. He seemed decidedly gratified with the result at the close of certain days towards the end; more, perhaps, than with the final state – and, indeed, comparison of photographs (taken by Herbert Matter) of the successive states suggests that the penultimate state at least was distinctly better than the last; the same seems to apply to another portrait with recorded states, that of James Lord. But because I was able to go on sitting, he saw no reason not to go on painting. A remorselessly dialectical approach precluded the idea of reaching a conclusion. As he said to Lord: 'That's the terrible thing: the more one works on a picture, the more impossible it becomes to finish it.' Circumstance might decide how long he went on with one and when he stopped. Otherwise he would often go on until there were too many layers of paint for it to be technically possible to put more on. This would be the point at which he did sometimes scrape off.

When modelling he had no technical barrier to going on indefinitely. Early in 1964 he started modelling a bust of Eli Lotar from life; after about four hundred sittings he had completed work on this and another and had had a third in progress for some time when his terminal illness brought things to a stop at the end of 1965. When he modelled from life, the coming and going of the form was gradual and continuous: he obliterated a part, rebuilt it, sharpened it, softened it, constantly modified here and there, sometimes slowed down and concentrated for hours on a detail, sometimes demolished sweepingly, but always retained the broad outlines of the mass. The sculptures from memory, on the other hand, oscillated violently between being and not-being. He was forever stripping down the plaster to its armature or squeezing the clay or plasticine back into a shapeless lump and beginning again from scratch, building with extreme rapidity. A small head or figure might be entirely demolished and remade several times over every time he worked on it: even a life-size figure would be built again from a bare armature within a couple of hours; or else a couple of hours might encompass the demolition and rebuilding of half-a-dozen different figurines. The process was repeated time after time for weeks or for months.

Perhaps the method was dictated by a compulsion akin to that of a writer given to starting afresh on a clean sheet whenever a page is to be revised. Certainly it was dictated by a will to summon up a human presence out of nothing as near as possible to instantaneously. 'Even when working from life, one ought to manage to realise the whole thing in one relatively short sitting. But as to that, I've not done it.' In working from memory, however, 'it's not a question of doing something precise or of trying to understand what one sees; it's more the realisation of an effect, which should be fairly simple and not make more of the thing than can really be taken in at a glance'. Here there was no retouching, changes were made from the inside out, the image had to be indivisible or nothing.

Giacometti's pattern of working, then, allied an often extreme rapidity of execution to an extreme persistency of effort. But occasionally a sculpture from memory was left as it came first time, done in a few hours once and for

all: in 1947, *Head on a rod*, the *Nose*, the *Hand* (each of these works was, in fact, realised in two slightly differing versions made within two or three days); in 1950, *Man falling* and *Figurine in a box*; in 1951, *Dog* and *Cat*; in 1958, the *Leg*. Most of the *alla prima* sculptures have subjects outside the three recurrent themes, and most of the sculptures of such subjects are *alla prima* works.

The *alla prima* way of working operated when he had an idea for a sculpture that he could see clearly and completely in his head before he started to execute it. Once a sculpture was visualised beforehand, its realisation, he said, presented no difficulties whatever. 'It's almost a bore to make it. You want to see it, have it in your imagination, need to see it realised; but the actual realisation is irritating. If you could have it made by someone else, you would be very satisfied.' Since he had to make it himself, he got this over as quickly as possible. The speed and certainty of execution brought into play an extreme facility and a lordly confidence in that facility. But making the thing was 'almost a bore', the few hours taken a waste of time that might have been spent in modelling a head or a standing figure or sitting down in front of one of his models for the thousandth time and trying to paint a nose so that it stood out from the face. The repetitive activity was what counted: the rest was marginal. The sculptures with subjects which he treated once and left alone were mostly made in one go and left alone; the sculptures exploring the persistent subjects were each persistently remade. The distinction between his work from memory and his work from life matters less than the distinction between the work in which the crystallisation of the image preceded its execution and the work in which the image crystallised out of its execution.

When he finally lost interest in taking a piece further for the moment or was bored with it, he might have it cast in bronze; might destroy it, might put it aside and make up his mind long after (sometimes five or six years after) whether to let it leave the studio or not. But, again, he might let a piece go because he had promised something for an exhibition and didn't want to let someone down. In the autumn of 1950, when faced with a deadline for an exhibition at Pierre Matisse's, he completely remade a number of the

major works in the course of a single night: he liked to boast of this, to the point of pretending that he had redone the entire exhibition that night, and also of neglecting to remind one that he had already made all the pieces many times. On other occasions promises were broken, exhibitions cancelled. But when he did let a head or standing figure go, it was always with the certainty that he would immediately be working on another. A sculpture was no less provisional at the time it was given up to be cast than it had been countless other times when standing there before being demolished.

Sometimes, indeed, he had bronzes cast from several states of a work in progress. Preparing for his exhibition at the 1956 Venice Biennale, he worked from memory for perhaps three weeks on a single standing figure, always with the same armature and virtually the same clay. From time to time he had a plaster cast made of the figure. He exhibited six of these at the Biennale, subsequently had ten cast in bronze. Again, in the early 1960s he had nine states cast in bronze of a bust of Annette from nature. In these series the last of the states was no more definitive than its predecessors. All were provisional. And from his point of view every head and standing figure was a state, hardly more than a means towards doing the next. He was sure to pull one up pedantically if one ever referred to anything of his as 'finished': it became comically difficult to find terms with which to make a purely pragmatic distinction between things he was currently working on and pieces long since consecrated in the world's museums.

Giacometti's effacing and remaking was the antithesis of the perfectionist's who aims at achieving a solitary gem-like masterpiece before he dies. His demolitions were a clearing of the ground so that he could go on. But how far was the endless repetition of the process determined by his aesthetic intentions, how far a matter of ritual? Asked whether he thought a sculpture was likely to be distinctly better after the fiftieth time of making it than after the twenty-fifth, he answered: 'Absolutely not. Maybe no better than the first time. It's rather that in realising something very quickly and in a way successfully, I mistrust the very speed. That's to say, I want to begin again to see if it'll succeed as well the second time. The second time, it never succeeds as

well; it begins to fall apart.' Perhaps, when he couldn't be bothered to do works like the *Leg* more than once, he was being canny. But there was no being canny when it came to a standing figure or a head. 'As I don't feel like leaving it, I go back to it. And when I stop, it's not at all that I consider it more complete or better; it's because that work is no longer necessary to me for the moment.' The time when he remade a number of pieces in a night he knew that the sculptures were less good at the end than they had been the day before: this didn't deter him from letting them go.

However, he felt he could definitely improve on the figurines in *Four figurines on a stand* and therefore authorised only one of the edition of bronzes to be cast. He continued working on the figurines, mounted on a bronze of the stand alone, exhibited the work in progress in Paris in 1951 – an instance of his habit of showing plasters in progress alongside bronzes – then went on with it intermittently for a time, without reaching a conclusion. For years the bronze stand surmounted by four bare armatures stood around in his storeroom. In 1965, when selecting his retrospective exhibition in London, I said I particularly wanted to include this work and he volunteered to make new figurines for it. He started doing so and brought them with him to London in an attaché case: they were in painted plaster and were somewhat shorter and plumper than their predecessors. While the exhibition was being installed at the Tate, he was making sculptures in the basement, and among them was a new version of the four figurines, more slender than the set he had brought with him, and which he preferred. But he had been using plaster bought for him in London, which was not of the quality he was used to, and the figurines, as he went on working at them, inclined to crumble. He broke them up, intending to make them again with the same proportions in a better plaster, but when this arrived from Paris he got involved with working on other things and never returned to the figurines. A few weeks later he agreed to supply the Tate with a cast of the *Four figurines on a stand*. Had he not died shortly after, I am sure he would have made the figurines again before they were cast in bronze.

He always tended, then, to allow circumstance to decide rather than insist

on controlling his work's destiny. His interest was not in producing the best results he might be capable of: it was in endlessly putting his capabilities to the test. 'I see something, find it marvellous, want to try and do it. Whether it fails or whether it comes off in the end becomes secondary; I advance in any case. Whether I advance by failing or whether I advance by gaining a little, I'll always have gained for myself, personally. If there's no picture, that's too bad. So long as I've learned something about why ...'

9

Something Altogether Unknown

Giacometti came from a place apart, a steep and narrow valley where the sun is invisible for three months of the year. The Val Bregaglia, where he was born and grew up and to which he constantly returned, runs from Maloja, by Lake Sils, for twenty kilometres westward to Chiavenna, near Lake Como, crossing the frontier between Switzerland and Italy at Castasegna. On both sides of the valley the mountains reach beyond three thousand metres: to the north they are verdant, with forests of beech and chestnut as well as pine; to the south they are often crystalline and stark. Giacometti's village was Stampa, a few kilometres from the border, so that it was normal to take an afternoon walk down into Italy – not that the frontier mattered in those days. The family house was across the road from the bank of the river, the Mera, in summer a rapid stream, in winter a slab of ice, beyond it to the north the looming wooded slopes of Piz Duan, its peak two thousand metres higher up. The summer house at Maloja – a large three-storeyed house used mainly for the children's sake – was in a setting which, though much wilder than it is today, was essentially benign, for there is nothing in its encircling mountains of the menace and the harsh sublimity of the steep rocky slopes that overlook Stampa from the south.

Giacometti belonged to a place apart and to a race apart. The Bregaglians, who numbered about two thousand at the time of his birth, are Italian, but have been Protestant since 1529 (and there are no others in Italian Switzerland). Their pastors, Diego told me, have generally been unfrocked priests from Piedmont but more recently from the south (he thought that a Sicilian had officiated at his mother's burial, a Neapolitan at Alberto's); they were much better paid than Catholic curés, owning Alfa Romeos and occupying

the nicest houses. Although in recent times some Bregaglians had defected to Rome, the Giacometti brothers came from Protestant families on both sides, and their mother was a devout believer. They, of course, were not, but it may still be relevant to see Alberto as an Italian Protestant.

Born in 1901, he was the eldest and Diego the second of the four children – the others being Ottilia and Bruno – of Giovanni Giacometti and Annetta Stampa. Giovanni was a post-Impressionist painter ranked among the leading Swiss artists of his time, though considerably less eminent than his cousin Augusto, who also came from Stampa, and his friends Segantini, Cuno Amiet, Alberto's godfather, and Hodler, Bruno's godfather. Life at Stampa and Maloja was as ordered as it was rarefied, ruled by the controlling genius of Annetta – who all but outlived Alberto – permeated with family solidarity and perhaps oppressively harmonious: Giacometti told me that as a child he never heard his parents have a row, and this was, I imagine, because his father invariably gave in.

Things were made easy for him to become an artist. He had a handsome face, a clever tongue, shone at school, quickly displayed an amazing facility in painting and sculpture. His father was a successful enough artist to help him but not so successful as to demoralise him. And he gave him every encouragement, sending him to study in Geneva, Italy and Paris, and continuing to subsidise him when he was well past being a student. He settled in Paris, of course, but he came back to Stampa and Maloja virtually every year: it was almost all the travelling he ever did.

Paris was as open as Stampa was closed, as fluid as Stampa was constant. But in one thing Giacometti established a stability and rootedness in Paris such as the Bregaglia gave him. In 1927, two years after he and Diego first took a studio, they moved to another, and this small room remained his studio for the rest of his life. Even so, he never became involved in a domestic life there: meals and drinks were taken in cafés and restaurants. His rootedness at the rue Hippolyte Maindron had its limits. Home was Stampa.

The moral encouragement which came from home was a key factor in the profound difference between Giacometti's history and that of a master

with whom he is endlessly compared because each of them struggled pain-
fully and heroically to represent reality in his own way. Not only did
Cézanne have to deal with strong parental opposition to his becoming an
artist; he had to deal with ridicule from the famous writer who had been his
closest boyhood friend and, despite winning great admiration from other
artists, also had to deal with indifference from the world at large, whereas
before he was thirty Giacometti was acknowledged by critics, dealers and
collectors as well as his peers to be an outstanding artist. But the important
difference was internal. Cézanne's point of departure was anything but the
Italianate facility and elegance that Giacometti started from. Certainly he
painted masterpieces before he was thirty, but only by finding a makeshift
technique with which to embody his vision. He had a desperate struggle to
win the adroitness of his maturity, and even then could still end up with
strained, awkward revisions. Giacometti seemed to be struggling for most
of his life to deny the adroitness he began with. Cézanne couldn't help
finding art difficult; Giacometti could have found it easy had he not seen
how difficult it could be made to be.

There was no crisis of confidence at first. 'I was terribly conceited when
I was ten. I admired myself, felt I could do everything with this wonderful
weapon, drawing – that I could draw no matter what, that I saw more clearly
than anyone. And I'd begun to do sculpture when I was about fourteen, with
a little bust. And that went well too. I had the feeling that there was no
obstruction at all between seeing and doing. I dominated my vision, it was
paradise; and that lasted until I was about eighteen or nineteen, when I got
the feeling that I could no longer do anything at all. Gradually things deter-
iorated. Reality escaped me. Earlier, I thought I saw things very clearly, had a
sort of intimacy with everything, with the universe. Then suddenly it be-
came foreign. You are you and there's a universe outside which becomes
very literally obscure.'

The difficulties arose when working from the model. During his stay in
Italy, 'the head of the model in front of me became like a cloud, vague and
boundless'. In Paris, when he tried from 1922 to 1925 to work from the

model in Bourdelle's class, 'the distance between one side of a nose and the other is like the Sahara, boundless, nothing fixed, everything dissolves'. After three years of frustration, he rented a studio, deciding 'as a last resort' to work on his own from memory.

For the next ten years, virtually all his sculpture was done out of his head, though he did make drawings from nature and a few paintings, usually when he was at home in the summer. He completed about fifty sculptures in that time. 'It was rather a happy time. I got around, I worked and the work in itself presented no difficulty; I did what I wanted to. But I knew that whatever I did, whatever I wanted, one day I would have to sit down on a stool in front of a model and try and copy what I saw – even with no hope of succeeding.'

The return to working systematically from life came a year or so after his father's death in June 1933. Doing so was to work as his father had done and as he had worked as a boy alongside his father. And in, as it were, carrying on his father's work, his most constant model was the brother who had sat for the bust which had been his first sculpture; he also worked from his mother, as he had when a boy. And during the first two or three years of this work the sculptures – though not the paintings – of an artist recognised as one of the leading sculptors of the day became the works of a student.

At the moment of his embarkation on this problematic voyage, he was not at all aware of what he was getting involved in. 'There was a desire', he wrote retrospectively, 'to do some compositions with figures. For this I needed to make (quickly, I supposed, in passing) one or two studies from life, just enough to understand the construction of a head, of a whole figure, and in 1935 I took a model. This study (I thought) should take a fortnight, and then I wanted to realise my compositions.' These compositions, he told me, were to be works of the order of The invisible object, and it was no doubt partly the difficulties he had had in realising the head of that particular piece that made him feel the need 'to understand the construction of a head'. But this did not take a fortnight. 'I worked from the model throughout the day from 1935 to 1940. Nothing was like what I imagined it to be. A head (I very

soon left figures aside, they were too much) became a completely unknown object without dimensions.' 'The more I looked at the model, the more the screen between reality and myself thickened. You begin by seeing the person who is posing, but gradually every possible sculpture interposes itself between the sitter and you. The less clearly you actually see the model, the more unknown the head becomes.'

Throughout those five years he would work from Diego in the mornings, a professional model, Rita, in the afternoons. He also sometimes worked from an Englishwoman he loved, at arm's length till 1940, Isabel – née Isabel Nicholas, then Isabel Epstein, currently Isabel Delmer, later Isabel Lambert and Isabel Rawsthorne. Periodically the works in progress would be cast in plaster: some of these casts were later done in bronze: others are recorded in photographs. Two photographs taken in the winter of 1935-6 show a head of Diego that is broadly modelled, with fairly abrupt transitions between planes, compact, strong, stocky in its proportions. An extant head of Isabel probably dating from the following winter is smooth in finish and stylised in the Egyptian manner. Versions or states of heads of all these sitters dating from 1937-8 are softer in modelling, the features more particularised, the vision pretty nondescript, as in art school life-studies, except in a beautiful head of Isabel clearly in imitation of Rodin. After the interruption of work through being run over by a car in 1938, the heads, now coming on a much smaller scale, were getting altogether sharper and more compressed.

Whereas the sculptures of those years mostly have little resemblance to those of Giacometti's maturity, there is a small group of paintings of the period in which his mature painting style is virtually formulated, notably a portrait of his mother and a still life of a single apple on a sideboard which were painted at Stampa in 1937. They reflect the influence of Cézanne and possibly that of Derain, whom Giacometti was seeing continually at the time, and have some affinity to the work of his close friend Francis Gruber: they have nothing of Gruber's Expressionism; they do have something of his nervous, spiky way of drawing with paint.

Meanwhile a passage from a letter written to Isabel in 1938 provides an

intimation of a vision of space which in a few years was to become explicit in his drawings and paintings and implicit in his sculptures.

'I'm quite incapable of describing to you the marvellous thing I saw in my room the day before yesterday. I'd lain down towards evening and fallen asleep, and when I woke at about six I looked up at the white ceiling and noticed two big patches I'd never seen before, so I looked at the rest of the ceiling and suddenly saw right in front of me a thread like a spider's thread but it was a thread of dust, a very very fine one hanging from the ceiling which is rather high, so fine that I couldn't make out exactly where it was hanging from, from what point on the white surface, but farther down it was a little thicker, then it became thin again and at the bottom there was a blob. The thread wasn't motionless even though the window was closed but in continual movement and describing great curves, raising, lowering, thrusting out its head or keeping it almost motionless while its body made the most varied and unexpected movements, it was like an animal in a hallucinatory sort of way, a snake, but no animal has ever made such beautiful movements, I'm quite incapable of describing them, light and sweeping and always different. Naturally I had the impression that I was up there, and looking down. It must seem absurd to write this, or I ought to know how to write it, but I'm sure you would have thought it very worth while to watch, it was also like a ballerina with infinite grace and flexibility. There were also movements that began right at the top and rippled down like waves to the bottom which itself was barely moving. In the end I got up and stood on the bed to see it from closer to, it was very lovely, incomprehensible (it was like a series of little blobs) and how it could support so much movement. I haven't looked at it much since but it's still there, even a little bit longer (there was its shadow as well).'

On starting in 1939 to work from memory, he made figures as well as heads, indeed, mainly figures – the minuscule figures which were the prototypes of all the later female standing figures. In a letter written from Geneva on 30 July 1945 to Isabel who, because of the war, had not yet seen any of these figures, he wrote: 'The figure is you when I caught a momentary

glimpse of you, a very long time ago, standing in the Boulevard Saint-Michel one evening, not moving . . . ' In an interview given in 1963, he said that he saw the recurrent figure as a portrait, the portrait of an English-woman. 'Because the sculpture I wanted to make of that woman was the very precise vision I'd had of her at the moment when I'd caught a glimpse of her in the street, from quite a distance. So I tended to make her the size she looked when she was at that distance. This took place in the Boulevard Saint-Michel, at midnight. I could see the enormous expanse of darkness above her, and some houses, so to reproduce the impression I'd had I ought to have made a painting and not a sculpture. Or else I ought to have made an enor-mous base so that the ensemble would correspond to the vision.'

This was what lay behind the famous description in the letter to Pierre Matisse of what happened when in 1939 (he wrote 1940), he stopped modelling heads from life and started working from memory 'principally so as to see what all this work had left me with . . . But wanting to do from memory what I had seen, to my terror the sculptures became smaller and smaller. Only when small were they like, yet these dimensions revolted me, and I kept on beginning again only to end up, a few months later, at the same point.' He would start again and again, Diego told me, on a plaster figure ten or twelve inches high and would end up again and again with a figure not more than about an inch high standing on a base whose size would have been normal for the figure he started with; at first these bases were simply the residue of what happened in working.

The Second World War came and went; the ritual, unaffected, outlasted it. Two momentous events occurred at the time of France's capitulation in June 1940. The day before Isabel had to leave Paris for England, he went to see her, did some drawings of her lying naked and, he told me, went to bed with her for the first time and was impotent. A few days later he, Diego and Nelly, his companion, set off by bicycle for Bordeaux. At the end of nine days they were back in Paris having seen horrors all along the route and having them-selves come under fire from the air.

The atmosphere of the Occupation was strangely stimulating, so strong

94

was the sense of certainty of German defeat. Work continued; he saw a good deal of Picasso and Dora Maar. Towards the end of 1941 he decided that he must go back to Switzerland for a while, as neither he nor Diego had seen their mother for two years. He left on the last day of the year, intending to stay for perhaps three months, but he made the mistake of promising Diego and Francis Gruber that he was going to come back with some sculptures of a less absurd size. He did in fact achieve one such work, made at Maloja in 1943 – a standing female figure nearly four feet high mounted on a roughly cubic base with a small wheel, in working order, at each corner: the Chariot. But with this one exception the figures still kept getting tiny. Not wanting to lose face, he stayed on in Switzerland and went on trying to make them come out bigger, working away in a small hotel bedroom in Geneva.

In a letter dated 14 May 1945 to Isabel – the first she had received from him, because of the War, for five years, he wrote: 'I've been paralysed here since I came in 1942 (infinitely regretting leaving Paris even for a short time) fully intending to return after five months at the latest but with a sculpture the way I wanted it; after that time I found myself with a sculpture that was all wrong so I was incapable of moving and put off my departure from day to day until now, working as much as I could. I started the same thing over and over again, never getting it right. My figure ended up so minuscule every time and the work was becoming so imponderable and yet it was nearly what I wanted only I had the idea of a certain size that I wanted to achieve and it's only during the last year that I've managed it but not to the point I want, the size, yes, yet I know that I shan't give up the one I've been working on since September and that I shall finish it in spite of everything unless I'm completely deluding myself which I find hard to believe since I make a little progress every day . . .'

Then, in that letter of 30 July in which he told her that this minuscule figure was about the sight of her standing still one evening in the Boulevard Saint-Michel, he said: 'I shall see you soon, it isn't the lack of a visa that's stopping me coming back, I can come back when I like, yes it's my sculpture that's stopped me coming back for the last three years, it's been keeping me

here in Geneva my life stagnating cut off from everything and I'm doing my utmost to get out of it as quickly as possible so as to be able to leave, I shall have to spend a fortnight in Maloja for various things and then I'll come back. Bring all my sculptures, Isabelle? If only I can manage to bring one back I shall be more than happy. There are some very small ones, four or five but they're not right and then one I'm working on at the moment to make a cast, always the same one, destroyed 20 times since I've been here – 20 sculptures really destroyed – I'm not going to destroy it any more but get as far as I can with it and not start it again but if I manage to have a cast that is just a little bit all right that'll satisfy me, it'll give me endless work just to go on with it without ever starting the whole thing again. But it could also be that I went about it the wrong way and have wasted a lot of time, no I don't think so, the time hasn't been wasted, that work had to be done first quite apart from the result but anyway there will be a result . . .' On 17 September he took the night train to Paris, bringing with him the residue of three years' work in six matchboxes.

Almost immediately Isabel moved in with him, but at the end of the year they parted. The following summer a girl he had been seeing in Geneva, Annette Arm, arrived in Paris, moved in, and stayed. At first this meant that she had to get a part-time secretarial job. The brothers were largely living on borrowed money. Working as Alberto was, he had no sculpture to exhibit or in which to involve Diego's usual collaboration as a craftsman. During the 1930s they had been supporting themselves by designing and producing utilitarian objects – lamps, vases and so on – for Jean Michel-Frank, the interior decorator, but during the war Frank, a Jew, had died in New York by his own hand. Now they were living off the scraps gained from the odd sale of a few drawings or minuscule sculptures, from an occasional commission for a portrait bust, from writing those articles for Skira, and off borrowed money. Zervos, with his usual editorial flair, devoted sixteen pages of the issue of *Cahiers d'Art* dated 1945-6 to reproductions of recent drawings and minuscule sculptures. What was happening in the studio was obviously some of the most exciting art being produced anywhere and it instantly became legendary.

At some moment during this period of resettlement and crisis, Giacometti underwent what he felt was a crucial change in the way he saw the world. 'Before, reality had been something familiar, banal, or let's say stable. This completely stopped in 1945. For example, I realised that there hadn't been any interruption between going to the cinema and coming out of the cinema: I'd go to the cinema, see what happened on the screen, come out, and nothing would astonish me, in the street or in a café . . . My view of the world was a photographic view, as I think almost everyone's is, near enough . . . And then all of a sudden there was a break. I remember very clearly, it was at the news theatre in Montparnasse. First of all, I no longer knew what I was seeing on the screen: instead of its being figures, it was becoming black and white blobs, that's to say they were losing all meaning, and instead of looking at the screen I kept looking at my neighbours, who were becoming something altogether unknown. It was the reality around me that was the unknown, not what was happening on the screen. Going out on to the boulevard I had the feeling of being faced with something I had never seen before, with a complete change in reality – the unseen, the altogether unknown, the marvellous. The Boulevard Montparnasse took on the beauty of *The Arabian Nights*, fantastic, altogether unknown. And at the same time, the silence, an unbelievable sort of silence. And then this grew. Every morning when I woke up in my room, there was the chair with the towel on it, and that affected me and made me almost feel a chill down my spine, because everything had an air of absolute stillness. A sort of inertness, of loss of weight: the towel on the chair was weightless, had no relation to the chair, the chair on the floor didn't weigh on the floor, it was kind of inert, and this gave a sort of feeling of silence. This was a beginning. Then the way everything looked became transformed, as if movement was no more than a series of points of stillness. When a person was talking there was no movement, stillnesses followed one another, completely detached one from another – moments of stillness which, after all, could go on for an eternity, broken and followed by another stillness.'

This was how he told it years later – in 1961 – to Pierre Schneider. In the

autumn of 1946 he wrote, in *The Dream, the Sphinx and the death of T.*, of 'beginning to see heads in the void, in the space surrounding them', of how, 'as I looked at a head it became fixed . . .as if it were something simultaneously alive and dead', of how his towel and the chair it was on and the floor the chair stood on were 'separated by immeasurable chasms of emptiness'. When he described that experience to Jean Genet in 1954-5 he phrased it: 'The towel was separate, so separate that I felt that if I were to remove the chair the towel would stay where it was. It had its own place, its own weight, its own silence, even. The world was light, light . . .'

It is not clear how the location in time of this overwhelming experience related to that of the production of the last of the minuscule figures. Giacometti, like most people, was not perfectly accurate about the dates of important events in his life: he was surely wrong in telling Pierre Matisse and interviewers subsequently that he had resumed doing sculpture from memory in 1940 rather than 1939, and he could have been wrong in telling Pierre Schneider and others that the experience at the news theatre happened in 1945; it could have been early in 1946 – so long as it was 'some months' before the death of T., which occurred on 25 July. And there is also doubt about precisely when he stopped making minuscule figures on large bases: it is certain that he went on doing so after his return from Geneva, less certain whether this continued into 1946, and if so how far into 1946. But it does seem likely that some of the examples that were photographed in the studio and bought from the studio in 1946-47 are relevant, no less than the larger figures that followed, to his encounter with the 'altogether unknown'.

In 1946 he started working on standing figures of various sizes up to four feet high, on the first of the male walking figures, *Night*, and on heads and busts, some of these from the model, and he was painting and drawing from the model and sometimes out of his head. He said that the drawing from the model was an important factor in his being able to make larger sculptures. Here again, reduction took over: 'to my surprise, only when long and slender were they like'. 'I did fight against it; I tried to make them broader. The more I tried to make them broader, the narrower they got.' In 1947 he

completed several figures which were life size or near life size as to their height and often as to their breadth until he started paring them down, leaving slag-heaps of plaster on the studio floor. They included the standing figure about five feet tall and called the Lion-woman, which is his most consummate portrait of Isabel, a standing figure more than six feet high, his first life-size Man walking, the life-size Man pointing, and the Hand, and the Nose, and the Head on a rod. The style of his mature work was crystallised, a style deriving above all from the Egyptians – for example, in the hunched shoulders of the women (especially reminiscent of pre-dynastic ivories) and in the way a walking man advances one leg as if discovering the act of walking.

Early in 1948 he had the first of his exhibitions at the Pierre Matisse Gallery in New York, his first one-man show for more than thirteen years, had it 'mainly because I don't want to be thought of as sterile and incapable of achieving anything, as a dry branch almost'. The exhibition played safe in that a dozen of the thirty-odd sculptures were works of 1925-34, several of them original plasters; the new pieces were mostly cast in bronze, but several were in plaster.

And now the attenuation became more extreme. The figurines of walking men of 1948-50 have trunks as well as limbs that are like twigs. A standing woman of 1948 that is life-size as to height has a waist that can be circumscribed with one hand, and those proportions are repeated in a number of female figurines of the next four or five years. It is often said that these proportions were derived from Etruscan sculptures, but, while certain particular works, such as The Chariot of 1950, must have been based on Etruscan images, their famous attenuation was probably not a stylistic influence: those sculptures were far too relaxed in form to appeal to an artist whose eye had been educated by the Egyptian, the Sumerian and the Cycladic. Giacometti often used to speak of his stylistic indebtedness to the Cycladic, pointing out that in his slenderest figures the lateral attenuation was more marked than the frontal: the profile view does indeed present a thin line joining the head to the huge jutting feet; the frontal view of the trunk gives an impression of flatness as much as of slenderness.

The extreme attenuation was closely linked – one cannot say it was necessarily cause and effect – with a disappearance of figures on a large scale. After that life-high female figure of 1948, it was not until 1960 that Giacometti completed and preserved another figure, female or male, as tall as life. In the intervening years, there was no sculpture of a figure that was more than two feet high. At first the figures on this scale or less mostly appeared as figures in compositions, compositions of three distinct kinds.

One kind presents scenes resembling scenes in real life: the two versions of *The Square*, completed in 1948 and 1949. There is a nice interplay between artificiality and an air of casual reality in both subject-matter and design. The figures seem like any five figures arbitrarily focused on in a street, only it turns out that all the four walking figures are men, the one standing figure is a woman (waiting to one side like a street walker). The figures are so placed in one of the versions that lines drawn between them tidily form a cross, but the direction in which each figure is turned means that none of the four walkers seems to be moving along those axes: so the design, by proposing a relationship between the figures, makes its denial significant dramatically.

A second kind of composition is rather formal, staged, with somewhat artificial groupings of figures raised on a usually elaborate kind of platform. It occurs in the two compositions with four naked female figures lined up like troops – schematic realisations of the way half-naked girls in two particular brothels had been viewed – and in the two compositions with three walking men – grouped more as in a dance than in the street, especially in the version so designed that, when the group is seen from an angle from which the three heads are superimposed, the heads become the apex of an isosceles triangle enclosing a regular pattern of triangles.

The third kind involves the juxtaposition of elements on disparate scales – in one case nine standing female figures of assorted heights, in another seven assorted figures combined with a male bust rising from the ground, in another three assorted figures with a bust, in another a single figure with a bust placed in a space-frame that signifies a room.

Giacometti realised no further compositions after 1950, though he made two abortive attempts, with life-size and over-life-size figures. When making the Man pointing in 1947 he had intended it to have a companion, a standing male figure: hence the position of the pointing man's left arm, raised and bent to encircle the other's shoulders. In 1951 he executed the second figure and exhibited it in painted plaster alongside a painted bronze of the pointing figure. After the exhibition he destroyed the plaster and abandoned the idea. In 1959-60, responding to an architect's request to produce a large-scale group for a piazza at the Chase Manhattan Bank in New York, he tried to realise a composition bringing together, for the first time, a standing woman, a walking man and a head. He abandoned the enterprise, but preserved a head three feet high, two male figures just over six feet high, and four female figures eight or nine feet high, though he felt dubious, at the time and afterwards, about their value, especially that of the female figures. When he had stopped working on them it was not because he had any feeling of having resolved them, but only because he felt disinclined to waste any more time on them.

It was significant that whereas almost all the figures made around 1950 went into compositions, there were numerous single heads and busts, for from then on Giacometti produced, in terms of works that left the studio, many more busts than figures. The busts he was making around 1950 were extremely narrow in their proportions and oddly angled in space, so that they deflect the gaze as one tries to look at them: it is rather as if they caused one's line of sight to slip past them. Here again – as in the standing women – there seems to be some sort of anamorphic effect at play, and in this case the distortion resembles that of the anamorphic skull in Holbein's Ambassadors.

The element of streamlining in these heads was developed in 1954-55 in the series of 'slicing' heads, which seem almost to systematise the tendency of Giacometti's busts to be a low relief of a frontal view of the shoulders surmounted at right angles by a low relief of the profiles of the head. The frontal view is visible only so long as one stands where its nose is pointing

straight at one's own. As soon as one moves an inch or two to right or left, only one eye is seeing the edge of the blade; the other is registering a profile. An inch or two more, and the front view is totally lost and the blade is only a profile. There is virtually no transition between front view and side view. The elimination of the three-quarter view may have been suggested by the New Hebrides figures which were Giacometti's preferred type of tribal art. It was an answer to a problem that constantly bothered him when observing heads in reality – the total discrepancy between a front view and a profile, which was such that neither could be inferred from the other: an eye, for example, was 'two completely contradictory things', round from the front, pointed from the side. One way to insist that a head was two contradictory things was to realise it as only those two things without weakening the force of the contradiction by admitting views in which it was a bit of both.

A number of bronzes of busts and figures from 1950 on were painted in fairly naturalistic colours. Giacometti had first coloured some of his pieces while in Bourdelle's class, where he became impatient with monochrome sculpture, and had gone on to put a wash of colour over certain plasters of 1925-30. From the mid-1940s on, the plasters in the studio were often decorated with free linear drawing in black and rust, some of it indicating features, especially eyes, most of it free-wheeling. The purpose of this calligraphy was presumably to break up the whiteness of the plaster. But about 1950 he began to paint some of the bronze casts completely, chiefly at that time and then when he painted them on site at the Venice Biennale in 1962 and again for the opening of the Fondation Maeght at St Paul de Vence in 1964. He certainly believed that in principle his sculpture ought to be coloured. But for one thing he suspected that, because light colours make volumes appear to expand, proportions that were right when a work was in bronze would be disrupted when it was painted. Then again he felt that the degree of illusion given by naturalistically painted sculpture was highly suspect, that such sculpture would 'quite likely be dreadful', by being in some senses so close to reality that one would become only too aware of the fact of its being a dead object. Finally, there was the inevitable reservation

that, since the form was inadequate anyway, what point was there in dolling-up 'something you don't believe in'.

This sort of feeling about its being beside the point to do things like paint his bronzes or assemble compositions was a by-product of a growing obsession with working from life. Giacometti had never stopped painting and drawing from life. He had resumed modelling from life in 1953, when he began to make a practice, at the end of Diego's sittings for paintings, of working from him on a bust for a while, and he was soon giving whole sessions to this. And after he had done so for a couple of years the busts from memory were never again so extremely slender. In 1953 he also had Annette pose for a figurine from life. The following year its quite generous proportions and rounded forms were echoed, almost caricatured, in a series done from memory of decidedly well-fleshed little women – well-fleshed but not complacently rounded, for their breasts thrust forward, elongated, as the elongated trunks of their predecessors thrust upwards. This plumpness was never repeated, but the subsequent standing figures from memory – such as the *Venice women* of 1956 and those for the Chase Manhattan project – though slender, were never as slender as before.

In 1935, when Giacometti started modelling heads and figures from life, he had 'very soon left figures aside, they were too much'. The same happened twenty years later. He decided (despite what seems the remarkable success of that figurine from life of Annette) that the attempt to model nudes from life must be postponed while he concentrated on the head. He never got round to trying again. Shortly before his death he said that once he managed to get somewhere with the head the rest would come easily. The notion of beginning from the head and working his way down was, indeed, manifest in the tendency of his later busts to take in more of the figure: the earlier busts give the head and shoulders; the later ones often go down to the waist or the hips, sometimes include the hands.

The idea of getting a part right and going on from there had wider ramifications in his later thinking and practice. Whereas he had always believed that it was necessary to grasp something as a whole, towards the end

of his life he tended to say that, at least in working from life, if he could just get one detail, the eye, right, all the rest would follow. From about 1958, when modelling or when painting from life, he would seem to work outwards from a prominent point – an eye, the tip of the nose, the centre of the forehead. And when working from memory he would sometimes vividly establish certain parts and simply leave others out. Whereas in the 'slicing heads' of the mid-fifties, the whole head is trimmed and sharpened but with everything there, fined down, compressed, in the late fifties he made a number of heads in which the central part of the face – the chin, mouth, nose, eyes, frontal plane of the brow – are there almost without attenuation and the rest has been stripped away. At this time he also made figurines of standing women which are less attenuated than before but from which it is as if parts had been torn off. In the last two years of his life he made heads from memory which are a thrusting nose and chin and thrusting eyes within sockets thrusting backwards, and anything else that is there is only what is needed to hold together these separately thrusting features. Modelling from life, in the late 1950s he was making heads with quite conventional dimensions, but in the 1960s – as in the series of states of Annette's head – he was spreading the volume and the details out before him, broadening the face, compensating by flattening the head behind the ears so that he ended with something that was less a bust than a mask.

It was as if he was looking at the face from very near, so that all sense of the head as a sphere out there in space was lost and he was left with the prominent features thrusting themselves at or spreading themselves before his gaze. In painting from life in these last years he never sat the model at a distance in the studio so that he could see the whole figure in an ambience. He would paint within a few feet of the model, concentrating violently on the head. In these late paintings the illusion of space around and behind the figure, behind the canvas, disappears. The new treatment of space reflects the wish he was constantly expressing to emulate Byzantine mosaics in creating the illusion of a nose thrusting forward from a surface. The poetic mood of the studio's space is replaced by a forthright confrontation with a presence

104

that dominates the space in front of the canvas. At the same time, in the later portraits of Caroline there is often an immediacy to the point of coarseness which could be the result of a conscious effort by Giacometti to deny his instinct to create elegant, poised forms. These portraits bring together that almost brutal realism with an ideal symmetry and geometry to achieve something of the reconciliation between the direct and the hieratic which distinguishes the San Vitale mosaics at Ravenna.

This growing love of a hieratic formality and symmetry was not directed only at the Byzantine; it applied to medieval pictures in general as against later pictures. There was nothing new in this bias: when he first went to look at art in Italy, at the age of eighteen, he began in Venice and, as two published texts of his avow, at once fell in love with Tintoretto, only to find on reaching Padua that Tintoretto was dethroned by Giotto and some months later on visiting Assisi that Giotto in his turn was supplanted by Cimabue. (The feeling for Tintoretto endured nonetheless and his style of drawing clearly influenced Giacometti's art.) Towards the end of his life, though, this pull of the medieval became even stronger. When I accompanied him in 1955 on his first visit ever to the National Gallery, the picture that he liked most of all was an early fifteenth-century altarpiece of *The Trinity with Christ crucified* by an unknown Austrian artist, and when he paid his next visit there, nine years later, he picked out precisely the same rather uncelebrated work without giving any sign that he had thought about it in the meantime. In an interview we recorded shortly after, he talked of his admiration for the Van Eyck portrait of a man in a red turban; in the presence of the actual pictures, he had felt more at home with a medieval piece whose primary concern was far from being the recording of appearance. Again, on the last visit we paid together to the Courtauld Collection, in 1965, he scarcely bothered to glance at the pictures by Cézanne: he focused on a couple of late medieval panels.

While his later paintings reflect on the one hand this increasingly exclusive attachment to art forms which are not generally thought of as especially relevant to a search for appearance, they simultaneously reflect the fact that

Giacometti became increasingly obsessed with the idea that all he was trying to do was to copy his sensations – 'simply to copy, so as to take account of what one sees'. 'Copy' is a word that appeared in his vocabulary only rarely before the second half of the 1950s. In the interview by Georges Charbonnier recorded in 1951 which was his first substantial exposition of his ideas about representing reality, he talked about 'copying' it only once, whereas he used the word several times in a recording with the same interviewer in 1957. In the late 1940s and early 1950s he constantly alluded to his search for 'likeness', but the word he tended to use of his activity was 'realise' – a word that relates to the making of the work of art as a viable entity as much as to the idea of depicting. In 1954-5, while painting Jean Genet, he said that 'you have to paint exactly what is in front of you' and added 'and, what's more, you also have to make a picture', whereas in 1960, while painting me, he said that 'if a picture is true, it will be good as a picture; even the quality of the paint will necessarily be beautiful'. By then, 'copy' was very current in his vocabulary, and it remained so. Back in 1950, when we were talking about the current art scene, I asked him who were the contemporaries, if any, with whom he felt any affinity at all and he answered: 'In spite of everything, the Tachistes'. By the same token, he said to me at that time that the conception underlying his current work and his surrealist work was the same, that it was only the means of expression that had changed. I do not think he would have said either of those things ten years later: by then he was too embattled an exponent of 'copying'.

This commitment, however, didn't seem to make him feel much alignment with even a single contemporary who was also working from the model and who might also claim to be concerned with copying what he saw. Once in the 1960s I asked him what he thought of the work of Balthus, an old friend to whom he remained devoted; he answered discreetly, saying he liked some of the drawings. The artist with whom he felt the closest affinity then was probably Francis Bacon. During his first visit to England, in 1955, I had made a point of taking him to see the Bacons in the stock of the Hanover Gallery, and had been disappointed though not surprised by his

reaction that Bacon was 'too expressionist' for his taste. In 1960, how-
ever, when I showed him reproductions of some of de Kooning's figure-
paintings, he said that he found these less interesting than he did Bacon: I
suspect that this interest had been awakened by their mutual friend Isabel.

They had several meetings in the 1960s – though only once, I believe,
tête-à-tête – which reflected a strong mutual regard and growing affection.
(Giacometti, of course, continued to have certain reservations about Bacon's
work; Bacon, who was even more difficult to please, considered Giacometti
to be the greatest draughtsman of his time and also liked some of his paint-
ings of the late 1940s; he rather detested most of the sculpture, finding it
'arty'.) One night in the summer of 1964, after we had all dined together in
Soho, I was taking Gicometti back to his hotel and complaining about the
damnable sophistry Bacon was capable of. Suddenly he said: 'Who do you
think is the more ambitious artist, Bacon or me?' My reply was conditioned
by something that Giacometti often said about himself – that whereas the
Brothers Le Nain, say, were able to deal with appearance and still manage to
convey a range of human feelings, he himself found the problem of dealing
with appearance so consuming that he was incapable of doing anything
more. Thinking of this beside the tragic power to be found in Bacon, I an-
swered: 'I'm sure that you're the greater artist, without question, but I think
that Bacon is the more ambitious'. He, of course, said: 'You're wrong'. His
reason was implicit in something lately said to me in an interview: 'Simply
trying to draw a glass as you see it seems rather a modest enterprise. But
then, as you know that's practically impossible, you no longer even know
whether it's modesty or pride.'

The final state of his thoughts about copying and about art in general was
committed to paper during the last three months of his life, in 'Notes on
copies', three separate texts written to preface a book reproducing a selec-
tion of the thousands of drawings he had made after works of art. In the last
of them, dated 30 November 1965, he says that his motive for copying art
is the same as for copying reality – to help him take account of what he sees
– but that nowadays he rarely copies works of art. 'The distance between any

work of art and the immediate reality of no matter what has become too great, and in fact only reality interests me now and I know I could spend the rest of my life in copying a chair.' In another text, written on a boat from New York to Le Havre, he wrote: 'Impossible to concentrate on anything whatever, the sea invades everything, for me it has no name although today it is called the Atlantic. For millions of years it had no name and one day it will again be nameless, limitless, blind, untamed as it is for me today. How can one talk here of copies of works of art? – ephemeral, fragile works of art that exist here and there on land, works that come apart, wilt, gradually rot, many of which – including some of the ones I like best – have already been buried deep under the sand, earth and rocks, and all go the same way. And all those that once so excited me but now leave me almost indifferent, and grow pale and empty in my memory. Almost all of them precarious, feeble, pretentious things which after all I can do without; but at the same time all the countless moving and marvellous works that exist rise up before me. But often these themselves are only witnesses to the hardest, blackest, most intolerable civilisations which I find the most horrific. In fact, I no longer know what to think of anything whatever, and then every word I write is only the expression of my vanity, my pretension, my hypocrisy, yes, of my pleasure in shining and shocking – all "qualities" I was already bursting with when I was twelve. Luckily, afterwards there was a very long period of respite, in fact almost up till these last few years, but now I am the same as I was at twelve, no, not entirely, I have made enormous progress now I know that I only go forward by turning my back on the goal, I only make by unmaking. I don't know if I'm an actor, a phoney, an idiot or a very scrupulous chap. I do know I have to try and copy a nose from life.'

So the nameless untamed ocean made all art puny, his vanity ridiculous, but the imperative 'to try and copy a nose from life' was as undeniable as the ocean. Everyday, familiar, near things aroused a yearning in him like that with which Romanticism searched for the indefinable, boundless ultimate beyond things. For these too offered a confrontation with the unknown: 'the distance between one side of a nose and the other is like the Sahara, bound-

less'; 'a head . . . became a completely unknown object without dimensions'. The Romantic search for the ultimate in far-off exotic places was transferred to the nearest available object (often, when he talked, an object of a type which in fact he rarely copied but which tended to be there as he was talking): 'If the glass there in front of me astounds me more than all the glasses I've seen in painting, and if I even think that the greatest architectural wonder of the world couldn't affect me more than this glass, it's really not worth while going to the Indies to see some temple or other when I have as much and more right in front of me.'

What was in front of him was marvellous because it was unknowable, but also because it was something more than what was in front of him. The image of a person or an object in the Paris studio became overlaid with memories of sublime spaces. The sculptures made there provide a classic example of the common phenomenon of an artist's unconsciously finding his equivalents for the human body in the forms of his childhood surroundings. Heads and figures incorporate Stampa: the spare uprightness of the conifers on the slopes; the granite rocks in the meadows or among the trees; the blanched stony bed of the Mera; the pervasive sense of a rarefied space; above all, the sharp mountain peaks and ridges, these above all. The sculptures continually echo certain distinctive and astonishing rock formations that oddly enough do not appear elsewhere in the valley but are conspicuous in three adjacent granite peaks to the south of Stampa, the peaks dominating the view from the back of the Giacomettis' house. Working in Paris, scrutinising or recalling the head or body of someone near, he was recovering a familiar distant landscape – as he surely was whenever he stopped in his tracks in the street and stood for minutes gazing up at a tree – the paradise of childhood and home.

10

A Separate Presence

The women are figures standing motionless, the men are figures in action or they are heads, and these too are active. The nose sticks out from the plane of the face, thrusting forward, or the whole head has the form of a wedge, slicing through space. They are heads which appear to see before they are seen. They can have something of the sharply attentive look of the blind, the look which makes us feel that they see us while it is we who do not see them.

'A blind man is feeling his way in the night' was the first line of a poem Giacometti wrote when asked to write something about himself. (It is thought to have been Michelangelo's own choice to be depicted as a blind man with his dog on the verso of the medallion by Leone Leoni.) The first of Giacometti's figures of walking men was entitled *Night*, another was interpreted by him as 'myself hurrying down the street in the rain'. The other men walking could well, perhaps unconsciously, be himself. It is relevant that he never posed a model in a walking posture: it suggests that his walking figures were conceived empathetically rather than visually, were about motor sensations when walking – sometimes, perhaps, when walking before the accident that left him with a limp.

And some of the heads from memory became, involuntarily, self-portraits. A 'slicing' *Bust of Diego* of 1955 ended with a profile which is quite precisely Alberto's; the fragmentary head of *Stele II*, 1958, presents a detailed likeness of his own eyes and mouth, though again expressly intended to be a head of Diego. It was not a matter of family resemblance. The portraits of Diego made from nature, while varying in their proportions, consistently have a longish face, round eyes, a squarish jaw, a domed skull, and so do most of the heads of him from memory. But there are others with a totally

different cast of countenance, which is very specifically Alberto's: a pointed face, almond eyes, a lean jaw, a peculiarly flat back to the head. All of these are sculptures in which volume is very reduced, their physical substance elusive, their presence asserted through the thrust of their gaze. The heads that resemble his own are heads that seem to live through a driving gaze. The confrontation between artist and model is compressed into an image in which artist and model coincide.

In the *Cage* of 1950 a single bust of this type and a single female figure are brought together, placed at right angles to each other. Initially, the woman had her arms outstretched, till Giacometti found this 'intolerable'; the women have to stand at attention as if they are there expressly to be looked at. They are neither caught unawares engaged in pursuits of their own nor asked to perform expressive gestures. While the male figures are condemned to be active, the female figures have to stand there motionless, arms as though pinioned, legs tensed as though arresting a will to move. They stand there as if offering themselves. Desired, they reflect the shape and the tumescence of desire; desired, they stay out there beyond reach. When near they are inviolate within their separate space.

The relationship is what it is: the hold of women who are unmoving and unmoved, the anxiety that they should remain so. It is also the paradigm of every human confrontation, the encounter between two beings whose likeness to each other is the likeness of their apartness from each other. The distance is intraversable. But the relation of the artist to the sculpture itself is quite other. He has had this in his grasp, and that is very evident. He has mauled it, squeezed it, stretched it, gouged it, lacerated it, demolished it and seen it grow out of his hands over and over again, postponing the moment when it had to leave his hands, letting it go pitted and scarred with his gestures, gestures made with a kind of rage as if frustration at not being able to dominate and possess the model – beyond keeping her there interminably – were vented upon her effigy.

In building the effigy he could exercise omnipotence, shaping formless clay or plaster in the image of the elusive other and in the image of his own

gestures. Yet the sculptures have something of the character of carvings (as his drawings have the character of carvings, the luminosity of marble). Giacometti's need to work by trial and error precluded carving as a technique. But he did not have the modeller's characteristic orientation, the tendency to spread out from a centre: he moved towards compactness, like the instinctive carvers (from the Cycladic to Michelangelo to Brancusi). The slenderness is not as if insufficient matter had been tentatively put there but as if an excess of matter had been fastidiously fined down. So these modelled sculptures seem rather as if carved, given their look of having emerged when matter has been chipped away, and with their likeness to mountainous rocks, attributes which affirm a self-subsistence surviving the artist's dominance.

The artist's imposition of himself, the rock-like otherness of the resultant image, are equally asserted, left in opposition. In its mode of representation this sculpture is as much about vision as sculpture has ever been, yet its properties as an object are such that it could have been shaped by a blind man: seeing and touching are, as he said, dissociated. No synthesis is offered, no comforting resolution. As in talk every argument had to be inconclusive, so in the work everything was unfinishable, and as it stands keeps the dialectic going. Opposing qualities are equally respected, each pushed to an extreme – as when a head is defined as the sum of two contradictory views and no other – the tension between them stretched to an extreme. The passive unattainable female figure is the weapon of male desire. A hieratically rigid form is a trap for shifting, fugitive sensations. The traces of a nervous, unquiet activity shape the image of a separate presence.

11

A Sort of Silence

The sight of towering granite, stark, greyly luminous, somehow weightless, soaring to jagged splintered summits, appears in images of fragile heads and figures which are also giving form to a vision of urban reality suddenly filled with 'an unbelievable sort of silence' where any head was 'as if it were something simultaneously alive and dead', every object 'had its own place, its own weight, its own silence, even', was separated from other objects by 'immeasurable chasms of emptiness'. And we, confronting the embodiments of those coalesced sensations, feel a shock of recognition of ourselves and of our mutual separateness.

This consummation happens with perhaps twenty or thirty of Giacometti's sculptures. I would name certain of the minuscule figures made around 1945; the *Head on a rod* and the *Lion-woman* and the *Tall figure* and the life-size *Man walking* of 1947; the *Standing woman* of 1948 that's about 167 cm high and about 16 wide; the *Composition with three figures and a head* of 1950; two or three female figurines made around 1952; several very attenuated busts of 1950-55.

The minuscule figures which were the beginning of all this, so far from owing much, as a recent monograph has it, to de Chirico's little figures in looming spaces, are their antithesis. It is crucial to de Chirico's minuscule figures that they appear in pairs, like discursive archeologists in eighteenth-century pictures of ruins: they are essentially picturesque figures and also anonymous figures. It is no less crucial to Giacometti's tiny figures that they appear singly: they are about the way in which an isolated figure in space tends to command and hold the attention of the viewer, and they were even inspired by the view of a particular person standing alone in the street, a

person adored by the artist. Those isolated figures, and the ones on larger scales that came after them, were a fresh instance of an ageless tradition of confronting the viewer with an isolated compact frontal figure, a female idol, a variation on that theme which presents an extreme condensation of the figure and with it an illusion of an unnervingly actual space around it, creating a sense of an uncanny alert stillness, like the sensation experienced at the moment when a great dancer stands motionless and seems to be containing the volume of her body somewhere inside its actual contour, or – to reiterate another approximation – seems to be drawing her body and the ambient air inward to a still centre. In compositions with several figures, that spellbinding quality of the standing woman is best retained when the composition is palpably artificial, as in the one with a bust and three figures on different scales. In the compositions in which a standing woman is placed with four walking men in a naturalistic sort of relationship, the image subsides slightly into anecdote.

Perhaps that comparison with de Chirico was encouraged by the fact that something of the atmosphere of Surrealism survives in the sculptures of 1945-47 as it does in the text written at that time, *The Dream, the Sphinx and the death of T.*. The *Head on a rod* recalls the head of the *Slaughtered woman*. The men walking – both the life-size figure and the one called *Night* – inhabit the sort of deeply silent sleepwalking atmosphere which pervades, say, Magritte's *The meaning of night*, with its ordinary man walking towards us from the sea and his double walking away from us towards the sea. But the Giacometti figures are more than *images* of mystery. Giacometti had broken with the Surrealists because they could not begin to understand that there was a further mystery to be investigated, that of the actual *appearance* of a man: his figures are searching examinations of what is going on physically when a man is walking as if under a spell. One of the most enduringly satisfying qualities in the way Giacometti's sculptures re-create appearance is how bodies disappear at their edges – a sort of three-dimensional *sfumato*. And in pieces such as *Man walking* and the *Head on a rod*, the swimminess of *sfumato* ties back this aspect of the work into the atmosphere of dream.

This same conjunction of a dreamlike quality with a precise re-creation of an aspect of appearance had been present in a previous summit in Giacometti's career, the plaques of the late 1920s, above all the *Gazing head*. Executed in plaster, cast in plaster, copied in marble and decades later cast in bronze, only in its plaster versions does it have the kind of luminosity which fulfils all its inherent magic (a magic that can survive breakage and repair). It is a piece at once small enough in scale and smooth enough of surface to be practicable in plaster form, unlike most of the sculptures completed in 1947, which could be expected to survive only if cast in bronze. But it is certain – on the evidence both of photographs and of extant, mostly broken, plasters – that these works have never been as beautiful in bronze as they were when Giacometti made them in plaster. And there is good reason to suppose that when Giacometti saw them cast in bronze, he was disappointed. He had been working and reworking them in white plaster that was full of light, having scarcely had the experience in his early career of seeing his work translated into bronze, and now he was confronted with artefacts of his which had lost their matt light and become dark and heavy and shiny and shadowy. The ground for suspecting that he felt this disappointment is that within a couple of years he started painting his bronzes in pale life-like colours, so disguising the material. For bronze has tended since Rodin to become a material which there seems to be too much of. And the reason why the sculptures Giacometti made in 1948 were so very much more slender than those made in 1947 could well have been that, having seen sculptures of his cast in bronze, he wanted to be rid of some of the bronze.

In certain works made between 1948 and 1953 with these extremely attenuated forms, Giacometti achieved a resolution of the duality that had appeared in the 1920s between his feeling that figures had to be some sort of lightweight construction before they could correspond to his vision of reality and the creation of surfaces giving some scope to inflect the play of light upon them. There followed a series of works in which attenuation was almost systematically explored, the busts with 'slicing heads' of 1954-5, a series that could be said to sum up his contribution to the art of sculpture.

They do not have to share the credit for their qualities, as the standing women and walking men have to do, with Egyptian prototypes; their architecture is totally original, found in nature, for their shapes – like that of the Head on a rod, even to the angle at which it is set – are there in certain distinctive rock formations in the mountains overlooking Stampa from the south. Furthermore, they are – above all the one where the head most closely resembles the artist's own, the Bust of Diego of 1955 which is 56.5 cm high, an acute image, with its profile like an arrowhead, yet especially gentle in its modelling – a supreme exemplification of the artist's particular mastery of form. When Giacometti tried to make a sculpture of the front view of a head, with a head's normal width, he seems to have had great difficulty in managing to realise the full volume of the head: it always tended to become a mask. It was a weakness that showed in an early work which as a whole was astonishingly precocious, a head of his mother done in the early 1920s, and it was a weakness that had not gone away forty years later in the series – successive states – of heads of Annette done in the early 1960s and the busts of Eli Lotar done in the middle 1960s. Giacometti's genius was for low relief, for inflecting a flattish surface, whether one at right angles to the line of vision – as in the Gazing head – or one continuing it. In the busts with 'slicing' heads the shoulders present, roughly speaking, two flattish surfaces back to back which are at right angles to the line of vision while the head presents the same thing continuing the line of vision. And in the best of these works in which Giacometti does not give himself anything like the volume of a head to play with, he somehow models the profiles of a head which physically is no more than a wedge so that this wedge implies the entire volume of a head and the entire presence of a frontal view.

I do not think he ever again made a sculpture reaching the level of those pieces, for he never again attained the same perfect balance between likeness and structural coherence. That crucial loss was not sufficiently compensated for by any gain of insight into appearance, even in the highly sensitive modelling of Lotar's face. Furthermore, there is a diminishing sense of energy: perhaps one reason why these busts are poignant works is that they are

116

palpably tired works. Photographs of Giacometti taken when he was fifty give him the look of a man of forty; photographs taken when he was sixty give him the look of a man of seventy. That ageing surely related to the cancer that was to kill him at sixty-four. While a fatal illness can give an edge to an artist's work, it seems to me that in some of the sculptures of his later years – those of Lotar – there was a sad fatalism, a sense of resignation, while in others – the Chiavenna busts – there is an over-compensatory insistence on the drive of form through space that gives them the tiresome pugnacity of Mr Punch.

Towards the end of the poem written and published in 1952 there is a recapitulation of the two themes of its opening lines:

A blind man is feeling his way in the void (in the dark? in the night?)
The days pass, and I delude myself that I am trapping, holding back,
 what's fleeting.
I run and run, staying in the same place, without stopping . . .

This is beautiful writing, and its poignancy tends to obliterate the fact that an artist whose progress resembles that of Alice and the Red Queen is in a bad situation. And the lines, I think, were prophetic; indeed, before long the work was not even staying in the same place. (In art, if it doesn't get better, it usually gets worse.)

It seems to me now that the figures and busts made after 1955 no longer have that 'contained violence' which Giacometti prized above all in sculpture. The series of standing women made from memory in 1956 for the Venice Biennale have little of the 'pent-up energy', the density, the vibrant stillness, of the standing women of 1945-53. As to the standing women and walking men and male heads which were made from memory in 1960 for the Chase Manhattan commission and which are perhaps Giacometti's most famous works, the over-life-size head of Diego is a lovely piece, both sensitively modelled and impressive, but it does not jolt the nervous system as the *Head on a rod* does, while the two life-size walking men, though splendid pieces – complementary pieces, a buoyant, rather manic, character and a

depressive character, like a survivor in the pages of Beckett – have lost
the tragic grandeur and mystery of the 1947 figure. Unlike those works,
the four women break new ground in being about three metres tall and
because of this are radically different in intention from all the previous
women, but they lack intensity of presence. However, when I saw the four
of them crowded together in a rather small high room in an exhibition at
the Galerie Beyeler in Basel in 1989, they suddenly looked – it was a classic
example of how very much presentation can do for and against Giacometti's
sculptures – far more real and compelling than they had ever done when
placed in the generous space of, say, the courtyard of the Fondation Maeght.
Now they looked very near, and they were suddenly interesting pieces. There
may be a relevance here to something he said about making these figures. 'At
first you think you need less space to do a small thing and much more to do
a big one, but it's the opposite. A very large sculpture can be made in a very
small space . . .'

Giacometti had always previously stayed with combining no more than
two of his perennial themes. Here he tried combining all three, with one
example of each, and I suspect it was his awareness of the difficulties rather
than the scale on which the project was to be realised that prompted him to
depart from his usual way of working and make maquettes for the units.
What has since made me feel that the difficulties were insurmountable was
something I experienced in 1981 when installing a Giacometti exhibition
in a beautiful small gallery in a park. The exhibition initially included three
of the Chase Manhattan pieces – the head and two walking men. This was the
untried combination of two themes, and I decided to give the three pieces a
sizeable square room to themselves and see what would happen. Within ten
minutes they had found their places and the room was alight. But halfway
through the course of the exhibition one of the standing women became
available; I tried again and again to place it in conjunction with the head and
one or the other of the walking men, and they seemed utterly resistant to
being grouped as a trio. And he himself said that he 'had practically no
feelings about how they should be grouped'.

It was not, in fact, a project that meant very much to him. His whole approach to it was casual. He got involved through 'a sort of nostalgia for large outdoor sculpture. Anyway, I had always rather wanted know how large a piece I could do.' He may have been attracted to it too because it was an enterprise that ran completely counter to his direction at that time. Since about 1955 he had been finding that work from memory was much less absorbing than working from the model. And he worked from a model – and I mean from a model, not simply from nature – not only for most of the sculpture of his last ten years but also for virtually all the painting: there were very few still lifes and landscapes such as he had been painting previously; now he only made drawings of these subjects. The interest of working so relentlessly from the model – sacrificing the mental distance from reality that encourages creative freedom – probably lay to some extent in the human interaction. Giacometti was an extremely inner-directed man, but he was not a solitary. He enjoyed talking and listening, above all in a one-to-one situation, and his models were people he loved or people he liked to be with, so that working from the model was a pretext for extended conversation. And when the talk had to stop for the real work to take over, this involved a still more absorbing interaction. Giacometti was not one of those artists who wanted the model to be an apple; he demanded the 'attentive presence' of which Annette spoke to me. And that confrontation could satisfy a need which governed his whole existence: Giacometti did not want to be alone but he did want to be apart. The living model provided him with someone to be apart from, someone to situate in the work at a certain distance, someone whose presence opposite him established his separate existence. At the same time, working from that person also guaranteed a gratifying sense of failure inasmuch as any artist working from nature is unremittingly taunted by his awareness that he is failing to make the artefact in front of him match the reality in front of him.

The painting, it seems to me now, advanced no more during those last ten years than the sculpture did. During numerous visits to the retrospective at the Tate in 1965, I found increasingly that the paintings with which I spent

the most time, hypnotised by their gaze, were the large portraits of Caroline seated, painted in the 1960s – works in which more and more of the effort went into solidifying the face and its aura while leaving the rest of the picture almost untouched, a result of that consuming obsession to copy a nose so that it stood out from the face as it did with the Byzantines. Seeing them again in major retrospectives in 1978 and 1992, I felt they were clearly inferior to those pictures of the end of the 1940s which are marvellous in their subtle but never conventional harmonisation of everything on the canvas and their realisation of a hallucinatory vision of figures in space, transforming the intimate spaces of a room into long vertiginous perspectives: I am thinking especially of a portrait of Diego, seated with legs crossed in the foreground of the Paris studio, of 1949; of the portrait of Annette at Stampa of 1949 in the Neumann collection, Chicago, and of the portrait of the artist's mother at Stampa of 1950 in the Museum of Modern Art.

From the mid-1950s on, the paintings and sculptures alike became, I think, increasingly expressive of the difficulties of making them, increasingly indifferent to the need of a picture to be a convincing entity as well as a convincing representation, increasingly careless of creating a style, as Cézanne did, in which uncertainty was made beautiful. It seems to me now that Giacometti sacrificed his art in the pursuit of an obsession. And when I say his art, I am not speaking merely of aesthetic qualities but of precisely what he valued most, likeness: in these late paintings the sense of a struggle to surmount difficulties overwhelms the sense of a human presence. Recalling his daring statement that the quality of the work was in ratio to the artist's obsession with the subject, it does seem that here the obsession is less with the subject than with the method. (Certain fifteenth-century painters got similarly obsessed with the method of perspective.) Especially as the likeness with which Giacometti was obsessed was a very obsessional kind of likeness, frontal likeness.

When Tériade, a lifelong friend of Giacometti's and as good a judge of as anyone of painting, told me in 1975 that he felt my portrait was the best portrait Giacometti had painted, he was doubtless partly paying a friendly

compliment to a sitter, but there can be no doubt that this work is among the better paintings of Giacometti's last years. And it may be significant that it is not perfectly frontal: the sitter is turned slightly towards the right. The unusual pose has not gone unnoticed by writers, and they have naturally inferred that Giacometti chose here to depart from his usual practice. In fact, he didn't choose. Because of a flaw in my eyesight, if I look someone straight in the face I see double, which is painful, so that in order to sit and gaze at Giacometti as he required I had to get his agreement to my turning a little towards one side. For once, he could not control the pose, and this released him from the prison of his obsession and allowed him to pay attention to other things.

Nor did the obsession with frontality distract him when he made drawings of all the various subjects that presented themselves to him. His limited control here of the subject gave him a freedom that may have been relevant to the way his drawing developed in the course of the two decades between the time of his return to Paris and his death. Here the magic in his vision was never diminished by the indefatigable effort to trap appearance. The radiant intensity with which he could realise a single standing nude isolated in space was sustained and increasingly refined in complex interior and exterior scenes where a luminous space floods the image as if voids were the positive and solids the negative.

Fluidity of vision is reconciled with a crystalline clarity of structure. A precise tentativeness in recording facts is warmed by an intoxicating breath of the sublime. Michelangelo's belief that the sculptor brings to light a form buried in the marble he is carving becomes a metaphor for the act of drawing, even to the contrasts between totally polished parts and parts that are still emerging from the block. The air is alive, like the air in Giacometti's room when he lay on his bed and watched the dance of a pendant thread of particles of dust. Solid bodies of an uncanny lightness are locked into a space charged with a buoyant, exhilarated, numinous energy and filled and filled by light.

INTERVIEW

D.S. *You have said that all you want to do is to copy what you see, that what matters to you is likeness, and that this remains your purpose whether you're making a sculpture or a painting or a drawing. Yet the forms in your sculptures do tend to be decidedly thinner than those in your paintings and drawings.*

A. G. Yes. But when you do a painting you create a total illusion of the reality, the appearance of a person in a particular position and a particular environment, and you can't separate the person from that environment. And when you're looking at someone full face, for example, you aren't thinking about what's behind his face; you aren't thinking conceptually, you're thinking visually. There's more illusion involved than when you're working with real volume. With sculpture – in the first place I'm the slave of a tradition, because for me as for everyone else realistic sculputure, sculpture that is like a head, means a Greek or Roman head, therefore one seen as a volume, as a sphere, as the equivalent of reality itself. Even Rodin still took measurements when he was making his busts. He didn't model a head as he actually saw it in space, at a certain distance, as I see you now with this distance between us. He really wanted to make a parallel in clay, the exact equivalent of the head's volume in space. So basically it wasn't visual but conceptual. He knew it was round before he began: that's to say, he started from the conventional idea of a head that had prevailed in all European sculpture since the time of the Greeks, and made a volume in space unlike anything he actually saw, because in the ordinary way it would never occur to me to get up and walk around you. If I didn't know that your skull had a certain depth, I wouldn't be able to guess it. So, if I made a sculpture of you according to my absolute perception of you, I would make a rather flat, scarcely modulated sculpture that would be much closer to a Cycladic sculpture, which has a stylised look, than to a sculpture by Rodin or Houdon, which has a realistic look. I think we have for so long automatically accepted the received idea of what a sculptured head should look like that we have made ourselves completely incapable of seeing a head as we really see it.

That's why it has become almost impossible for me to do a head from life. I can't even understand how anyone can do a head life size – either in paint-

ing or in sculpture. When I see a life-size head in a picture by Cézanne, or a head by Rodin or Courbet or Titian or anyone else, I can't even conceive how they could have done it. In this respect the scale of the Primitives is much nearer to me. Like Van Eyck, the little Van Eyck with the red turban in the National Gallery: this seems nearer to how I see a head than all the life-size portraits that have been made since.

And heads that are larger than life size?

If it's larger than life size, it's outside our domain. It becomes a monumental thing, and then it's made for a particular site, generally a building. You look at it from far off, and at that distance it becomes small again. If the Egyptians situate sculptures five metres high in front of a temple, you only see them as sculpture when you're forty metres away, so they become small again, like a small sculpture on a table. Large sculpture is only small sculpture blown up. The key sculptures of any of the ancient civilisations are almost all on a small scale. Whether Egyptian or Sumerian or Chinese or prehistoric, they are almost always more or less the same size, and I think that this actually was the size that instinctively seemed right, the size one really sees things. And in the course of history, perception has been mentally transposed into concept. I can do your head life size because I know it's life size. I don't see directly any more, I see you through my knowledge. Actually this has always been the case, but to a greater or lesser degree.

For example, my father, who made portraits from life, made life-size portraits quite instinctively, even if I was sitting for him three metres away. If he did apples on a table, he did them life size. Once, when I was about eighteen or nineteen, I was in his studio drawing some pears that were on a table, at the normal distance for a still life. And the pears kept getting tiny. I'd begin again, and they'd always go back to exactly the same size. My father got irritated and said: 'But just do them as they are, as you see them!' And he corrected them. I tried to do them as he wanted but I couldn't stop myself rubbing out. I kept on rubbing out, and half an hour later they were exactly the same size to the millimetre as the first ones.

Until the war, when I was drawing I always drew things smaller than I

believed I saw them: in other words, when I was drawing I was amazed that everything became so small. But when I wasn't drawing, I felt I saw heads the size they really were. And then, very gradually, and especially since the war, it has become so much a part of my nature, so ingrained, that the way I see when I'm working persists even when I'm not working. I can no longer get a figure back to life size. Sometimes, in a café, I watch the people going by on the opposite pavement and I see them very small, like tiny little statuettes, which I find marvellous. But it's *impossible* for me to imagine that they're life size; at that distance they simply become appearances. If they come nearer, they become a different person. But if they come too close, say two metres away, then I simply don't see them any more. They're no longer life size, they have usurped your whole visual field and you see them as a blur. And if they get closer still, then you can't see anything at all. You've gone from one domain to another. If I look at a woman on the opposite pavement and I see her as very small, I marvel at that little figure walking in space, and then, seeing her still smaller, my field of vision becomes much larger. I see a vast space above and around, which is almost limitless. If I go into a café my field of vision is almost the whole of the café; it becomes immense. I marvel every time I see this space because I can no longer believe in – how can I put it? – a material, absolute reality. Everything is only appearance, isn't it? And if the person comes nearer, I stop looking at her, but she almost stops existing, too. Or else one's emotions become involved: I want to touch her, don't I? Looking has lost all interest.

When you're actually making a sculpture, it's within reach of your fingers. But you make it according to how you see the model in your studio, or a model you might have had in your studio, or someone you've seen in the street – you make it as if you've seen it from a distance. But you aren't distant from the sculpture you're making, you're distant from the person represented by the sculpture, and the dimensions and proportions you give the sculpture correspond to what you saw at a certain distance. The spectator who sees your finished sculpture, though, doesn't necessarily see it at the same distance as you did. And yet it works: the proportions and dimensions are right, or look right. Can you explain this?

They may look right, they may look right, but in actual fact they aren't!

It's all become more complicated in the last month or two. When I'm making a sculpture I can't walk round the model. So I can only make it, say, frontally. But when I make it frontally it's almost impossible to see in depth, to see the angle of the nose in relation to the forehead, in relation to the eyes. Even the sculpture I'm working on becomes almost as illusory as a painting on a canvas. And anyway, in reality we always see in colour, don't we? If I make a sculpture in grey clay or cast in bronze, the impression of thinness is greater; if I paint it it tends to look much more true than if it's not painted. That's why I always feel I want to make painted sculpture.

But you have!

I've always tried, but the form was never sufficiently realised and it isn't worth painting on a thing that doesn't exist. But I fully intend to get around to producing painted heads.

You'd like to make painted sculptures all the time?

Yes. Because sculpture too has suddenly become an illusion. It's no longer an object in bronze or stone, a beautiful material one wants to touch; it has become a questionable or very equivocal object, really, because if it's painted with the colours one chooses, those which are nearest to what one sees, let's say, then the material is of no further interest, it no longer counts. So you can't really touch it any more. It actually becomes a sort of appearance itself. But I'm still working on this by trial and error, so it's very difficult to talk about as I have no idea where it may lead me. I want to make heads from life, push them to the limit, and they'll certainly be much thinner than they have been so far. And if they were painted, they'd quite likely be dreadful. If I managed to do what I was aiming at, it would be something almost intolerable to look at. Although I'm not so sure ...

Why would it be almost intolerable?

Because on the one hand it would seem too real, or give too great an illusion of being real, and then all one would feel was that it couldn't move. That's to say, it's a dead object, isn't it? If you give it eyes, do you paint them? That would be very peculiar, wouldn't it? And if you paint them as if you were looking at them and then they don't move, well, then the head could

become an extremely unpleasant sort of object. And you were talking about my saying that the sculptures of the New Hebrides have a gaze without having eyes: well, no one can ever be upset by that. But if I really model an eye and put in a black pupil to try to imitate its brilliance, as the Egyptians did by putting in stones, it's still an illusion in which you have no great belief. Even with the Scribe, fine as it is, the eyes still have a strange effect, and you can only stand that because it isn't as real as you'd supposed at first. It's very complicated. You still see it as real because its pent-up energy is what matters. Or its tension. So tension takes the place of movement; it's as if it *were* movement. And then the thing becomes tolerable.

You're always saying that you yourself find these proportions too narrow, but that whether you like it or not, that's the way they always come out.

At one time I wanted to hold on to the volume, and they became so tiny that they used to disappear. After that I wanted to hold on to a certain height, and they became narrow. But this was despite myself, even if I fought against it. And I did fight against it; I tried to make them broader. The more I tried to make them broader, the narrower they got. But the real explanation is something I don't know, I don't know yet. I can only know it through the work that I'm going to do in the future. But so far there is no doubt that a head with proportions that don't look true seems more alive than a head whose proportions look more true – which is worrying me a great deal at this moment.

I've heard you say, for example, while you were working on a standing figure, that the more you take away, the bigger it gets. Do you know at all why this happens?

What I do know is that more than ever, the more I take away, the bigger it gets. But as to why, I still don't know. Because, in the bust I'm doing at the moment, I never stop taking away, yet it's so big that I have the impression that it's twice as thick again as it really is. So I have to go on taking more and more away. And then, well, I just don't know. That's where I really get lost. It's as if the actual material were becoming illusory. You have a certain mass of clay, and at first you have the impression that you're making it more or less the right volume. And then, to make it more like, you take away. You do

nothing but take away. It goes on getting bigger. But then it's as if you could stretch the actual material to infinity, isn't it? If you work on a little bit of unworked clay, it gets to look bigger. The more you work on it, the bigger it gets, doesn't it?

Yes, that's true.

It *is* true! So every little speck of clay must be worked on, it mustn't stay dead, and then obviously a very small amount of clay would be enough to make a head of about normal size. But in that case everything seems to become absurd.

There may perhaps be an explanation: it's possible that when the thing is narrower, and therefore denser, it has more pent-up energy. And if this energy, this contained violence, goes on increasing, you have the impression that the sculpture dominates more space. And the more space it dominates, the bigger it seems. Could it be that?

There is that, probably, and then there's another thing, which is that, in fact, if I copy exactly the surface of a head in a sculpture, what has it got inside it? A great mass of dead clay! In a living head, the inside is as organic as the surface, isn't it? So a head that looks real, a head by Houdon, for instance, is in fact like a bridge, in that its surface looks like a head but you have the feeling that the inside is empty, if it's in terracotta. And if it's in stone, that it's a lump of stone. But the fact that it's empty or a lump of stone already makes it false, because it isn't at all like, since there isn't a millimetre inside your skull that isn't organic. Therefore, in a certain sense, heads that are narrow have just enough clay to hold them together: the inside is abso-lutely necessary. It's necessarily more like a living head than if it were a copy of the outside. And this is actually why I think that while it may be possible to do a painting that is like a head, I'm no longer at all sure that it's possible in sculpture. This very afternoon at the British Museum, looking at the Greek sculptures, I felt that they were great boulders, but dead boulders. When I see someone looking at them, the person looking at them has no thickness and seems like an appearance which is almost transparent – and light. The very weight of the mass is false. What makes a being alive is that even if he is very fat he can stand very lightly on a single toe; he can dance on it, can't he? So

one of the reasons why I have made life-size figures that became extremely thin must be that for them to be real they needed to be light enough for me to be able to pick them up, pick them up with one hand and put them in a taxi next to me. Whereas with a sculpture by Maillol — I don't say this to criticise Maillol — but, with a life-size sculpture by Maillol, if it takes four men with machines to move it, isn't that enough to make it false to start with? The problem is to find the real through external appearances.

And the problem is still more difficult when sculptures are painted with naturalistic colours, because then you have bronze inside and on the surface a very precise illusion. So in that sense, it's still more false!

Yes and no. For example, a sculpture that has a narrow look when it isn't painted, as soon as you paint it it seems to get more like the way we see things. Whereas if I made it broader and then painted it, I still don't know what would happen. To be able to paint it, it may be that the volume has to be more reduced than one would think. Because a light colour dilates, dilates a volume (you can see that on a canvas, can't you?). So the sculpture probably has to be narrower than one at first thinks it should be, so that it can come out right once it's painted. But these are things I don't know about. What I do know is that, if I want to do an eye as I see it, so far I've never succeeded. I've never succeeded in sculpture – or in painting either, but still less in sculpture – because if you look at it from the front, it doesn't seem very convex, it seems rather to have an elongated oval form. If one looks at it from the side, though, it seems to slice through the air, doesn't it? So it's two completely contradictory things, and in reality it's actually round and pointed at the same time. So how can you do something that's both round and pointed at the same time? You'd think that if you have some clay and you look at a face from the front in a good light, it ought to be possible to make the curve of an eye, to model it as you see it. Yet that seems to me the most impossible thing in the world. Impossible not only for me, but for always, and for everyone. The only eyes that seem to me at all like are those of the sculptures that people consider the most stylised – above all, Egyptian sculptures, but also Byzantine ones, to some extent. Compared to these, the eyes

of almost every stone sculpture ever made aren't very real.

Actually, you've painted sculptures quite often, but intermittently, haven't you?

Not long after I'd begun to do sculpture I did paint a few, but then I destroyed them all. I repeated this at times. In 1950 I painted a whole series of sculptures. But as you paint them you see what's wrong with the form. And there's no point in painting something you don't believe in. I tried again, only a month ago. Painting them brings out the deficiency in the form. Well, I can't waste time fooling myself that I've achieved something by painting it if there's nothing underneath. So I have to sacrifice the painting and try and do the form. In the same way as I have to sacrifice the whole figure to try and do the head. And as I have to sacrifice the whole landscape to try and do one leaf. And as I have to sacrifice all objects to do a glass. You can only get to do anything by limiting yourself to an extremely small field. Up till only a year ago I believed it was much easier to draw a tablecloth than a head. I still think so, in theory. But a few months ago I spent three or four days simply trying to draw the cloth on a round table, and it seemed to me totally impossible to draw it as I saw it. I should really not have given up on the tablecloth until I had got a better idea of whether I could do it or not. But in that case I would have had to sacrifice painting, sculpture, heads and everything else, confine myself to a single room and reduce my entire activity to sitting in front of the same table, the same cloth and the same chair. And it's easy to foresee that the more I tried, the more difficult it would become. So I'd be reducing my life to practically nothing. That would be a bit worrying, though, because one doesn't want to sacrifice everything! Yet it's the only thing one ought to do. Perhaps. I don't know.

At any rate, since I've become much more responsive to the distance between a table and a chair — fifty centimetres — a room, any room, has become infinitely larger than before. In a way it's become as vast as the world. So it's all I need to live in. So that has gradually put an end to going for walks. That's why I don't go for walks any more. When I go out, it's to go to the café, which is necessary, and then I prefer to go by car rather than on foot, since it's no longer for the pleasure of taking a walk. The pleasure of an

outing to the forest has completely disappeared for me, because one tree on a Paris pavement is already enough. One tree is enough for me; the thought of seeing two is frightening. While I used to want to travel, these days it makes no difference to me whether I do or not. I am less interested in seeing things because a glass on a table astounds me much more than it used to.

If the glass there in front of me astounds me more than all the glasses I've seen in painting, and if I even think that the greatest architectural wonder of the world couldn't affect me more than this glass, it's really not worth while going to the Indies to see some temple or other when I have as much and more right in front of me. But then, if this glass becomes the greatest wonder of the world, all the glasses on earth equally become the greatest wonder of the world. But so does every other object. So, in limiting yourself to a single glass, you have much more of an idea of every other object than if you wanted to do everything. In having half a centimetre of something, you have more chance of getting some feeling of the universe than if you claim to embrace the whole sky. On the other hand, simply trying to draw a glass as you see it seems rather a modest enterprise. But then, as you know that's practically impossible, you no longer even know whether it's modesty or pride. So you come full circle.

It's a matter of complete indifference to me whether a work is a success or not. Success or failure in a painting, success or failure in a drawing – none of that means a thing. A failure interests me just as much as a success. And we ought to exhibit our less good works rather than choose the best. Because if the less good hold up, then the good ones certainly will. If, on the other hand, you choose the ones that seem to be the best, you're deluding yourself. Because if there are others hidden away that aren't so good and don't hold up, even if you don't show them they still exist. And if someone looks very carefully he can see weaknesses even in the best of them. So we should start with the poorest.

* * *

133

What's the essential difference for you between working from life and working on the same subject from memory?

Memory is short, very short. When you look at reality, it's so much more complex, and when you try to do the same thing again from memory, you realise how little you remember. So the work becomes simpler because there's less of it, but at the same time you also achieve less. It's less interesting. But there again I really don't know where I am for the moment.

When you're working from memory on standing women, for instance, every time you remake them you usually make them very, very quickly, don't you?

Yes. Because the aim is in fact fairly limited. On the whole, what matters is getting certain proportions right. It's not a question of doing something precise or of trying to understand what one sees; it's more the realisation of an effect, which should be fairly simple and not make more of the thing than can really be taken in at a glance. So here, obviously, you go very fast and can hardly have any second thoughts. You would have to demolish the entire sculpture and remake it as it was.

So when we see, say, a standing woman, this sculpture cast in bronze has possibly been made in a couple of hours but had already been done perhaps fifty or a hundred times.

Yes, certainly.

Do you know whether you need this constant repetition for personal reasons or for artistic reasons? And when you've redone something fifty times, is it decidedly better the fiftieth time than it was the twentieth?

Absolutely not. Maybe no better than the first time. It's rather that in realising something very quickly and in a way successfully, I mistrust the very speed. That's to say, I want to begin again to see if it'll succeed as well the second time. The second time, it never succeeds as well; it begins to fall apart. So the original one is the best. But as I don't feel like leaving it, I go back to it. And when I stop, it's not at all that I consider it more complete or better; it's because that work is no longer necessary to me for the moment. That's to say, I actually stop on the very day the work would just be beginning.

You seem to take your work from life much more seriously than your work from memory.

Not more seriously, that's not the word; it's only that it fascinates me more. In the first place it's more difficult. I fail, and that actually helps me: I get to know more about what I'm looking at.

All the same, you still need to work on things from memory?

More or less. Nowadays, I do it very little.

But doesn't working from memory to get an idea of what you've seen help you when you begin working from life again?

Oh yes, certainly. It's even absolutely necessary. That's why I always, or very often, work in parallel on the same head both from life and from memory. It always helps me. Or even if it's not the same model, even if it's two heads of two different people, one from memory and the other from life, it's exactly the same pursuit; I have to try to understand the same thing. And if I make some progress from memory, it opens up more possibilities when I'm working from life. That's quite certain.

So far, the sculptures you've done from memory have generally been narrower than those done from life.

On the whole, yes. Because they get narrow despite myself. From life, they do this less. But, in fact, working from life I've never pushed things far enough. And that's what I'm going to try and do now. But in any case, I know that I've made very few sculptures of whole figures from life; I haven't sculpted a nude from life for nearly ten years. So I'm looking forward to starting again. But I realise today that the ones I did ten years ago have at least three times too much substance; I'm sure of that. The ones done from memory probably have too little. But the truth lies between the two – the relative truth of perception, anyway. And that's why I'm now trying to work on a figure, not a big one, from life as best I can, and I'm going to push it as far as possible from memory, have a plaster cast made without destroying it, and then go on working on it from life and see where the difference begins, with the idea that the difference shouldn't be all that great. But I'm still not altogether sure about this. It's the same thing with the heads from life: they have three or four times too much substance. The ones from memory are more right in a way. But none of them is really right, which is why one has

to go on trying. For me, working from memory is just a matter of trying when I'm alone to remake things I've seen. Because in working from life, you always see much more than you can cope with, so you get lost in too many complications. In working from memory, you try to retain what has struck you most forcibly. At the same time it helps you to go on working from life. Ultimately, my idea would be to work in exactly the same way whether from memory or from life – that the two should overlap completely.

Was the very large head of Diego of 1960 done from memory?

It was done from memory and it isn't right, inasmuch as it doesn't at all correspond to what I saw. It's almost as if I was thinking back to pieces of Roman sculpture, probably to a head I saw in 1920 in a piazza in Rome which made a great impression on me. It's a sort of nostalgia for a kind of sculpture that used to be done but which I can't do any more. But to be sure that you can't do it any more you have to go on trying, so I tried to do it on this scale. In fact it's completely ambiguous; it doesn't quite correspond to what I saw. And that's why I'd like to do it again some day.

And what about the four tall figures of women, nearly three metres high?

They were done in the same way as the head, in a sort of nostalgia for large outdoor sculpture. Anyway, I had always rather wanted to know how large a piece I could do. So, when an architect suggested that I should make some sculptures for a piazza I accepted, because it was a good way of settling the question. I'm absolutely against the current practice of making small sculpture and enlarging it mechanically. Either I can make it myself as big as I want to or I can't. I could easily agree to having it enlarged mechanically if it's only to speed things up, but I must also be capable of doing without mechanical aids, mustn't I? And I should be interested to discover the maximum height that I could do by hand. Well, maximum height, that's precisely what the tall women are. They're already almost beyond all possibility, and in that case we're talking about something completely imaginary. But then it would become easy again! That's to say, if I wanted a sculpture twenty metres tall to be something like a figure, I know beforehand that I'd make some-

thing long and fairly thin, almost smooth, rather like a plank, leaning forward a little, with a small knob on top, and looking down. But that's another thing really, practically decorative sculpture. Perhaps not entirely decorative, but another thing altogether.

You intended to make a composition for a piazza with these large sculptures, with a standing woman, a walking man and a head. And you did make them, but did you ever group them together?

I made four tall women, two walking men and two heads. Then, as none of them came right, the initial idea of the composition took second place. And I had practically no feelings about how they should be grouped. The two walking men are the only two remaining ones out of at least forty which were neither better nor worse. They are fairly different from one another. The four women too were the only remaining ones out of ten; the others were destroyed. But I haven't solved the problem and I gave up the whole idea when I saw that if I was ever going to realise them I would have to devote myself to them for years. It wasn't worth it; I was making more progress when I was simply trying to start by doing a head from life rather than attempting a large sculpture that would impress by its size. For size does play a part, though you may think it an unfortunate part. We are impressed by something very large even if it isn't very good. If the same sculpture were smaller and of equal quality, we wouldn't take much notice of it. Besides, if I made that large sculpture, what would happen to that head up there? There's no telling, is there? Because you can't model it as you model a head from life. But the problem interests me much less because in the first place it's easier, and then it's much more an architectural thing. That's to say, if you have a feeling of height in relation to a certain space, the question of whether it's a bit better or not becomes secondary. It's the relationship that matters, so it becomes almost entirely the qualities of the proportions, and this isn't strictly a sculptural but more or less an architectural thing.

Usually when you do a figure you can see the whole figure you're making, but when you were working on the the tall women, weren't you too close to see the whole?

No, that's a complete misconception! In the sense that one needs much less space to make a large figure than a small one. If I do a sculpture fifty

centimetres high I need to keep stepping back four or five metres to see it, don't I? If I do a sculpture three metres high, like those I've done, I do it in the same studio – you know how small it is – almost without stepping back.

Yes, but then you can't see the whole!

It's not necessary. You see it all the same. At first you think you need less space to do a small thing and much more to do a big one, but it's the opposite. A very large sculpture can be made in a very small space, but all the same you need a reasonable space to make a small one.

No, I wasn't necessarily talking about the possibility of stepping back; what I meant was that when you're working on a small sculpture even without stepping back, when you have your hands on the clay you can see the whole. But when you did the big ones and were near enough to work on them, you couldn't see the whole, could you?

It doesn't make a great deal of difference; much less than you might think; hardly any. I had the idea of the whole even when only stepping back a very, very little. Because the very fact that they are much larger than life turns the whole back into a concept; it isn't a percept of the outside world, it's already something I have imagined. I can already see its size and the proportions in my head. So almost all I have to do is carry out what is already there.

As, for instance, when you did the Leg or the Cat?

Yes, but the Leg is resolved, for better or worse. Whether better or worse, it is what it is. So is the Cat. On the other hand, the tall women could be slightly different from what they are; in short, they aren't resolved. For that to happen they'd need working on, and I find it a waste of time for the moment. Maybe I'll come back to them one day ... On the other hand, to do a head from life would be impossible without all that work beforehand, even if it has to be done all over again at each sitting, and even if all that remains at the end was done in one go. So you never efface. Even if you think you've effaced what you did in the previous days it isn't true, you haven't undone it. The little bit that was successful remains. And that's why it's much more fascinating for me than doing large figures which impress people. That's really why I stopped and don't want to go on. The largest sculpture I

want to do now would be just smaller than life, like someone seen from three metres away. I still don't know what might come of it, but larger than that doesn't interest me at all any more. I know how it's done, I know that tomorrow I could easily do a large figure in a couple of hours that would certainly be a bit better than those I made in 1960. But it would only be to create an effect, really, and it's not worth wasting my time trying to do it. So that's the end of the story. After all, I stopped work on the large figures one day because, when I saw I was wasting my time, I had them cast so as to make the break final, and then some time later I thought I'd destroy them, but in the meantime I left them at the foundry. For two years, in fact. When I took them back I decided not to destroy them; I told myself, 'They were studies done at a certain time, they were useful to me, so I'll keep them.' Anyway, even if they *are* big, at least there's nothing monumental and massive about them. But I never thought they were successful; they were failures. So if anyone wants to give them any importance now, it's totally exaggerated in relation to the rest of my work, and solely because they're big, and that's a totally idiotic, primitive reason. It is quite simply a kind of megalomania. You make big objects because you imagine that by doing so you become bigger yourself. Whether they are sculptures, buildings, churches, large frescos or anything else, their purpose must be to give people the feeling of being more powerful than they actually are. Exaltation of oneself, or of oneself and others, that's to say for reasons that have nothing to do with formal considerations, is defensible, though. But it's rather primitive, like the child's wish to conquer the world: the more you have, the happier you are. But here we ourselves are being childish – which we are anyway most of the time.

* * *

When you began working from memory in 1925, wasn't it because you were beginning to despair of your work from life?

I wasn't actually in despair, I just thought it was a total impossibility. No, I wasn't in despair. If you want to jump as high as the moon and are stupid

enough to believe you can, one fine day you realise it's hopeless, so you forget about it. It's completely idiotic to get desperate. It was just impossible for me, so it didn't even make me sad. It's impossible and that's that. It didn't interest me any more. But at the same time other painting also interested me less. I lost almost all interest in surrealist painting. And while I may have made sculptural objects either as a vague recollection of what I had made from life, or to express sensations or ideas, that after all was only an exercise which I knew beforehand would soon be over – which cancelled it out – and I knew that the time would very soon come when either I wouldn't be able to do anything any more or I would have to sit down in front of a model again and copy from life. When I managed to do an entirely abstract sculpture, well, the adventure was over. I could only go on repeating myself. I had to start again from life, and since other solutions didn't exist – for me, at least – there was nothing for it but to try to work, but without any guarantee. It's all the same to me whether it produces results or not, since I myself gain from it. I gain from working, because I have the feeling, or at least the illusion, that every day reality looks a little different to me, and always a little more fascinating. And this helps me to think, and to see works of the past in a different way. For instance, when I was looking at the Rodin busts in the Tate Gallery just now, I saw them in a different way from before simply because I had done good work on busts for a fortnight. So I saw what worked in the Rodin ones and what didn't. So for me personally it's a worthwhile study. As for other people, I really don't care whether it interests them or not.

Did you care whether your surrealist works interested other people or not?

At the time I did. I wanted them to be interesting. It was just like having to write an article when you're trying to communicate something to people. So I did realise them, but not just for myself. It was firstly so that the objects would exist, but also so that other people would see them. I had a need of other people, and I was very conscious of reaching them or not. Now, on the other hand, I don't much care whether they like them or not. Nobody can think any worse of them than I do, so I can't expect others to like something

that I myself think barely worked on or very mediocre.

Are there any of your surrealist works that you still like?

Oh, all of them ... in a way.

In what way?

At the time, they were necessary. All the ones I made were necessary to my work, so I don't repudiate them because it is precisely through them that I managed to begin my work again in a different light. And then, I made them from memory, so there's bound to be something in common with everything I've done from the first thing right up to the present day. Even with those that look the most different from each other. After all, our way of seeing ... and here I come back to the fact that our way of seeing doesn't change so very much – or, rather, our sensibility. Our limitations are really fairly narrow. Anyway, given that I am what I am, I can only do that and nothing else. It's always extremely limited. Like the fact that you can only survive with a temperature of – what – between 36 and 39 degrees – and that's already very very bad. So you can only really live with a temperature of between 36.8 and 37.8. And everything's like that.

Was the fantasy side of your surrealist work influenced by the surrealist movement, its iconography, and, even, say, its feelings? How far were you influenced by it?

By Surrealism? Not at all, I could say. Not by Surrealism. But on the other hand I was certainly very definitely influenced by modern art in general and by those forms of art, whether archaic or exotic, that interested me at the time, even if it was unconsciously. But not especially by surrealist works, which I didn't actually like very much. I only stayed with the Surrealists three or four years, and I was working with the abstract painters as well, Hélion among others. I never considered myself as someone actually realising surrealist works, as was the case with others who remained Surrealists. For them it was their genuine aim, but for me it was more like a transitional exercise. And I have always felt myself rather remote from them, really. Besides, there were hardly any other surrealist sculptors: Arp, yes, but I hadn't much in common with him. A little. On the other hand, there was clearly a surrealist atmosphere that had influenced me. For instance, in *The palace at 4*

a.m. or in *The invisible object* there was certainly a common atmosphere. If I hadn't felt something or other in common there wouldn't have been any reason for me to approach them. They might have been completely indifferent to me, or I might even have refused to accept them. The fact that I was interested in them meant that we had something in common. And maybe it's still there, somewhere ...

In 1933 you wrote an article in which you said that for years you had only made sculptures which already existed ready-made in your mind, and which you wanted to realise in space. Wasn't this a rather visionary kind of art?

No, it was different. It was an exercise. I wanted to know if something could be imagined so precisely that it could be made exactly as imagined. And that's a very long exercise, because you can be mistaken. You begin by being utterly mistaken, you think you see it clearly, but when you want to do it, the whole thing has disappeared. I know I spoke to another sculptor of this attempt to realise exactly what I saw in my mind. He said it was impossible; he said that if you really begin to realise it, your way of seeing changes. And you discover that the vision you thought you had was very very vague, that it has to be transformed in order to be realised. Personally, I was convinced of the opposite. So it was almost an exercise in style. Something like bringing off a circus turn. But at that time I really had managed to do what I wanted.

You really had?

Absolutely.

Managed to do what you had ...?

In every detail. For instance, *The palace at* 4 a.m. is fairly complicated. I knew to the nearest millimetre how it ought to be. I didn't retouch a thing. I made it in one go just as it is.

What about the visions you had in your head? Did they mostly come to you in a flash, or had they evolved over a period of time?

They had evolved over a time, and they were always very complex. There were probably several impressions, each completely independent of the others, which finally crystallised into the vision of an object. For instance,

there was the connection with what I had just done; if I had just made something very smooth like the surface of a cheek, I'd want to do the complete opposite and make the skeleton of something. To alternate, as it were. There were things I saw that impressed me. There were always several motives together which finally took shape. And, besides these, unconscious ones, which will always be unconscious, because even if I do what I want to do, this desire is fairly mechanical. I don't actually much believe either in choice or in free will, or if one does have free will, it's in spite of oneself. It's somewhere between obsession and will; in any case as far as sculpture is concerned, there's no difference. Or hardly any. I can't not do what I do. So I have no choice. But why is that? It may be because of deficiencies, even physical ones, the need to complete oneself by realising something outside oneself.

There is one aspect of Surrealism that has remained with you. About 1950, when you made those compositions with several figures – The Glade and The Forest – in which you had several figurines which were on the floor of your studio and which you took just as they were and made into compositions, weren't you working according to chance, as the Surrealists did?

No, that's where you're wrong. During my surrealist period, I never would accept any chance factor. In the first place, I never have believed in chance, either then or now. I don't even know what the word means. And in the constructions I made there was no chance – or at any rate I didn't accept it. And later, when I made a composition of the figures that had been put on the floor, supposedly by chance – does anybody really put something down by chance? Personally I just don't believe it. You put them down in spite of yourself in a certain order, after all. When I put a glass of water on a table, even just because I need to put it down, I always tend to put it in one place rather than another. I never put it on the edge, I'd hate to see it on the edge, or in the middle. I'll always put it down very instinctively, which is – how shall I put it? – the most nearly necessary way. Or even in a certain pattern.

But you do that without thinking?

Yes. Because if I think about it ...

But that's just what automatism is. You happen on a pattern without thinking.

Yes, but when you come to think of it, three-quarters of what you do throughout the day, no, ninety-nine per cent, is automatic. Actually, so many things have been ascribed to Surrealism that I really don't know any longer what it means – except for a special atmosphere at a certain time, something very vague which was common at that time and was just as political and mental as it was artistic. Nothing at all precise. When they wanted to go in for automatism, well, they didn't do very much. Nobody works in a less automatic manner than Breton. And all the others ... And the artists – on the whole they were as far from being automatic as anyone could be. When they say Dalí is surrealist and Arp and Max Ernst and Miró, actually it's very difficult to see what they have in common. And when they do have something in common, they share it with many others who aren't Surrealists, with all the abstract painters or Cubists or Constructivists or whatever. I really don't know what one could put one's finger on apart from certain common ideas and principles. For instance, politics played a very important part at the time, and atheism, and nonconformity. But quite a number of other people who had no direct connection with the surrealist group had this in common with them. And then Surrealism did last for quite a time, but what became of them afterwards? If you take the chief ones, like Eluard, Breton, Aragon, Queneau, Leiris, when they met they had all come from different backgrounds. They had something in common for a while, and then they went off again. So that Aragon today is as far as possible from the work Breton or Queneau are doing. Leiris is absolutely on his own. Eluard has found his niche as a poet in a certain tradition of French poetry. And anyway, the main part of their work has tended to be what they did later, rather than what they did during their youth in the surrealist group.

Why do you think the surrealist group was formed?

In the first place I joined them very late, almost at the end, really. When it began it was quite probably post-war youth, the influence of Apollinaire certainly, and of modern art in general.

There was one thing they wanted to stress – the importance of the subject. From the point of view of iconography, the subject wasn't of much importance for the Cubists. They painted a still

life with a guitar in much the same spirit as they painted a woman playing a guitar. But with the Surrealists it was different.

Certainly, and that was why I joined them. And personally, I still insist on the importance of the subject.

In that sense?

Not exactly in the same sense, but I insisted on it both before, during and afterwards. And now more than ever.

But one thing that came out of the Surrealists' insistence on the subject was the importance of titles and their poetic and evocative character. That was true for you, I think, with titles like No more play *and* The Palace at 4 a.m..

Yes, but it wasn't gratuitous poetry. *The Palace at 4 a.m.* was called that because it represented a palace and because I did it at 4 a.m., that is, really conceived it and saw it, at 4 a.m. When I made *No more play* there was a little grave in the middle, with a skeleton inside and two figurines separated from each other in a sort of bowl, in which they couldn't move. So it was quite simply and literally the title, the indication of what it was meant to be. If it became poetic or poetically evocative, that was almost in spite of myself.

What about The time of footsteps?

Ah, yes, That was certainly wholly influenced by the surrealist spirit of the time. Besides, I'm not even sure that it was I who thought of the title.

Did the titles usually come after the works?

Usually, because the only need for titles came when I showed them. I had no need myself for titles. Or very little.

It's certain that for Max Ernst and Dalí the title is essential.

Yes, but it never was for me. The sculpture for which it was essential was *No more play*. Or again, *Point to the eye*, which is a sort of point that just touches a small skull. But in that case it was no more poetic or invented than a glass on a table. *Suspended sphere* is nothing more than a ball hung on a cord. It might seem poetic but only because it's less common than a glass on a table. That's the only difference. For the things I did afterwards – for example, *Figurine in a box*, with the woman walking between two houses – I would probably have tried to find a more poetical title during the surrealist period. Although I'm

not so sure. And I can't even tell, because I wouldn't have been able to do it during the surrealist period.

Weren't these rather poetic titles, titles full of atmosphere, a way of somehow completing, of giving more meaning to, something which didn't go far enough for you?

It may perhaps have been simply to complete it ... Once again, what brought me close to the Surrealists was something I had in common wth them – nothing more than a kind of revolt against the recent past. Like the youth of today and of every generation. And this was at every level. What interested me in them was much more the political and moral attitude than the artistic one. And I was also interested to get to know them. I know that one of the reasons I wanted to meet Aragon or Sadoul was the fact that they had just come back from Russia, so I could find out what they thought about it. But it was also the political question that finally alienated me from them because for many of them it was a kind of intellectual game, marginal politics.

<p style="text-align:center">* * *</p>

I remember I once asked you which, of all the paintings you had seen, you considered the closest to reality. You replied, Egyptian paintings with trees. Before you copied them you thought they tended to be a bit schematic, rather than very like. But after you had copied them, or while you were copying them, you realised how like they were.

Yes, that's true. And I still find that, in painting, the arm which looks most like an arm to me remains an Egyptian arm – that is, in an art which at first glance seems the most stylised. But here, I still don't know why. There were some moments when practically everything that had been done in the past interested me. It came towards me, interested me, and then went away again; at any rate, with the things that have remained permanent, like Egyptian and Byzantine painting, which still fascinate me, or the portraits of Fayum or the Roman paintings at Pompeii. In any case, the painting which is the most remote for me and which seems to me the least like is the painting that is usually considered the most realistic and like, the painting done after the

Renaissance.

Including the Impressionists?

No, up till the Impressionists. In them there is after all something which affects me more, even though ...

Do you know why antique or Byzantine painting is more like than that of the Renaissance?

Yes. It's in the painting itself. The way the nose sticks out in a Byzantine head is more like the way I see it than in any painting whatever since the Renaissance. Including Rembrandt. The construction of an eye is more like in a Byzantine painting, for me at any rate, than in all the painting done since, which I don't understand much. When I first saw a painting by Cimabue, who ultimately stayed closer to the Byzantine tradition than the other painters of the Renaissance, I immediately liked it better than all the paintings done since that I have seen.

Did you prefer it because it was more like?

That's right. The only reason. And if I like Cézanne very much it's because he's more like things done before the Renaissance than since, and the only one more or less since Giotto who has this quality.

Not Velásquez, Rembrandt or Chardin?

Much less.

Do you know why?

I know why the big nudes, for instance, the compositions of big nudes, seem to me closer to the Romanesque tympana in French cathedrals than the nudes of the Renaissance; it's because I find them simply more like.

But can you explain why?

Take the Man in the red waistcoat; the proportion between the head and arm, which looks too long to some people, is nearer to the proportions in Byzantine painting than in all the painting since the Renaissance. You've only to look at it. It seems odd, you think it's elongated, as you think Byzantine paintings are elongated. But to my mind it is more real than any other painting.

Is the reason why you find Renaissance and post-Renaissance works less like because they tried to make it like by accumulating details?

Not necessarily.

To do an eye that looks like, and then a nose, and then a mouth – can it be that?

Not necessarily, no. It's a way of seeing that is foreign to me, that's all. Why is it foreign to me? That's very difficult to say. Perhaps because it seems superficial and willed. At any rate, when I look at you, you look more like a Byzantine head or a Cézanne head than a Titian. But how can I explain it? I can't explain why my nose is one shape and yours another.

That means that the idea of what looks like becomes completely subjective.

Of course it's subjective. It is for everyone and has always been so. That is, it only becomes objective when several people find the same thing like. But for the person who did it it was merely strictly subjective. When I'm copying from life, I only copy what stays in my consciousness. It's direct, so it's totally subjective. When you look at art made by other people, you see what you need to see in it. Partly, you look for what it contains – either what is the most useful or the closest to you, in spite of yourself. If the first time I saw a Cimabue I was enthusiastic, it was because I found it more like. But the fundamental reason why I found it more like is almost inexplicable.

Granted that there are certain things in art where our judgments are necessarily subjective, we still believe that the quality of looking 'like' is something fairly universal, don't we? In a certain period ...

No. Taste for things of the past evolves, doesn't it? What was a masterpiece a hundred years ago is no longer so today. While everyone today goes into raptures about Cycladic figures, a hundred years ago everyone would have laughed. And a hundred years from now, they'll laugh again.

But do people go into raptures because they find it more like or for other reasons?

Because it's more like. I think the fact of seeing things as like is unconsciously much deeper than one would think. I know in my own work ... I try to do busts from life, and when everyone gets interested and buys them it's because they think they're complete inventions. But I personally think that, involuntarily and unconsciously, without realising it, they see something in them, or feel something in them, that looks like reality.

148

Biographical Note

Giovanni Alberto Giacometti was born on 10 October, 1901, the eldest child of Giovanni Giacometti, the painter (1868-1933), and his wife Annetta Stampa (1872-1964), whose other children were Diego (1902-1985), Ottilia (1904-1937) and Bruno (b.1907). Both sides of the family were natives of the Val Bregaglia in the canton of Grisons, Switzerland, which is to say Italian by race, Protestant by religion. Alberto was born at his mother's village, Borgonovo, brought up at his father's, Stampa, just down the road, and at a summer house in Maloja, at the head of the pass.

In 1910 he began to draw from life, in 1913 started painting in oils and in 1914 made his first sculpture. From 1915 to 1919 he was at secondary school as a boarder at the cantonal capital, Chur, where he acquired French and German.

In the autumn of 1919 he moved to Geneva, where he studied sculpture at both the Ecole des Beaux-Arts and the Ecole des Arts et Métiers. In the spring of 1920 he accompanied his father on a trip to Venice and Padua. After a few further months in Geneva he returned to Italy alone and spent nine months there, mainly in Florence and Rome, filling numerous sketchbooks with copies.

On 9 January 1922 he arrived in Paris to continue his studies. He remained there for the rest of his life but spent part of virtually every year at Stampa and Maloja, and he retained his Swiss citizenship.

From 1922 to 1925 he worked from the model in Bourdelle's class at the Academie de la Grande Chaumière, doing sculpture in the morning and drawing in the afternoons. In 1925 he decided to give up working from life and took a studio at 37 rue Froidevaux together with his brother Diego, who started giving him technical assistance. In 1927 they moved to 46 rue Hippolyte Maindron, off the rue d'Alésia, where they stayed for the remainder of their lives.

In 1929 he signed a contract with Pierre Loeb of the Galerie Pierre. After exhibiting there with Miró and Arp the following year, he was invited to become a member of the surrealist group and accepted. He also started working, in collaboration with Diego, for Jean Michel-Frank, the interior decorator, designing lamps, vases and other household goods.

In 1931 he was first published as a writer, in Le Surréalisme au Service de la Révolution. When Aragon broke away from the Surrealists in 1932 on the grounds that they were counter-revolutionary, Giacometti left with him and contributed political drawings to a periodical he founded. After about six months Giacometti rejoined the group.

In 1932 he had his first one-man show, at the Galerie Pierre Colle. He had his first exhibition abroad in 1934, at the Julien Levy Gallery, New York.

In 1934 he started working from the model again, which provoked his expulsion in December from the surrealist group. Till 1939 he made sculpture almost exclusively from the model, mainly from Diego and a professional model called Rita but also, from 1937, Isabel Delmer. When he resumed doing figures and heads from memory, they almost invariably came out on a minute scale, and this state of affairs went on for about seven years.

In 1938 he was run over by a car. He was hospitalised briefly and left permanently disabled. He was therefore exempted, when war broke out in September 1939, from conscription to the Swiss army. He continued his work in Paris – apart from an abortive attempt to leave as the Germans arrived – until the last day of 1941, when he travelled back to Switzerland intending to pay a short visit to his mother. In the event he remained there until September 1945, mainly working in a small hotel room in Geneva.

While there he was seeing Annette Arm. On his return to Paris he lived briefly with Isabel, now Isabel Lambert. In 1946 Annette Arm came to Paris and moved in with him. They were married in 1949.

Though working at sculpture mostly from memory, he was painting and drawing from life, usually from Diego or Annette in Paris and from Annette or his mother at Stampa.

In January 1948 he had his first exhibition for fourteen years, at the Pierre Matisse Gallery in New York, with which he now had a contractual arrangement. He had a second show there in 1950. In 1951 he had the first of his shows with his new Paris dealer, the Galerie Maeght.

In 1953 he resumed doing sculpture from the model, working mainly from Diego but also from Annette. Both were continuing as sitters for paintings; during 1954-55 this function was also performed by Jean Genet. In 1956 he started working from Isaku Yanaihara, a Japanese professor of philosophy who continued sitting for him intermittently until 1960.

In 1955 he crossed the Channel for the first time.

In 1959-60 he made several large sculptures in an abortive attempt to produce a work for the new Chase Manhattan Bank building in New York.

In 1960 he met a prostitute known as Caroline, who became his principal model for paintings for the rest of his life.

In 1963 he had an operation for cancer of the stomach.

In 1964 he started doing sculptures of Eli Lotar, the photographer, who went on sitting for him almost every day.

In the autumn of 1965 he crossed the Atlantic for the first time.

On 5 December 1965 he was hospitalised at Chur. He died on 11 January 1966 and was buried in the churchyard at Borgonovo.

References

'Écrits' is an abbreviation for *Alberto Giacometti: Écrits*, edited by Michel Leiris and Jacques Dupin, Paris, Hermann, 1990. References to it are given here both for material first published there and for all reprints included there of material published elsewhere.

The page references given for quotations from the interview by the present author relate to its publication in translation here.

1. PERPETUATING THE TRANSIENT

page 3 *physical superfluousness* ... Herman Melville, *Moby Dick*, Ch.26
 A blind man ... Giacometti, Untitled poem included in his contribution to a set of 'Témoignages' in *XXe siecle*, n.s. No.2, Paris, January 1952, p. 72 (Écrits, p. 64).

 4 *to give the nearest* ... Giacometti, interview reported by Giovanni di San Lazzaro, 1951, in ibid., p. 71. The quotation comes from a sentence which elsewhere includes an aberration: 'L'important etait de recréer un objet qui put donner la sensation la plus proche de celle ressentie a la vue du sujet'. Giacometti confirmed to me that he actually said 'créer un objet', not 'recréer un objet'.

2. A BLIND MAN IN THE DARK

10 *in every work of art* ... Giacometti, 'A propos de Jacques Callot', *Labyrinthe*, No.6, Geneva, 15 April 1945, p. 3 (Écrits, p. 26).
12 *If this work has a value* ... Ludwig Wittgenstein, *Tractatus Logico-Philosophicus*, London, Kegan Paul, 1922, p. 29.
 it seemed to me ... Giacometti, interview by Georges Charbonnier recorded 3 March 1951, in Georges Charbonnier, *Le Monologue du Peintre*, Paris, Julliard, 1959, p. 163 (Écrits, p. 244).
 it was always disappointing ... Ibid., p. 162-3 (Écrits, p. 244).
 I make them public ... Ludwig Wittgenstein, *Philosophical Investigations*, New York, Macmillan, 1953, p. xi.
 All I can do ... Giacometti, answer dated 17 May 1959 to an inquiry, in Peter Selz, *New Images of Man*, New York, Museum of Modern Art, 1959, p. 68 (which gives an English translation; the original was first published in Écrits, p. 84, and is newly translated here).

3. A TIME-SPACE DISC

13 *The Dream, the Sphinx and the death of T* ... Giacometti, 'Le rêve, le Sphinx et la mort de T.', *Labyrinthe*, No.22, Geneva, 23 December 1946, pp.12-13 (Écrits, pp.27-35).
14 *A disc about two metres* ... Ibid., p. 13 (Écrits, p. 35)
 Once the object ... Giacometti, Response to an inquiry in *Minotaure*, no.3-4, Paris, 12 December 1933, p. 109 (Écrits, p. 17).
15 *reminded me of the corner* ... Giacometti, excerpt from an undated letter written in the autumn of 1950 to Pierre Matisse, in *Alberto Giacometti*, New York, Pierre Matisse Gallery,

153

November 1950, p. 20 (Écrits, p. 59, where two marginal interpolations - given here in parenthesis - are not reproduced).

4. THE RELEVANCE OF OPPOSITES

20 *A blind man* ... Untitled poem, 1952, loc. cit., p. 72 (Écrits, p. 64).
 The nearer one gets ... Giacometti, 'Objets mobiles et muets', *Le Surréalisme au service de la révolution*, No.3, Paris, December 1931, p. 18 (Écrits, p. 2).
 When I'm walking in the street ... Giacometti, quoted in Jean Genet, *L'atelier d'Alberto Giacometti*, Paris, Marc Barbezat, 1953, [p.8].

5. THE RESIDUE OF A VISION

22 *revolted* ... Giacometti, Undated letter to Pierre Matisse written late in 1947, in *Alberto Giacometti. Exhibition of sculptures, paintings, drawings*, New York, Pierre Matisse Gallery, January-February 1948, p. 45 (Écrits, p. 44).
 only when small ... Ibid., p. 45 (Écrits, p. 44).
 only when long ... Ibid., p. 45 (Écrits, p. 44).
 If a picture is true ... In conversation with D.S., August 1960
23 *I have often felt* ... Giacometti, 'Henri Laurens. Un sculpteur vu par un sculpteur', *Labyrinthe*, No.4, Geneva, 15 January 1945, p. 3 (Écrits, p. 23).
25 *the more I take away* ... It was in 1960 that I was especially aware of Giacometti's saying this, in regard to one particular figurine he was doing from memory.
26 *Once, when I was about eighteen* ... Giacometti, Interview by David Sylvester, 1964, p. 212-213 (Écrits, p. 289).
28 *I think that this actually was* ... Ibid., p. 212 (Écrits, p. 288).
 I've often seen them ... Letter to Matisse, 1950, loc. cit., p. 16 (Écrits, p. 57).
29 *Several naked women*Ibid., p. 14 (Écrits, p. 56).
30 *in a sort of nostalgia* ... Interview by D.S., p. 227.
31 *If I look at you* ... Giacometti, 'Pourquoi je suis sculpteur', Interview by André Parinaud, *Arts*, No.873, Paris, 13-19 June 1962, p. 5 (Écrits, p. 271).
33 *he demands an attentive presence* ... Annette Giacometti, in conversation with D.S., 1960.
 One day, when I wanted ... Interview by Charbonnier, 1951, loc. cit., pp.165-6 (Écrits, p. 246).
35 *thought himself impotent* ... Maurice Merleau-Ponty, 'Le Doute de Cézanne', *Sens et Non-Sens*, Paris, Nagel, 1948, p. 33.
 The days pass ... Untitled poem, 1952, loc. cit., p. 72 (Écrits, p. 64).
 Everything we see ... Paul Cézanne, reported in Joachin Gasquet, *Cézanne*, Paris, Bernheim-Jeune, 1926, p. 130.
 It might be supposed ... Interview by Parinaud, loc. cit., p. 5 (Écrits, pp.273-4).

6. TRAPS

39 *Reciprocal harmony* ... Giacometti, notebook entry, c.1925, published posthumously in Écrits, p. 115.
41 *I worked at home* ... Interview by Charbonnier, 1951, loc. cit., pp.162-3 (Écrits, p. 243-4).
 in some way like things ... Ibid., p. 163 (Écrits, p. 244).
43 *it was no longer a question* ... Letter to Matisse, 1947, loc. cit., p. 39 (Écrits, p. 41).
44 *Surrealist objects* ... Salvador Dalí, 'Objets surrealistes', *Le Surréalisme au service de la révolution*, no.3, Paris, December 1931, pp.16-7.

45 *started the fashion* ... Georges Sadoul, 'Giaco', *Les Lettres françaises*, No.1,115, Paris, 20 January 1966, p. 18.

the factors which ... V. André Breton with André Parinaud et al., *Entretiens 1913 1952*, Paris, Gallimard, 1952, chapter XII.

Objects operating symbolically ... Dalí, loc. cit., p. 16.

46 *All things* ... Giacometti, 'Objets mobiles et muets', loc. cit., pp.18-19 (*Écrits*, pp.2-3).

48 *an illusion of movement* ... Letter to Matisse, 1947, loc. cit., p. 37 (*Écrits*, p. 40).

for some years ... Untitled statement in Minotaure, loc. cit., p. 46 (*Écrits*, p. 17).

another sculptor ... V. interview by D.S., p. 233.

50 *reminiscences of those years* ... 'Hier, sables mouvants', *Le Surréalisme au service de la révolution*, no.5, Paris, 15 May 1933, pp.44-5 (*Écrits*, pp.7-9).

a sort of reclining ... Letter to Matisse, 1947, loc. cit., p. 41 (*Écrits*, p. 42).

51 *a contemporary article* ... Christian Zervos, 'Quelques notes sur les sculptures de Giacometti', *Cahiers d'Art*, 7th year, Paris, 1932, pp.337-342.

56 *sensation of a luminous sphere* ... Henri Laurens, loc. cit., p. 3 (*Écrits*, p. 23).

58 *a period of six months* ... Response to an inquiry, in Minotaure, loc. cit., p. 46 (*Écrits*, p. 17-8).

59 *I couldn't bear*In conversation with D.S., 1964.

60 *common nightmare experience* ... In conversation with D.S.

a woman strangled ... Letter to Matisse, 1947, loc. cit., p. 41 (*Écrits*, p. 42).

61 *of interest to others* ... V. interview by D.S., p. 231

everyone who saw this object ... Maurice Nadeau, *Histoire du Surréalisme*, Paris, Editions du Seuil, 1945, Part IV, Chapter 2.

63 *the realisation* ... In conversation with D.S., 1965.

64 *two finds* ... André Breton, *L'Amour fou*, Paris, Gallimard, 1937, p. 37.

everybody knew ... Reported by Simone de Beauvoir, *La Force de l'age*, Paris, Gallimard, 1963.

65 *something simultaneously* ... 'Le Rêve, Le Sphinx et la mort de T.', loc. cit., p. 12 (*Écrits*, p. 30).

I saw anew ... Letter to Matisse, 1947, loc. cit., p. 43 (*Écrits*, p. 43).

masturbation ... Reported, for example, in Marcel Jean, *Histoire de la peinture surrealiste*, Paris, Editions du Seuil, 1959, Chapter VIII.

Nobody likes ... In conversation with D.S., 1965

7. WITH SLIGHT VARIATONS

66 *As a child* ... 'Hier, sables mouvants', *Le Surréalisme au service de la révolution*, no.5, Paris, 15 May 1933, pp.44-5 (*Écrits*, pp.7-9).

68 *a yellow, ivory-yellow, spider* ... 'Le Rêve, le Sphinx et la mort de T.', loc. cit. (*Écrits*, pp.27-35).

75 *I saw myself* ... 'Henri Laurens', loc. cit., p. 3 (*Écrits*, p. 21).

76 *If a picture is true* ... In conversation with D.S., August 1960.

I know it is utterly impossible ... Answer to Peter Selz, loc. cit., p. 68 (*Écrits*, p. 84).

Simply trying to draw a glass ... Interview by D.S., p.224 (*Écrits*, p. 291).

I don't know ... Answer to Peter Selz, loc. cit., p. 68 (*Écrits*, p. 84).

77 *if it takes four men* ... Interview by D.S., p. 217

since there isn't a millimetre ... Ibid., p. 216.

all one would feel ... Ibid., p. 214.

If I didn't know ... Ibid., p. 211 (*Écrits*, p. 288).

one never copies anything ... Interview by Parinaud, loc. cit., p. 5 (*Écrits*, pp.273-4).

8. LOSING AND FINDING

79 the truth lies ... Interview by D.S., p. 226.
 Ultimately, my idea ... Ibid., p. 227.
82 Herbert Matter ... Several states in addition to those reproduced here are illustrated in
 Alberto Giacometti, photographed by Herbert Matter, text by Mercedes Matter, New
 York, Abrams, 1987, pp 48-51.
 James Lord ... Reproduced in A Giacometti Portrait by James Lord, New York, Museum of
 Modern Art, 1965, between pp. 32 and 33.
 That's the terrible thing ... quoted in Ibid., p.10
83 Even when working ... In conversation with D.S., 1964.
 it's not a question ... Interview by D.S., p.225.
84 It's almost a bore ... Interview by Charbonnier, 1951, loc. cit., p. 160-1 (Écrits, p. 242).
85 Absolutely not. ... Interview by D.S., p. 225.
86 As I don't feel ... Ibid., p. 225.
87 I see something ... Interview by Charbonnier, 1957, loc. cit., p. 182.

9. SOMETHING ALTOGETHER UNKNOWN

90 I was terribly conceited ... Interview by Pierre Schneider, 'Ma longue marche', L'Express,
 No. 521, 8 June 1961, p. 48, (Écrits, p. 263).
 the head of the model ... Letter to Matisse, 1947, loc. cit., p. 33 (Écrits, p. 38).
91 the distance between ... Ibid., p. 35 (Écrits, p. 39).
 as a last resort ... Ibid., p. 35 (Écrits, p. 39).
 It was rather a happy time. ... Interview by Schneider, loc. cit., p. 49, (Écrits, p. 264).
 There was a desire ... Letter to Matisse, 1947, loc. cit., p. 43 (Écrits, p. 43).
 I worked from the model ... Ibid., p. 43 (Écrits, p. 43).
92 The more I looked ... Interview by Parinaud, loc. cit., p. 5 (Écrits, p. 272-3).
93 I'm quite incapable ... Giacometti, unpublished letter to Isabel Delmer, [1938].
 The figure is you ... Giacometti, unpublished letter to Isabel Delmer, 30 July 1945.
94 Because the sculpture ... Giacometti, interview by Pierre Dumayet, 'Le drame d'un
 reducteur de tête' Le Nouveau Candide, no.110, Paris, 6-13 June 1963 (Écrits, p. 281).
 principally so as to see ... Letter to Matisse, 1947, loc.cit., p. 43 (Écrits, pp.43-44).
 ten or twelve inches high ... Diego Giacometti, in conversation with D.S., 1966.
 A few days later ... V. James Lord, Giacometti: a biography, New York, Farrar Straus Giroux, 1985,
 pp.213-215.
 The atmosphere of the Occupation ... Giacometti, in conversation with D.S., 1960.
95 the mistake of promising ... Ibid.
 I've been paralysed here ... Giacometti, unpublished letter to Isabel Delmer, 14 May 1947.
 I shall see you soon ... Unpublished letter to Isabel Delmer, 30 July 1945.
96 six matchboxes ... Diego Giacometti, in conversation with D.S., 1966.
97 Before, reality ... Interview by Schneider, loc. cit., pp.49-50 (Écrits, pp.264-5).
98 beginning to see heads ... 'Le Rêve, le Sphinx et la mort de T.', loc. cit., p. 12 (Écrits, p. 30).
 The towel was separate ... Quoted in Genet, op.cit., [p.23].
 25 July ... V. Lord, Giacometti: a biography, p. 268.
 to my surprise ... Letter to Matisse, 1947, loc. cit., p. 45 (Écrits, p. 44).
 I did fight against it ... Interview by D.S., p. 215.
99 mainly because I don't want ... Quoted in Jean-Paul Sartre, 'La recherche de l'absolu', Les Temps

Modernes, Vol.3, No.28, Paris, January 1948.

101 *he felt dubious* ... V. interview by D.S., p. 227-228.

102 *two completely contradictory things* ... Ibid., p. 217.
quite likely be dreadful ... Ibid., p. 214.

103 *something you don't believe in* ... Ibid., p. 218.
very soon left figures ... Letter to Matisse, 1947, loc. cit., p. 43 (Écrits, p. 43).

105 *fell in love with Tintoretto* ... V. ibid., p. 31 (Écrits, p. 37) and 'Mai 1920', Verve, vol.III, no. 27-28, Paris, December 1952, pp.33-34 (Écrits pp.71-73).

106 *simply to copy* ... Interview by Parinaud, loc. cit., p. 5 (Écrits, p. 275).
you have to paint ... Quoted in Genet, op.cit., [p.31].
In spite of everything ... In conversation with D.S., 1950: 'Les Tachistes, quand même.'
conception underlying ... Ibid.: 'La conception reste toujours la meme; c'est seulement les moyens d'expression qui ont change.'

107 *Simply trying* ... Interview by D.S., 224 (Écrits, p. 291).
The distance between any work ... Giacometti, 'Notes sur les copies', passage dated 30 November 1965, Le copie dal passato, Turin, Botero, 1967 (Écrits, p. 98).

108 *Impossible to concentrate* ... Ibid., passage dated 18 October 1965 (Écrits, pp.96-7).
the distance between one side ... Letter to Matisse, 1947, loc. cit., p. 35 (Écrits, p. 39).

109 *a head* ... Ibid., p. 43 (Écrits, p. 43).
If the glass ... Interview by D.S., p. 224 (Écrits, p. 291).

10. A SEPARATE PRESENCE

110 *A blind man* ... Untitled poem, 1952, loc. cit., p. 72 (Écrits, p. 64).
myself hurrying ... Letter to Matisse, 1950, loc. cit., p. 8 (Écrits, p. 61).

111 *intolerable* ... Ibid., p. 10 (Écrits, p. 54).

112 *seeing and touching* ... V. interview by D.S., p. 213.

11. A SORT OF SILENCE

113 *an unbelievable sort* ... Interview by Schneider, loc. cit., p. 49 (Écrits, p. 265).
as if it were something ... 'Le Rêve, Le Sphinx et la mort de T.', loc. cit., p. 12 (Écrits, p. 30).
had its own place ... Quoted in Genet, op. cit., [p.23].
immeasurable chasms ... 'Le Rêve, Le Sphinx et la mort de T.', loc. cit., p. 12 (Écrits, p. 31).
a recent monograph ... Yves Bonnefoy, Alberto Giacometti, Paris, Flammarion, 1991, p. 282.

117 *A blind man* ... Untitled poem, 1952, loc. cit., p. 72 (Écrits, p. 64).
contained violence ... In conversation with D.S., passim.
pent-up energy ... Interview by D.S., p215

118 *At first you think you need* ... Ibid., p. 229
had practically no feelings ... Ibid., p. 228

119 *a sort of nostalgia* ... Ibid ., p. 227

120 *the quality of the work* ... 'A propos de Jacques Callot', p. 3 (Écrits, p. 26).

Acknowledgements

Sadly, I have to express my gratitude in their absence to the artist, to his brother Diego, to his wife Annette, and to Michel Leiris and Pierre Matisse for many relevant conversations; to Isabel Rawsthorne for her gift of photocopies of Giacometti's letters to her and for permission to quote certain passages from them; to Herbert Matter, for photographing Giacometti's portrait of me at the end of each sitting; and to Patricia Matisse, for providing the photographs of sculptures – some of them already taken for the Pierre Matisse Gallery, others taken expressly for the book.

As to those who may actually read these words, my oldest debts are to Andrew Forge, with whom I talked endlessly about Giacometti during the 1950s and '60s and who saw and revised virtually every draft of what I wrote about him then, and to Pamela Sylvester, who from 1950 on shared many of my meetings with Giacometti, gave help with research and, above all, drafted translations of passages from his writings and interviews, including all of my own interview with him.

Parts of the translation of that interview were subsequently revised in collaboration with Grey Gowrie. Latterly, Barbara Wright has radically revised all the existing provisional translations for the book and made a few from scratch. Our lengthy discussions about problems of Englishing extended to problems posed by my own English.

The interview might never have been recorded had facilities not been provided by the BBC Third Programme, thanks to its willingness to broadcast a long dialogue in a foreign language when spurred on by that most indomitable of Talks Producers, Leonie Cohn. The transcript was never seen by Giacometti and it was our mutual friend Jacques Dupin who generously performed the task of editing it for publication. I am also grateful to him for talking to me about Giacometti, as I am to Louis Clayeux, to Michael Brenson and to the artist's brother Bruno.

I received invaluable editorial assistance in the 1960s from both Anne Seymour and Michael Raeburn. In the 1990s Francis Wyndham played an absolutely crucial role in the evolution of the book's final shape, Nikos Stangos provided useful suggestions, Janet de Botton took photographs for me of Giacometti's village, Jonathan Burnham, who was my editor as well as my publisher, made a number of welcome improvements in the text, and Peter Campbell also made helpful comments on it as well as realising my hopes for the book's design.

Three secretaries have given practical and moral support at different times: Johanna Bywater in 1959-60, Jennifer Barnes in 1965-66 and Eileen Smith in 1992-94.

Finally, I am deeply indebted to a number of individuals and institutions who in one way or another have facilitated the book's publication. First, to Lord Weidenfeld, to Michael Dover and to Sam Sylvester. Second, for their assistance over publication costs, to the Association Alberto et Annette Giacometti, which has waived the royalties for illustrations, to the Pierre Matisse Foundation, which has done the same in regard to Patricia Matisse's photographs, to Sir Robert Sainsbury, who has made a generous personal donation to cover certain costs, and to the Henry Moore Foundation, which has made a similar contribution.

List of Plates

Suspended sphere, 1930. Plaster, metal and string, H. 61 cm. The Alberto Giacometti Foundation, Kunsthaus, Zurich.

Figures in progress, 1947. Plaster.

A figure in progress, 1947. Plaster, probably a state of *Tall figure*, 1947.

Head on a rod, 1947, in progress (one of two versions). Plaster.

Large head, 1960 (one of two versions); *Man walking I*, 1960; and *Man walking II*, 1960, in progress. Plaster.

Man walking, 1947. Bronze, H. 70 cm. The Alberto Giacometti Foundation, Kunsthaus, Zurich.

Composition with three figures and a head, 1950. Painted bronze, H. 56.5 cm. Formerly Pierre Matisse Gallery, New York.

Figurine on a base, 1944. Plaster, H. 7 cm. Private collection, New York.

Four figurines on a stand, 1950. Painted bronze, H. 161 cm. The Alberto Giacometti Foundation, Kunsthaus, Zurich.

Annette from life, 1953. Bronze, H. 54 cm. The Alberto Giacometti Foundation, Kunsthaus, Zurich.

Standing woman, c. 1952. Bronze, H. 60 cm. Formerly Galerie Beyeler, Basel

Detail of *Bust of Diego*, 1955. Bronze, H. 56.5 cm. Formerly Pierre Matisse Gallery, New York.

Detail of *Standing woman*, 1946. Graphite, 53.5 x 28.5 cm. Galerie Jan Krugier, Geneva.

Detail of *David Sylvester*, 1960, in progress, photographed after the 19th and penultimate sitting by Herbert Matter.

Detail of *David Sylvester*, 1960. Oil on canvas, 116 x 89 cm., photographed by Herbert Matter. Collection of Emily and Joseph Pulitzer, Jr.

Hotel room III, 1963. Pencil, 50.4 x 32.7 cm. The Alberto Giacometti Foundation, Kunsthaus, Zurich.